THRACE & THE THRACIANS

THRACE & THE THRACIANS

by

ALEXANDER FOL & IVAN MARAZOV

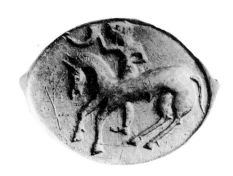

ST MARTIN'S PRESS/NEW YORK

For information, write:
St Martin's Press, Inc., 175 Fifth Avenue, New York, N.Y.10010

First published in The United States in 1977 by
St. Martin's Press, New York

Library of Congress Catalog No 76-29861

ISBN 0 312 80220 X

Printed in Great Britain by Balding + Mansell Ltd,
London and Wisbech

CONTENTS

PREFACE *page 7*

GENERAL INTRODUCTION *page 9*

PART I

Ivan Marazov

1 THRACIAN RELIGION *page 17*

2 IDEOLOGY OF KINGSHIP *page 37*

3 THRACIAN ART *page 60*

PART II

Professor Alexander Fol

4 ORIGINS & HISTORICAL DEVELOPMENT *page 131*

5 SOCIAL & POLITICAL HISTORY *page 144*

ACKNOWLEDGEMENTS *page 155*

BIBLIOGRAPHY *page 155*

INDEX *page 155*

PREFACE

THE INSTITUTE OF THRACOLOGY, the Bulgarian Academy of Sciences' newest institute, was founded in May 1972. A month later, the First International Congress of Thracology was held in Sofia. In August 1975, at the Fourteenth International Congress of the Historical Sciences held in San Francisco, a representative of Bulgaria read a paper on the Thracians, their history, culture, art, etc.

These events, the Philippopolis Weeks of Thracian History and Culture, held in October 1974 in Plovdiv, and the forthcoming International Congress of Thracology to convene in Bucharest in September 1976, show that a new lease of life has been given to a neglected subject of research and that Bulgaria is recognized as the legitimate centre of this research.

Prior to the Second World War, Thracian studies were regarded with a certain degree of condescension, despite the fact that eminent European scholars had made considerable contributions to them. This was largely because attention had concentrated on Greece and Rome to the detriment of their neighbours and also because the ideas of the German historiographic school, shifting the whole weight of research on to the rôle of the carriers of the powerful Indo-European civilizations, were so firmly entrenched. In the post-war period, however, this attitude has gradually changed, largely owing to the general advance in the materialistic philosophy of history, but also to the efforts of a number of scholars, among whom Bulgarian scientists hold a distinguished place. So it was natural that Bulgaria should become the centre of Thracian studies. The country's new government provided equipment and funds for training and over the last thirty years the number of specialists in the Bulgarian historical sciences, including ancient studies and archaeology, has increased many times over. Bulgaria literally teems with ancient relics and archaeological excavation is proceeding apace. Government concern has given rise to an entire generation of devoted researchers, endeavouring to see things Thracian from an angle untrammelled by old concepts and prejudices.

Many scientists in various countries are now engaged in studying Ancient Thrace. The research carried on in the USSR and the Socialist Republic of Romania is particularly useful and has yielded fine results. Work along these lines is also proceeding apace in other Balkan countries. Turkey and Greece have set up special groups for the purpose. Thracian studies are pursued in Italy, France, Holland, Britain, USA and elsewhere. Now, in several countries the general public has had, or will have, the opportunity of seeing and admiring works by ancient Thracian masters, as the exhibition 'Thracian Treasures from Bulgaria' goes the round. It has already been shown in Paris, Vienna, Moscow, Leningrad and recently in London. It will go to USA in 1977 and to other countries as well in the coming years.

The authors dedicate this book to their colleagues all over the world and to the visitors to this great Exhibition.

THE AUTHORS

Sofia, September 1976

GENERAL INTRODUCTION

THRACE was first mentioned in the ancient lays that Homer immortalized. In the sixth century BC when Peisistratus, that much maligned, but highly enlightened Athenian tyrant, had Homer's poems committed to writing, it became apparent that the epic memory of the Greeks had not played them false where Thrace and the Thracians were concerned. According to the *Iliad* Thrace stretched along the Aegean coast and included the so-called Thracians of the Hellespont (the Dardanelles), the Cicones who lived between the Hebrus and the Nestus (the rivers Maritsa and Mesta) and the Paeones, whose settlements were to the west of the Strymon (the Strouma) and along the lower reaches of the Axios (the Vardar). Such was the extent of Greece's knowledge of Thrace on the eve of the Trojan War in the middle of the thirteenth century BC, but by the time Peisistratus' scribes had inscribed the last character on their papyri that knowledge had already grown. Then came Herodotus who, using data supplied by the Ionian geographers to add to his own, pushed the frontiers of Thrace to the Istros (the Danube) in the north and to the valleys of the Strymon and the Axios in the west.

These were approximately the accepted frontiers of Thrace at the time when the Romans' diplomatic and military skill crushed Thracian resistance. In the first century AD, the Romans created three provinces: Upper and Lower Moesia, north of the Haemus (the Balkan Range) and along the Danube from Belgrade to the mouth of that great river; and Thrace, south of the Haemus and down to the Aegean. In the early second century AD, after Trajan's victories over the Dacians in the north, the entire territory of the Thracian tribes in Southeastern Europe was made an administrative unit and incorporated in the Empire, while the territory north of the Danube, where the Thracian tribes had just been subjected, was made the province of Dacia.

But, apart from its geography, what did the Greeks actually know of Thrace and the Thracians? What was their idea of this intriguing people and the land they inhabited?

Herodotus called them barbarians, but in his day there was nothing pejorative or contemptuous about the term, which merely meant that the writer considered their world to be less developed than his own. Not only that, but some authors even extolled barbarian virtues, contrasting them with the depravity of society in their day.

Greek writers, too, appear to have thought they could apply Greek criteria to these 'backward' neighbours and their way of life. For example, the rôle of any barbarian deity whose function was at all obscure, was given a Greek interpretation thus slanting people's ideas about Thrace. These ideas, however, have no historiographic value and did not survive the early Middle Ages, which is why Renaissance scholars had little or no knowledge of this part of the ancient world.

Thrace's rediscovery took place in similar circumstances. The Thracians left the historical stage in the sixth and seventh centuries AD, passing their traditions to the Slavs and the Bulgars who founded the First Bulgarian State in 681. Seven centuries later this state was conquered by the Ottoman Turks, who relegated it to the backyard of history for nearly five centuries. Once the Ottoman Empire had consolidated its boundaries, which were ceded by the European states of the fourteenth and fifteenth centuries rather than won by the Ottomans, there began quite a traffic of diplomats crossing Bulgaria on their way to Constantinople. Between the sixteenth and nineteenth centuries many travellers crossed Bulgaria and many truthfully described their journey to Constantinople (Istanbul). They were followed by a host of tourist-spies sent by their governments to map the country's rivers, mountains, inhabited places and roads, because of the country's strategic importance.

Probably the first to rediscover Ancient Thrace was Count L. Marsigli, who travelled along the Danube and then down the river Yantra in 1721 and was the first to mention the strange relics from Thracian times to be seen there. In the late nineteenth and early twentieth centuries, the travel jottings of F. Kanitz, K. Jiriček and the Šcorpil brothers continued the work.

Then came M. Cary's paper on the coins of the Thracian kings and the Cimmerians of the Bosphorus, which he read to L'Académie des Inscriptions et Belles-Lettres in France. It was more a historical narrative than a paper on numismatics and represents a first attempt to systematize the political history of Thrace.

Cary's attempt was so successful that some of his ideas, to support which there is now new evidence, could well be taken up anew. In his day, however, his efforts had little effect; but in the second half of the nineteenth century the work of such scholars as W. Tomaschek, K. J. Beloch, K. Kazarov and others finally set Thracian studies among the historical sciences of Antiquity. The two most important aspects of Thracian studies were religion and language, the latter finally being assigned a place among the Indo-European languages. Here the work of two dedicated scholars, G. Kazarov and D. Detschew, will long be remembered.

Unfortunately the scholars of that generation all adopted the premises of their ancient Greek predecessors, blindly following Herodotus and his successors, though this meant disregarding such obvious information as Homer's assertion that the material culture of the Thracians and their allies, the Trojans, was just as high as that of their enemies, the Achaeans. However, it was hardly likely that people would suppose that Homer could have been right at a time when the historical value of his poetry was still doubted.

Between the two World Wars, the German school dominated historiography with its obstinate and inflexible philosophical interpretation of the historical process, focusing all studies on Athens and Greece, Rome and Italy.

This Helleno- and Italo-centrism were nothing but an instrument for reducing the history of the Eastern Mediterranean, and of the ancient world in general, to two radically opposed, closed systems, one of which, the Graeco-Roman, was the cultural centre exerting its influence on its barbarian periphery. The Thracians, who were the most numerous and powerful neighbours of the Greeks, occupied a foremost place on this periphery.

The natural result of such a way of thinking was to bring Thracian studies to a standstill.

The only remedy, therefore, was to reject the Greek interpretation and look for the Thracian. The lack of Thracian written sources, however, means that before this could be done, general and concrete preliminary studies had to be undertaken and terms defined.

What is Thracology? Is it the history of the peoples between the Danube and the Aegean, or that of Thrace as seen by the Greeks? Is it the history of the population of the four Roman provinces between the Carpathians and the Aegean? Or is it the history of the Thracian dispersion which had its centre in the Balkan Penin-sula, but included regions as far afield as the Dnieper and Dniester basins, the Bosphorus Kingdom, the Crimea, the Aegean islands, Northern and Central Greece, Asia Minor, Egypt and North Africa and the vast Roman Empire?

The written sources and material data show that the territories between the Danube and the Aegean, the Vardar-Strouma valleys and the Black Sea were the actual tribal and cultural centres of the Thracian world. The areas north of the Danube, however, were an integral part of it, their population, its history and civilization having the same characteristics. The theory that at least two languages or dialects were spoken in this region – Daco-Mysian in the northern and western parts, and Thracian in the southern and eastern, makes no difference. The situation was the same in Greece, where people with a similar historical, ethnic and cultural background, but inhabiting different regions, were unable to communicate because of differences in dialect.

Leaving aside the earliest periods of the Neolithic and Bronze Ages, still in dispute, the first clearly-definable span of time relevant for the entire region between the Carpathians and the Aegean is the second half of the second millennium BC, as is vaguely indicated in the written sources, but now corroborated by archaeological finds such as the Vulchitrun treasure from Northern Bulgaria, dating back to the end of the Bronze Age. As elsewhere in the Eastern Mediterranean, this was the final phase of a brilliant age which has yet to be studied.

The second great period in the history of Ancient Thrace was that between the end of the second millennium BC and the end of the sixth century BC. If these centuries, or at least their early part, are looked upon as a dark age in Greek history, the same should be true of Thrace, in which profound changes took place owing to the introduction of the use of iron and the ensuing economic and political upheaval; yet there this age seems to have been brighter, for the traditions of the Bronze Age persisted in production, social structure, political life and culture. Some imposing megalithic tombs of between the twelfth and sixth centuries BC point to South-eastern Thrace as the centre of an advanced civilization. It is not surprising, therefore, that the next and third period, i.e. that between the end of the sixth and the beginning of the third centuries BC, was an era of great material, cultural and political advance. It was then that many tribal unions, amounting to states, came into being south of the Danube and along its lower reaches. These were important centres of production, building and the arts and crafts. Of these tribal unions that of the Odrysae was the best organized, the strongest militarily and a formidable political influence in South-eastern Europe.

The fourth period in the pre-Roman history of the Thracian tribes starts with the social and

political crisis in the Balkan Peninsula that began in the third century BC. This crisis was aggravated by the Celtic invasion, and ended in the break-up of the last Thracian political organization, the state of the Dacian king Decebalus, early in the second century AD. Decentralization continued throughout the period, political life being more intense in the northern regions, where the crisis had less effect and conditions favoured the emergence of new tribes, such as the Dacians. If this pattern is valid for the territories between the Carpathians and the Aegean, it can perhaps help date the Thracian dispersion. The problem here is that it is not enough just to record the presence of Thracian tribes in the various parts of the world; what we want to know is the reasons for their being there, and these reasons are to be sought in Thrace itself.

The Thracian ethnic element abroad will provide additional data on the social and political system, the life-style, culture and religion of the Thracians. The Thracian dispersion can be divided into three distinct periods: the first goes back to the time of the great migrations which lasted until the beginning of the first millennium BC, and covered the vast area between the Caucasus, the Black Sea, South-eastern Europe and the entire Eastern Mediterranean. There were many Thracian tribal enclaves in these territories, as the Greek colonists and travellers discovered, and their existence has also been established by archaeological finds and mythographical and linguistic data.

The second part of the dispersal coincided with the Hellenic period, the campaigns of Alexander the Great in the East and the early days of the Roman Empire. Our knowledge about it comes from written records, tomb and dedicatory inscriptions, coins, archaeological finds and papyri. These trace the boundaries of territories inhabited by compact Thracian civilizations, closely related as to their *mores*. Although influenced by local circumstances, the Thracians had well-preserved religious traditions and zealously defended them.

The third period of the Thracian dispersion began with the separation of the Eastern Roman Empire from the Western. It is best illustrated by the sources from Late Antiquity which refer to Asia Minor and Hither Asia and is further proof of the resilience of the Thracian ethnic element, which survived up to the Early Middle Ages.

As more and more archaeological discoveries were made in Crete and Mycenae, Asia Minor and Hither and Central Asia, they provided proof of the variety of social and political structures and showed how relatively equal were the cultural achievements of the ancient world. Only the most conservative can still support Hellenocentrism. The time has come when it should be realized that even Athens with its social structure, political system and cultural life is not the yardstick, but rather an exception to the classical slave-owning system. It

has been established that here the variety of forms is much greater than was previously thought, and that the ancient world did not develop along one ascending line culminating in the Parthenon, but in many directions and along parallel lines which rarely intersected. Today, the ancient world is seen as a mosaic of closed local systems, mostly isolated from one another, so that it was only in certain areas as, for instance, in South-eastern Europe and Asia Minor, that they influenced each other. It is, therefore, inadmissible to regard the history of either the Thracian tribal centre or its periphery as the product of the influence of a cultural centre, such as Athens. Rather, it was a part of the mosaic of the slave-owning society and economy of those days.

Since the time of Schliemann, Troy's discoverer, the idea of the Greek miracle of the fifth century BC has been so demolished that it is no longer taken seriously. It has been shown that it was the result of a tradition of much longer standing than had been imagined, that the Greek language had evolved over a long period of time, and that Greek mythology had had its pre-history, dating to the second millennium BC, to the Mycenaean period, at the latest. On the other hand, it has been established beyond doubt that Greek art was a remarkable synthesis of subjects and styles borrowed from the East.

The interrelations of Thrace and Greece, pose a problem. There is no doubt that elements of Thracian cosmography, philosophical, religious and state doctrines, of the Orphic doctrine in its archaic, pre-classical aspect, were interwoven with the Greek to a varying degree and at various times. A further difficulty in presenting the Thracian viewpoint of the history of that country is the absence of a script. For this the Thracians have their justification, as do other people like them, but this does not make it any easier. It is not easy to arrive at a Thracian interpretation to offset the Greek interpretation. To hear the voice of Ancient Thrace, it is not enough to read the few inscriptions in Greek characters on stones or rings, but the whole corpus of written sources, archaeological finds and linguistic data has to be assembled and interpreted. In such a situation there is always a discrepancy between historical reality and the way it is presented in the sources; and so in order to get to the genuine article the researcher has to remove the glosses which the Greeks and the moderns have put on the text or the excavated object.

In the case of Thracian history there are grave doubts as to the equivalence between historical reality and its presentation. It is not possible to compare texts, archaeological finds, numismatic objects and mythological data without first chronologically grading them, because very often sources of one and the same calendar date provide information from different periods.

The historical geography of the Thracian tribes is based on data extracted from records from the time of Hecataeus to that of Strabo, and from the time of Strabo to that of Ammianus Marcellinus. These data, covering ten or even sixteen centuries – if it is accepted that the earliest information in the *Iliad* refers to the time prior to and during the Trojan War – is usually lumped together and so placed on the ethnic map of Thrace, presenting a static picture which is meant to be valid for all periods, but which does not and cannot reflect a changing reality. As a rule each territory has been given the name of the tribal group mentioned by the Greeks as the most powerful, and that is why the method of the German cartographic school of the past century has to be totally revised, as should everything that has been written about the historical geography of Thrace.

The second book of the *Iliad* shows that the term Thrace then referred to a very limited area, but by the end of the sixth century BC it had gradually been adopted as the ethnic and geographic name for the territory south of the Danube and its inhabitants. It is still being debated whether the first 'Thrace' was on the Hellespont, as Homer indicated, or along the lower reaches of the Strouma, as some linguists think today. During the first half of the first millennium BC, the extent of the territory known under this name gradually expanded. In Homer's epic only three tribes are named: Thracians, Cicones and Paeones, but by the time of Herodotus the number had increased to twelve, while eighty are mentioned in the writings of the Hellenistic geographers. This increase was due to the decline of the centralized political power of the great Thracian organizations and the emergence of numerous local centres.

To what extent may we use the term 'tribe' outside its social context? The Greek writers never speak of a tribe (ethnos) but simply use the ethnonym. We have added the term tribe as a hint at the social character of the organization, but there is no need to say 'the tribe of the Getae' instead of just 'the Getae'. What is most probable is that the ethnonym derives from the name of a great family, which exercised political, military and religious power. Herodotus, for instance, writes that the Bessi were a family of the Satrae, and that they had charge of Dionysus' sanctuary in the Rhodopes. It is clear that the name Satrae, which only Herodotus mentions, was that of a family, now extinct, that had had strong political powers and that the name had later been assumed by a large tribal group. According to Herodotus, the name Bessi was that of a family which came into prominence later and gave its name to the population of the Rila and Rhodope Mountains. The Bessi reached the peak of their popularity as late as the second century BC and this is corroborated by numismatic finds and inscriptions.

Many coins of the tribes in South-western Thrace that have been discovered have been dated to the late sixth and the early fifth centuries BC, the period when the number of ethnonyms in Thrace first increased substantially. Some of the coins bear the name Getas, king of the Edoni. As the ethnonym Getae was used in North-eastern Thrace, the use of Getas in the south-west was explained as being due to an invasion of the south-west by the Getae and their subjugation of the Edoni. Then the coins were said to be counterfeit and the question was dropped. But the coins are genuine, and the question still remains to be answered. It is our conviction that the name Getas was used on Edonian coins not because of an invasion at a remote period, but because it was a Thracian royal name, like Teres, Sitalkes and Kotys. The royal origin of this name shows, though indirectly, that the Getae were a family of North-eastern Thrace and that they ruled that territory. They were in fact the family of the god-king Zalmoxis.

That this is the likely explanation is confirmed by an inscription from Mesambria (Nessebur) dated to the third century BC, which states that the town granted a number of commercial and political privileges to the Thracian dynast Sadalas and goes on to enumerate his ancestors, but never mentions the name of his tribe. Thus it was actually the dynasty which was granted the privileges, not the tribe.

In actual fact, Thrace was made up of large and small territories, which are now gradually being put on the map. Records and finds, when taken together, clearly indicate their areas. From west to east there were three territories in the northern part: the area between the Morava and the Isker which was occupied by the Triballi; the central part of present-day Northern Bulgaria, referred to in the sources as the land of the Moesians; and the region of the Lower Danube, designated in the sources as the territory and state of the Getae. The influence of these territories was felt in the north in the pre-Roman period, and their political, ethnic and cultural relations with the south have been established beyond doubt.

Some of the territories in Southern Bulgaria stretched beyond the country's present-day frontiers. They included the region between the Vardar, the Strouma and the Mesta, the lands between the Mesta and the Maritsa, and those to the east of the Maritsa, which were closely linked with the Thracian dispersion in Asia Minor.

Investigations now being carried out show that these small territories were geographic and economic entities, that they had a system of settlements, cult and economic centres, and were connected with neighbouring regions by a dense communications network. They could not have been partitioned between the various tribes because they were often enclosed plateaux in the foothills of a

mountain. So, politically they were parts of the larger territories of tribal unions. But they were also part of the ethnic and demographic map of Thrace, as there is no doubt that the country, covered with dense forests stretching over wide areas, now swampy, now mountainous and inaccessible, was inhabited only in those localities where conditions were most favourable. It was here that the people were concentrated and organized in families and family unions. It would thus be acceptable to use the word tribe.

It is obvious that, when political power was in the hands of a family or dynasty, it could not be separated from the religion or the cults practised by that dynasty's subjects. But it is not easy to tell what the religion was, or what the cults were, since Herodotus and all other writers saw Thracian religion through the prism of Greek religion. The cults and the names of deities that have so far come to light, show that each region and, sometimes, a smaller area within a larger one, had its local cult and local deity. Archaeological finds and especially the figures depicted on Thracian treasures indicate that local king-priests were actually deified. But there was no monotheism among the Thracians in the Christian sense.

The Thracians' deities controlled the political, i.e., the material, equilibrium in their capacity of king, and the natural equilibrium between the power of life and that of death, in their capacity of god. In their lifetime they were also priests, so that they could maintain their own cult. As a result there was no evolution in religious and political life throughout the entire pre-Roman period, as witness the plaques of Hero, the mounted Thracian deity, who was revered with equal zeal in all parts of the country.

It is obvious that Thrace was extremely conservative in all social, political and religious respects, and that from the sixth or fifth centuries BC life there was very different to life in Greece. The process of historical development seems to have been arrested in Thrace during the second millennium BC, as it was in Mycenae; while between the time of Agamemnon and that of Pericles, the Greek cities went on to make themselves the centres of the slave-owning system and the cradle of European civilization. Against such a background Thrace must have seemed backward.

But did evolution really stop in Thrace, or did it only appear to do so in comparison?

In Antiquity evolution proceeded in stages; because, as things were then, a change in social relations did not necessarily entail a change in the other spheres of life. There is data to show that Thrace developed at a rate which corresponded to her vast territory and power – it should be borne in mind that Thrace was the largest country in South-eastern Europe and one of the largest in Antiquity. Yet, in historical terms the rate was slower in comparison with those of the smaller maritime countries. All trends characteristic of the slave-owning system are to be seen in Thrace in at least an embryonic stage; and in certain parts or in some aspects, the historical process even reached the stage immediately before that attained in Classical Greece. But this general evolution which permitted the country to join the slave-owning system as late as the Roman period, did not touch such important spheres as religion and politics.

PART I

IVAN MARAZOV

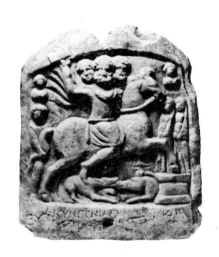

1

THRACIAN RELIGION

IT IS ONLY RECENTLY that Thracian religion has been seriously studied. Previously, the Hellenocentric idea that explained the Thracian pantheon by analogies with Olympus, had never been challenged, though this did not make the beliefs of Bulgaria's ancient inhabitants any less intriguing. When scholars began their search for other interpretations, they had to take known facts and from them evolve a streamlined system which would take account of existing analogies with the better known religious patterns of the Persians and Scythians. This showed that the Thracians formed a cultural community not with their southern neighbours, the Greeks, but with the tribes north of the Danube and east of the Hellespont. The geographic proximity of Greece was not enough to bridge the tremendous social and ideological gap between Thracians and Greeks.

It is not an easy thing to see the light of truth across the millennia. The ancient writers have left us scanty, confused and often contradictory information on Thracian religion, representing some beliefs and cult customs as exotic oddities or as illustrations of barbarian ways. More often than not, they gave the Thracian deities the names of Greek or Roman gods. Examination of archeological monuments have revealed something even more unexpected: that the Thracian pantheon included every imaginable deity. The votive reliefs from the Roman period feature practically all Graeco-Roman and Eastern gods. Initially, it seems to be reasonably simple: Asclepius and Hygieia are the protectors of health, Zeus and Hera of fertility, the three Nymphs of the springs and so on; but when confronted with the deity on horseback, of whom there are some three thousand reliefs, we find ourselves in a quandary.

This mysterious figure has no name – in the dedicatory inscriptions he is just 'Hero' or 'the God Hero'. The inscriptions themselves record so many different reasons for dedication – from a prayer against the bite of a rabid dog to invoking protection for the city gates – that we are justified in wondering whether they were all addressed to the same deity. The reliefs, however, leave no room for doubt. Many of them depict a horseman brandishing a spear and aiming it at a boar hiding behind an altar. Next to the altar there is invariably a tree with a snake coiled round it and one, two or three women standing nearby. The hunter is accompanied by a dog or a lion. On others, the horseman is depicted returning from the hunt, holding his quarry high, his dogs or lions leaping up trying to get a bite of it. In still other reliefs, the Hero is riding to the altar in triumph, a bowl held in his hand. The various iconographic types cannot be identified with any specific function of the Hero. The different epithets are not much help either, as they convey his local characteristics. One wonders if this Hero was not the representation of a universal god, revered by all the Thracian tribes, each of which gave him a local name.

This idea is borne out by the frequent representations of the horseman with three heads. A god with three faces occurs very early in the pre-Aryan monuments of Mohenjo-Daro in India, in the Luristan bronzes two millennia later, and here in Thrace, another ten centuries later. Multiplication of the face, body or limbs is an archaic way of suggesting omnipotence. Here we find the maker of one of the Hero's reliefs placing busts of both Sol and Luna above the horseman, thus indicating that he was linked to both the solar and to the chthonian cult; but some of the Thraco-Roman reliefs emphasize only one of these functions. In the famous sanctuary near Lozen, the horseman is called Apollo Geikethienos. Here, to stress the Appollonian or solar aspect, the artist has given the local deity the attributes of the Greek god of light: long hair, a lyre and a long mantle. On the other hand, many reliefs have been discovered in Northeastern Bulgaria in which the horseman is represented with the attributes of Pluto, king of the nether world: a beard, long robe and the horn of plenty. Quite often he was given the epithet of the great god Darzalas, an usage adopted also by the Greeks in Odessos. It should not be assumed, however, that if some aspects of the horseman were preferred in a given locality, his other functions were neglected there.

In Thrace, the Hero is always represented on horseback, though this can only have begun comparatively late, i.e. after the horse began to be used for riding, a skill which the Thracians acquired earlier than the Greeks. It is quite probable that the idea of the centaurs of Greek mythology was suggested by the Greeks' first contacts with Thracian horsemen. One of the most frequent epithets applied in Greek literature to the Thracians is 'horse-loving' and their country is referred to as 'horse-breeding'. The hero is always represented as a hunter, and it appears that it was the custom in Thrace to go hunting on horseback, as noted by Curtius in his biography of Alexander the Great. After the king's encounter with a lion, the Macedonians decreed that thereafter he should go hunting on horseback only, as was the custom among the Thracians. The Thracians, like many other ancient peoples, revered the horse as sacred to the sun god. On the other hand, it was also a symbol of the nether world. It is possible that the combination of these two beliefs made the horse the constant companion of the hero. Yet the most important reason for this must have been a social one. As the family community declined, the tribal aristocracy emerged and the horse became the symbol of its political, economic and military power. Philostratus enumerating the possessions of Rhesus, speaks of his many choice herds of horses. In the military organization, the aristocrat and his retinue were distinguished from ordinary warriors by being mounted. The Odrysae recruited their cavalry exclusively from their own members and the infantry from the other tribes. The hunt, another royal privilege among Eastern peoples, Mycenaeans and the Thracians, is a feature of the iconography of the Hero. Rhesus was a famous hunter, while the heroes in Hittite, Assyrian and Achaemenian reliefs are depicted fighting real or mythical beasts.

In the votive reliefs of the Roman period, an attendant is often depicted behind the horseman. He carries his master's two spears and runs alongside holding on to the horse's tail. This was not a new element. It occurs in some Asia Minor stelae of the fourth century BC, is of Eastern origin and reflects a specific type of relationship. It is interesting to find Alexander the Great depicted on one relief as a mounted hunter with Lysimachus as his attendant holding on to the horse's tail. The Macedonian knew well what to borrow from the East in order to consolidate his position. But it may be that this was an established custom at the Macedonian court even before Alexander's time. It is perfectly obvious that social considerations played an important part in shaping the iconography of the Thracian horseman.

The tree is an invariable symbol in the reliefs. In contrast to some Greek stelae, where it is represented bare and withered, in the Thracian reliefs it is always in leaf. It could, therefore, be assumed that it symbolized the rebirth of Nature. Maybe this was the reason why the Thracian sanctuaries were always erected amid fine groves. We should bear in mind, however, that a more or less stylized representation of the old Eastern symbol, the tree of life, is often to be met with in monuments from the pre-Roman period. When a palm tree was depicted on a votive relief from Roman times, this was not a predilection for the exotic, but rather adherence to traditional Eastern iconography: it was the genuine tree of life.

But why is it that in the majority of the reliefs the horseman is hunting a boar? The explanation is to be found in the Lovets belt, on which two horsemen are shown throwing their spears at boars symmetrically arranged around the tree of life. In the old myths of Greece and Asia Minor, the boar was closely associated with life and death: the Cretan Zeus was torn to pieces by a boar: one of the feats which won Heracles his immortality was the slaying of the Erymanthian boar. Meleager perished because he gave up his trophy, the head of the Calydonian boar which he had slain. The son of Croesus was accidentally pierced by a spear cast by one of the hunters chasing the Mysian boar. On the other

The hero in chain mail – detail from a helmet from Agighiol.

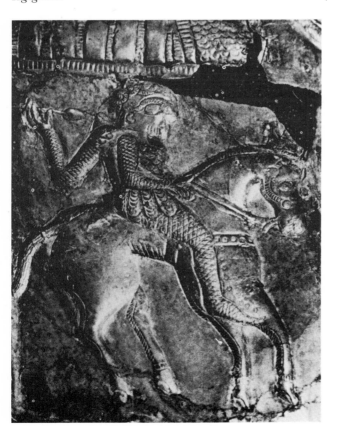

hand, the boar was the enemy of fertility, destroying the crops in the fields, as did the Calydonian and Mysian and Erymanthian boars; while the Gauls believed that the boar dug up the roots of the apple tree, the Northern tree of life. Thus, by slaying the boar in front of the tree of life, the mounted hunter was performing the symbolic act of guaranteeing the repetition of life's cycle and should, therefore, be viewed as the deity of renascent nature and the guardian of order in the world.

On the basis of this interpretation, the snake, which is depicted coiling around the tree in all the reliefs, should be another link with the vernal awakening of nature. This is quite natural, because it is in the Spring that snakes come out of their winter lethargy. Sleep was the symbol of death and awakening that of rebirth. What is more, snakes slough their skins in the Spring, this being yet another symbol of rebirth and, consequently, of immortality. This is the reason why all stelae featured a snake as the invariable attribute of deification, that is to say of immortality. This was also why the horseman was depicted as a hero. He destroyed the enemies of life, saved the tree of life and thus won immortality. In all probability, these were the high points in the mythical lives of all Thracian heroes. He might have different adversaries, but to ensure order in the world and the normal course of life, the hero was always depicted fighting the forces of evil.

Very often one, two or three women may be seen standing before the horseman. Were they his mother, his wife or beloved? The analogy with Dionysus and the Maenads, Asclepius and Hygiea, Zeus and Hera, suggests that they must have played a role in the so far unknown myth of the Thracian Hero. In India, Iran and Asia Minor a play on the preservation of life used to be enacted during the New Year festivities. According to this play, a three-headed dragon lorded it over the world. He had locked up the waters and captured all the women. The earth was parched and no more children were born. Then a god-like hero appeared and he fought the dragon and vanquished it. Water began to flow all over the dry earth, and the women were married to the hero. It is quite probable that the myth of the Thracian hero may have followed those lines, for various episodes of it may be seen on the appliqués of the Letnitsa treasure. In one of these a woman is feeding a three-headed serpent from a bowl. Is the idea not the same as that of the women held captive by the dragon? In another appliqué, a Nereid is riding a hippocampus, which is probably a symbolic representation of the released waters. In a third, a warrior is depicted in hierogamy with a woman, while another woman is offering them an amphora and a twig – are these not the women whom the hero freed and who became his wives? In India the dragon was personified by rain clouds, so, during the festivities, arrows were

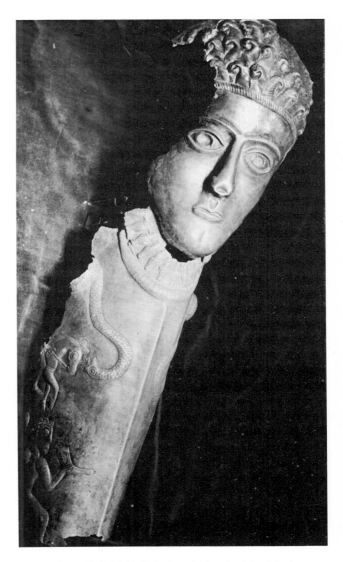

Greave from Agighiol, depicting the head of the Mother of Gods with necklace and torque.

aimed at the clouds; it was in this way that the Iranian Mithras overcame the dragon. Herodotus writes of an analogous custom among the Thracian tribe of the Getae, who shot into the sky arrows aimed at the thunder and lightning. One wonders if the great historian was not actually present at a re-enactment by the Getae of this ritual fight with the monster. The scene on a pectoral from Mesambria depicting the myth of Perseus who rescued Andromeda from a monster, probably carries the same religious meaning. Upturned vessels, the water freely flowing from them, are sometimes depicted on Thraco-Roman votive reliefs. Could this not be a symbol of the hero's feat? In this case, the women waiting for him at the altar could be regarded as his future wives, who had been delivered from the monster. It could be objected that here the horseman is fighting a boar, not a dragon; but might not the two motifs have been combined: the hunt of the boar near the tree of life and the

Gold ring (from Glojene) depicting the mounted hero holding a rhyton.

rôle of the Hero in the perpetuation of the human race? Both motifs tie in with the essence of this demigod, whose function it was to ensure the natural order of the world through rebirth and reproduction.

Sometimes there is a second horseman on the votive tablets. He is smaller and is always depicted riding to the left, while the Hero gallops to the right. What was the reason for this additional motif? Who was the second horseman, an assistant or an enemy? A very distant prototype may be seen in the Lovets belt, where two horsemen are depicted hunting boar near the tree of life. The images are symmetrically arranged around the central motif. Similarly, a large palmetto, symbolizing the tree of life, is inserted between the two winged chariots on the Vratsa gold jug. There is no contradiction here, for in all probability the symmetric repetition of motif symbolizes the dual essence of the basic idea. And should we not look for the same meaning in the reliefs of the so-called Danubian horsemen in which the two riders are facing each other? The essential thing in the myth of these twin-horsemen (Cabiri) is that they took turns in experiencing death and immortality, in heaven and in the underworld below. The cult of the Cabiri – their likenesses may be seen on a goblet from Romania – was practised in Seuthopolis. Orpheus initiated the Argonauts into their mysteries in Samothrace. Indeed, the doubling of the horsemen in the Thracian votive tablets is not an indication of nascent dualism, but a typically Thracian idea of the hero's dual essence.

The various representations of the Thracian horseman portray the different facets of his legendary life and the acts expected of him by the dedicators. But it would be an error to assume that there was no more to it than that. There are missing links, and to find them we have again to turn to the Persian and Scythian religions, which were obviously close to the Thracian. Herodotus devotes a great deal of space to the Scythian versions of the story of the origin of the human race. According to one of these, the Scythians were the descendants of Targitaus, the first inhabitant of the then desert land, and according to another, they sprang from Heracles' marriage with the Scythian snake-limbed goddess. Iranian texts also record legends about 'the first people' Yima, Hoshang and others. These heroes, at least one of whose parents was divine, were the forefathers of their respective peoples. A similar legend could well have existed in Thrace. Indeed, it is possible that the hierogamy scene in the Letnitsa appliqué depicts the hero in his role of progenitor. On many reliefs of the Roman period he is given epithets which reveal this aspect of his nature: patrios, genikos, progonikos.

It could be that each tribe had its hero, who was its ancestor and who was known by a local name. This father of the tribe was expected to watch over Nature's fruitfulness, and his aid was sought by his tribe's members. The most general function of the Thracian horseman was the protection he offered, and that is why he appears on so many votive tablets with a shield on his left arm, although he was no warrior.

However, in order to produce his offspring the hero had to have a partner, a mother for the human race; and this brings us to another essential feature of the Thracian religion: the cult of the Great

Mother of Gods. Scholars maintain that this was a concept of Eastern origin. However that may be, the Mother of Gods, who was anonymous, was the mainstay of everything in the world. She was both heaven and earth, the source of life and the progenitor of mankind. This religion developed in several stages. First came the single female idols of the Neolithic and Eneolithic Ages; towards the end of the Bronze Age when the Thracians had already settled in the Balkans, you begin getting two idols, one placed inside the other, as in the Orsoya find. Were these both goddesses, mother and daughter, symbols of reproduction? The symbolic burial found in Sofia district is dated only a few centuries later. It consists of three vessels – clay, bronze and gold – one placed inside the other. Does this not signify the appearance of a third member – the son of either the Great Goddess or her daughter? As we shall presently see, it was the Thracians who introduced the Eleusinian cult of Demeter and Persephone, mother and daughter. Even their names are an exact translation of this function. (Demeter = Mother Earth; Core = girl in the sense of daughter.) Later they were joined by Dionysus as Persephone's son. Why did a son have to appear? Because impregnation had to be explained in a way that would not violate the principle of the goddess's omnipotence. Her son became her lover. Such was the case with Cybele and Attis, Aphrodite and Adonis, Persephone and Dionysus. Their

hierogamy was an important aspect of the cults of the Eastern peoples, marital union ensuring reproduction. The erotic scene of the Letnitsa appliqué very probably shows the consummation of the marriage between the Great Goddess and her son and lover. Next to them is another female figure: the goddess's daughter. This appliqué is very important because it shows the hero, who figures on other trappings in the find, as the son and lover of the goddess. A strange figure, called Deloptes in the inscription, is shown next to that of Bendis in another relief from Athens. His presence is solely justified by the etymology of his name, which means lover of the earth. We see in this relief a different form of marriage between the Great Goddess and her son. It is interesting that the only probable etymology of the epithet Bendis derives it from the Indo-European root *bhendh* which means to tie, unite, combine. The Great Goddess was, therefore, the protectress of marriage.

But to return to the sources on Thracian religion. Herodotus mentions a Thracian goddess, Artemis the Queen. This name, accompanied by the same epithet, also occurs in votive tablets. In the East and in Greece of the archaic period, Artemis was not only the goddess of the hunt and of wild life, but of nature and life in general. She merged into the Mistress of the Animals, who was herself a form of the Great Mother of Gods.

The Thracians could hardly have called this

Hunting scene – detail from the silver Lovets belt (see page 40).

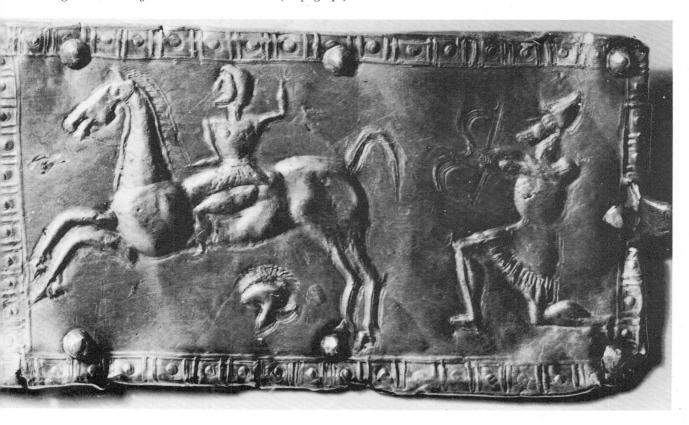

goddess by her Greek name, as Herodotus claims. What is more, it is highly unlikely that she would have been addressed everywhere by the same name. Polyaenus tells us that the supreme deity of the Scaeae and the Cebrenii was Hera. There is additional information that a cult of Hera existed in Thrace which was not connected with that of Zeus. Hera was worshipped on the Reskythian Mountain near the mouth of the Maritsa, where there was a temple dedicated to her and to Apollo of Zerynthus. This association between Hera and Apollo is again seen on one of the rhytons of the Panagyurishté treasure, where Hera is depicted seated on a throne – a royal prerogative – while Apollo and Artemis stand close by. Aeschylus described the orgies of Kotytto or Cotys of the Edoni, which were known as far afield as Asia Minor. There is also mention of the goddess Tereia, who was honoured in one of the mountains near Lampsacus.

The personification of the Great Mother of Gods most popular among the Thracians was Bendis. Until recently she was identified with Artemis or Diana, and it was believed that she was depicted under these names in some votive tablets from the Roman period showing a goddess, bow in hand, riding a doe, a quiver of arrows slung across her back. Elsewhere she is shown chasing her quarry, holding her bow in one hand and reaching towards her quiver with the other. Another representation of the goddess widespread in South-western Thrace, and especially in the area around Philippi, shows her with a spear and a twig in her hands. This would seem to match up with a ceramic fragment from Lemnos dating to the seventh century BC, on which Bendis is depicted carrying two spears. In one of his comedies Cratinus calls her 'two-speared'. Indeed, we know a great deal about Bendis, because her cult was officially adopted in Athens in 429–428 BC. Many inscriptions, dedications and reliefs survive and these provide ample information about her. In two Attic reliefs she appears dressed in a chiton, an animal skin thrown over her shoulders, wearing a Phrygian cap on her head, two spears clasped in her hands. This is perhaps the best portrayal of her attributes. On a coin of the Bithynian king Nicomedes I (third century BC), Bendis is similarly depicted and is also grasping a sword. She was greatly honoured by the Bithynians who named a month in their calendar after her. Probably the use of this term for the Great Goddess was most widespread in South-western Thrace, in the valleys of the Strouma, Mesta and Vardar, but no doubt her cult was also well known in North-western Asia Minor, since the Bithynians were a Thracian tribe which moved to Asia Minor from the valley of the Strouma. The ancients even said that the Bithynians were originally called Strymonians. The Bithynians honoured the goddess during the Spring, when she appeared as a woman of huge proportions, spinning and tending pigs.

Nereid riding the hippocampus (Letnitsa treasure). See page 93.

The three nymphs.

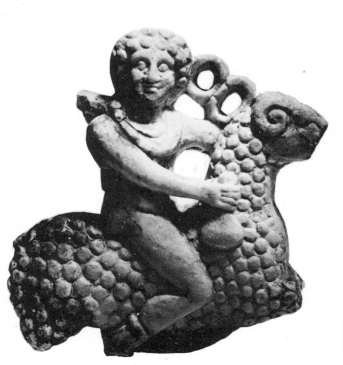

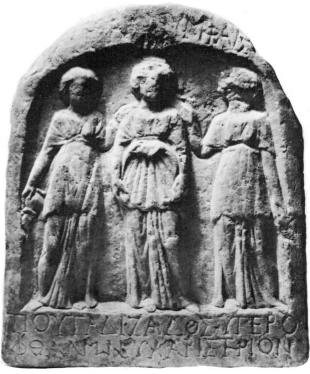

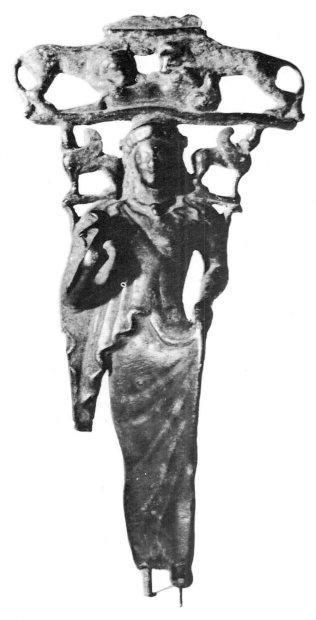

Handle of a bronze mirror of the fifth century BC. *The figure is Artemis. Above her are two lions with their prey.*

This is reminiscent of Anahita of the Eastern hymns, who was a woman as big as a mountain.

The best information about the cult of Bendis is provided by Socrates, who himself had attended the Bendideian festivities: 'I went down to Piraeus yesterday with Glaucon, the son of Ariston, to honour the goddess and to see how they were going to arrange the procession as this was being held for the first time. The procession of the local citizens was very nice, but that of the Thracians was no less beautiful!' Then follows a conversation between Socrates and Polemarchus and Adeimantus who tried to talk them into staying for the whole evening: 'Don't you know that tonight there will be a horse race with torches in honour of the goddess?' 'On horseback?' Socrates asked. 'This is something new. I wonder if they will hand the torches to one another while racing! Or what do you suppose?' 'That's how it is going to be,' Polemarchus said. 'What is more, they will have a celebration during the night which will be worth seeing.' And it was! The Athenian Bendideia, which were celebrated on 19–20 Thargelion (May–June), greatly dazzled the Greeks. The procession marched from Athens to Piraeus to arrive at the sanctuary of the Nymphs near the temple of Bendis. There a sow, the sacrificial animal of the goddess, was killed. This act had the same function as the cult of Persephone, in which the wheat to be sown was sprinkled with blood from the pig so that the animal's fecundating power could be passed on to it. Recalling that the Thracian and Paeonian women sent their gifts to Artemis, the Queen, bundled in straw, the affinities between the Greek and Thracian concepts of the Mother Goddess are clear. It is interesting that a pig's skeleton was found in a Thracian burial from the Bronze Age. Evidently, the hero and the Great Goddess shared functions: he fought life's inimical forces (the boar) and she stimulated fertility (its symbol being the sow), thus guaranteeing order in the world.

The sanctuary of the Nymphs was on the Munychia Hill in Piraeus, not far from the temple of Bendis. In a classical relief, the goddess is portrayed with the Nymphs, showing that in Thrace the Nymphs were connected with the cult of the Great Goddess. This explains why these divine beings held a place of distinction in Thracian mythology. Legend has it that the country's name could be traced back to the Nymph Thrake. It is quite natural, therefore, to see the Nymphs depicted in many reliefs from the Roman period as symbols of the curative power of springs. Bearing in mind their ancient link with Bendis, it would not be surprising to find them figuring on votive tablets together with Hera – the other image of the Great Goddess. Actually, this is a repetition of the idea underlying the Athens relief, only there Deloptes has been replaced by Zeus.

The ancient writers saw much in common be-

tween the orgiastic celebrations of Bendis and Kotytto, on the one hand, and of the Phrygian Cybele, on the other. This is further evidence of the religious links between Thrace and Asia Minor, which seem to have been more natural and easier than those between Thracians and Greeks. To Plato, Herodotus, Xenophon and the other ancient authors, the Thracian cult seemed strange and incomprehensible. They attended the ceremonies as interested spectators and, though describing them as something exotic and out of the way, they recognized features common to the cults of the various Thracian goddesses and felt that the same essence was there beneath the different names. Aristophanes even called Bendis the Great Goddess.

Naturally, the Great Goddess had not only different local epithets, but also different functions. Hesychius has compared her to Persephone, showing that she was also connected with the nether world. The twig which she is depicted holding in some Thraco-Roman reliefs is another indication of this, as this twig granted free passage to Hades. In these reliefs the goddess's hair is adorned with a crescent moon, identifying her with Selene. A sepulchral monument from Mesambria reveals the complex syncretism of the goddess's functions practised in Roman times. In the pediment she is represented as a huntress like Artemis, but is wearing the Thracian headgear of Bendis. In the next panel she is shown as Hecate, holding two blazing torches in her hands, and then as Persephone again holding torches, but seated in a chariot which is taking her to the nether regions. Here again we have a deity of many images, performing many functions, making it possible for her to appear as Artemis, Diana, Persephone, Selene, Phosphorus or Hecate. It is possible that the Bithynians saw their Great Goddess as a woman of huge proportions because of the versatility of her qualities.

Herodotus, whose writings are an inexhaustible source of information on Ancient Thrace, also provides details of the Thracian pantheon, telling us that of all the gods the Thracians revered only Ares, Dionysus and Artemis. For a long time this was accepted without argument; yet there are several doubtful points here. Firstly, Herodotus himself mentions other Thracian deities, thus invalidating his own statement. Secondly, he never mentions the hero, the Thracian mounted deity who became so popular during the Roman period. Then again, many more votive tablets to Zeus and Hera, Asclepius and Hygiea, Apollo and others have survived than those dedicated to Dionysus. It can be argued that by giving the Thracian deities Greek names, Herodotus made them more comprehensible to his countrymen. But was this the best approach and could the Greek gods really be identified with the Thracian? This requires further scrutiny, but Herodotus seems to have acted deliberately, so as to have the traditional triad with

Artemis playing the rôle of Mother of Gods, Dionysus that of Father, and Ares of Son. The whole construction seems rather artificial and it is somewhat difficult to have complete confidence in the Father of History.

To Herodotus's contemporaries, the presence of Ares in the Thracian panthenon was only to be expected. They could not even conceive that such a blood thirsty wild god could be a product of the Greek imagination. He must have come, they presumed, from the world of the barbarians, as had Boreas, the god of the cold north wind. Fascinated by their new ideals, they must have forgotten that many of the feats of their forefathers and heroes fell short of the high moral and ethical principles they now professed. Indeed, they must have deliberately closed their eyes to the inhuman acts of many of their contemporaries. On the other hand, could there be a more convincing personification of Ares' spirit than the warlike Thracians? As early as the seventh century BC, the poet Archilochus called the Thracians, (in his case the Abantes), the gods of battle, and was not ashamed to admit having once fled from the field, leaving his shield as booty to a Thracian warrior. The ancients were hard put to it to decide which of the many Thracian tribes was the most valiant: the Getae, Odomanti, Thyni, or Odrysae. It was natural for the Greeks, who had frequent encounters with the Thracians, to fear their Ares, the mythological personification of the Barbarians' fighting qualities. Later records from Thrace also mention this deity. In AD 13, the Roman commander Piso defeated the Bessi and celebrated his victory 'by chaining their Ares'. An epigraph of the second century AD was discovered in Sozopol (ancient Apollonia Pontica) mourning a warrior 'slain in murderous battle with the Thracian Ares'. In several votive tablets from Thrace, the horseman is represented with a helmet and shield, while in others, and also in the rock reliefs near Philippi, he is depicted swooping down upon an enemy. Evidently, this concept of the god to whom Herodotus assigned a foremost place in the Thracian pantheon, persisted into that late period.

Did the Thracians have their own god of war? There is a long description in Herodotus of how the Scythians offered sacrifices to their Ares. We know that they paid reverence to a short sword (*akinakes*), which they smeared with blood from men and horses slain in its honour, and in Medgidia (in the Romanian part of the Dobroudja) a bronze sword, shaped like an *akinakes*, with an eagle holding a snake in its beak engraved on the haft, has been discovered. What its use was has still to be explained, but it could well have been a symbol of a Thracian god of war. We know from Herodotus that when the Apsynthii captured the Persian commander Oeobazus, they sacrificed him to their household god Pleistorus, as was their custom. Florus writes that before their battle against

Marcus Crassus (29 BC) the Moesians slaughtered a horse in front of their ranks and pledged to sacrifice all enemies slain and let the gods have a taste of their entrails. This practice of offering sacrifices to the god of war was very widespread in the ancient world: not only the Thracians but also the Scythians, Illyrians, Celts, Persians and even Greeks in the period of recorded history resorted to it to make sure of Ares' intercession on their side. It is clear Ares was also revered in Thrace, but was he a separate deity or did Herodotus apply a separate name to what was just one function of the versatile Thracian deity?

If there was a god of war in the Thracian pantheon, he could very well be Pleistorus. But Herodotus explicitly calls Pleistorus the household god of the Apsynthii, which makes him the universal god of the Propontic littoral populated by this tribe. In that case, the Persian commander Oeobazus must have been sacrificed to the military functions of this god or hero. Other facts corroborate this hypothesis. There are several appliqués in the Letnitsa treasure showing men's or horses' heads behind the horseman. It is this particular attribute that distinguishes the hero from his other representations, in which he also wears chain-mail and is pointing his spear threateningly. It is interesting that Livy records that after a victorious battle the Thracians would bear the heads of their slain enemies aloft stuck on the points of their spears. In all probability, the heads in the Letnitsa appliqués were symbols of the pledge by which the chieftain hoped to secure the protection of the god or hero. It may be inferred that the Thracian Ares appeared here not as a deity in his own right, but as one of the functions of the universal god, as was the case during the Roman period, when the hero is only given the attributes of Ares in those reliefs which are dedicated to Thracian warriors.

Not only Herodotus, but all the ancients believed that Dionysus was a Thracian god and that he had come to Greece from the north. Many modern scholars share this belief. Initially, however, Dionysus was alien both to the Greeks and the Thracians, though it is probable that his religion was established in Thrace before it spread to Greece. His Asia Minor origins are beyond dispute. He came to the Balkans across the Hellespont, the most convenient passage between the two continents, and from the Thracian shore of the Propontis began his victorious progress among Barbarians and Greeks. Euripides, one of the best authorities on the Dionysiac cult, was convinced that Dionysus was already revered by the Barbarians when he made his appearance in Greece. It was natural for the Greeks to believe in a Thracian origin of Dionysus, all the more so as throughout Antiquity the Thracians were considered inveterate drunkards.

Information about the first contact of Dionysus with the Thracians can be found in literature. The first mention is in Homer, who records that when he first set foot on the European shore of the Hellespont, Dionysus there met Lycurgus. Homer does not specify that Lycurgus was a Thracian, but Aeschylus, whose tragedy *Edonoi* has not survived, seems to have assumed that his realm was near Mount Pangaeus. After this, the ancient writers appear to have accepted that Lycurgus was a Thracian. Diodorus Siculus gives the fullest account of his encounter with Dionysus. According to him, when Dionysus was preparing to lead his army from Asia into Europe, he struck up a friendship with Lycurgus, king of those Thracians who lived by the Hellespont. He then let the Maenads cross over first to what he considered was a friendly country, but Lycurgus ordered his soldiers to attack the Maenads during the night, hoping to destroy them and Dionysus. A local man by the name of Charops betrayed the plan to Dionysus, who was in a nasty predicament, for the whole of his army was still on the opposite shore, only a few companions having crossed with him and the Maenads. Secretly Dionysus sailed back to his army, leaving the Maenads to their fate. Lycurgus duly attacked them during the night on the so-called Nyseion, and slew them all. Dionysus, however, brought his army over, vanquished the Thracians, caught Lycurgus alive, blinded him and, after putting him to the torture, crucified him. What historical truth can one extract from this Greek myth?

There is no doubt that the Lycurgus episode reflects the ancients' awareness of the religious conflict that occurred in Thrace when the Dionysiac cult clashed with the old traditional beliefs. In Greece, too, the new god cruelly punished Pentheus, the Theban king, when the latter opposed him. Thus Dionysus imposed the new religion by force and, even more, by cunning: in Thrace making use of the services of a traitor and in Greece setting the women against the men when the latter clung to the old cults. This policy of pitting part of the people against the rest, is typical of the method of infiltration used by Dionysus in the lands he wanted to subdue, and it suggests that the spread of his cult in the Balkans was connected less with the migration processes, than with the social and political crisis which gripped the Peninsula. The appearance of the new religion was the result of the profound changes which had taken place in society and in the consciousness of the Balkan peoples.

The crisis, a struggle between the old and the new, and a substitution of one ideology for another, lasted a long time. Diodorus writes of the contradictions in Thracian society. According to him Lycurgus had a brother called Butes. Both were sons of Boreas, the North Wind, but by different mothers. Butes, who was younger, plotted against his brother. When his plot was uncovered. Lycurgus did not harm him; he just ordered him to board a ship with his fellow conspirators and look for

another country to settle in. Such could actually be the cause of the migration of the Thracian tribes and their colonization of neighbouring lands.

Centuries later the Greek cities also dispatched groups of their politically unreliable citizens to look for new lands. So Butes and his Thracians moved to the island of Strongyle, the future Naxos, and became pirates. On one of their forays they came to Drius in Thessaly, where Dionysus's nurses were celebrating the orgies in honour of the god. Butes abducted Coronis and ravished her. Outraged, she invoked the help of Dionysus, who sent Butes off his head, so that he jumped into a well and was drowned. As we see, Thracian expansion was opposed by a counter-current, but the adepts of Dionysus succeeded in subjecting Thrace which was torn by a social and demographic crisis. Obviously, all these names and episodes connected with them are not history, but legend. It is perfectly clear, however, that mythology is retelling actual events of this period of transition.

In all probability, this was the end of the Bronze and the beginnings of the Iron Age. What, then, was the kind of religion with which the new god entered into conflict. During the last phase of the Bronze Age, the solar cult was widespread in Thrace. Objects of daily use and works of art were decorated with ornaments symbolizing the sun. The cliffs near Paleocastro are studded with an amazing number of schematic representations of the sun cut in the rock. It was inevitable that Lycurgus, identified with the sun's brilliance, should clash with a god who was born of moisture and sought salvation in it. Thus two cults – the solar and the chthonian – collided. The terrible death of Lycurgus was the triumph of the new religion.

Dionysus having installed the traitor Charops as king of Thrace and initiated him into the secret rites of the mysteries, continued his progress into Greece. Later, Charops' son, Oeagrus, inherited both the kingdom and the knowledge of the secret rites and passed this knowledge on to his own son, Orpheus. The mythical Orpheus was a great figure in Thracian religion. His name was always linked with that of Dionysus. (Apollodorus even wrote that Orpheus had invented the Dionysiac mysteries.) This association between Orpheus and Dionysus is not accidental. The common elements in the two cults preclude that. Some schools even think that Orpheus was the Thracian replacement of the moribund deity Dionysus found in the country. Comparison of the two myths certainly allows such an assumption. Dionysus died by being torn to pieces by the Titans, as Orpheus was torn to pieces by the Maenads. Dionysus was said to have been buried in the temple at Delphi. Orpheus's grave also became a sanctuary. The human race was born from the ashes of the Titans, while after

Orpheus's dismemberment, the earth ceased to bear fruit, the oracle declaring that it would become fertile again only after the head of the singer had been found and buried. Thus the death of both Dionysus and Orpheus were made a pledge of life's continuance.

Every deity of vegetation is inevitably linked with the nether world. To the Greeks, Dionysus was sometimes the son of Persephone, queen of the realm of the dead; at other times, he was identified with Hades, king of the world of shades. A Thracian relief from the Roman period shows Dionysus, not Hades, in the scene of the abduction of Persephone. In Roman times, the Thracian celebration in honour of Dionysus – the Rosalia – were the days on which homage was paid to the dead. The myth of Orpheus also contains strong chthonian overtones. Some etymologists derive his name from the word 'darkness', others link it with Orphos, a deity of the nether world. The Greeks considered him one of the most important members of the entourage of the underworld rulers. Polygnotes depicted him playing his lyre near their palace. Orpheus was believed to have been fathered by Oeagrus and conceived by the muse Calliope in a cave, the cave is a chthonian symbol which occurs frequently in Thracian mythology. Rhesus, for example, went to a cave in the 'silver-veined' mountain after his death. Zalmoxis went to live in a cave which was inaccessible to others. The rock-hewn tombs of Thrace are nothing but an imitation of a cave, another lead back to Dionysus. Was not the Cretan Zeus, whom some scholars regard as another form of Dionysus, secreted away and reared in a cave in Mount Dicte or Mount Ida? And yet this is only indirect evidence of Orpheus's chthonian essence.

The most lyrical episode in the myth of the Thracian singer is the one about his descent to the nether world. He was led there by his inconsolable grief at the early death of Eurydice. With his music, he soothed the three-headed Cerberus and claimed the attention of Hades and Persephone. Enchanted by his performance and sweet manner, they gave him permission to take Eurydice back with him. He left the nether world happy, only to become desolate the next moment, for he turned back to see if his wife's shade was following him, and lost her for ever, because the sun had not yet had the agreed glimpse of her. There is a parallel to this legend in Greek mythology, according to which Dionysus went to the nether world to fetch his mother, Semele, but, unlike Orpheus, he succeeded in his undertaking. Interesting, too, is the story that Dionysus, having fallen in love with Ariadne, got Artemis to kill her so that he could take her with him to the nether world. This is a repetition of the story of Persephone's abduction by Hades. Another version of the Orpheus legend has it that in despair over his failure to bring Eurydice back, he committed suicide so that he could join her in the realm

of darkness. The two myths have this further point in common: in order to enjoy love and happiness, both Dionysus and Orpheus had to live in the realm of darkness. It is possible that the legend of Eurydice was invented to justify Orpheus's periodic descents to the nether world. If this is so, then this touching myth shows that in the image of the inconsolable singer linger survivals of an older Thracian deity of plant life, whom the new religion had obliged to become an adept of Dionysus.

The chthonian character of Orpheus and his resemblance to Dionysus become all the more obvious when viewed in relation to the Eleusinian mysteries. Our knowledge of these mysteries is far from complete: they were celebrated at Eleusis and were dedicated to the deities of the nether world, Demeter, Persephone and Pluto who ensured fertility, and these were later joined by Dionysus, probably because of the latter's close association with the Great Mother of Gods in Asia Minor. Euripides points to this association several times in his *Bacchae*, a wonderful source on the Dionysiac cult. He even identifies the Dionysiac orgies with those of Mother Rhea (i.e. Cybele). Later, Apollodorus stated that he was convinced that Dionysus had learned the mysteries from Rhea in Phrygia. In Eleusis, Dionysus was considered the son of Persephone, but, of course, Persephone and Demeter are mere embodiments of the anonymous Mother of Gods, which is why in Greek mythology Demeter was associated with her mother Rhea, who was the Mother of Gods. Homer's hymn to Demeter tells us that Rhea decided to institute mysteries in honour of her daughter. The link between the cult of Dionysus and the Great Mother of Gods was a very old one, probably going back to that stage in the development of religious ideas when the two goddesses, mother and daughter, were joined by a son to symbolize fecundation. This association also occurred in Greece, hence the joint cult celebrated at Eleusis, of what Euripides called 'the two basic principles in the world. One is Mother Demeter . . . She gives us only dry food; Semele's son her bounties increased; he gave us wet food – the juice of the vine . . .'. There is an ancient description of the idol of Demeter which says that it had been carved from a vine tree – there can hardly be a better symbolic association of the two deities. These considerations alone justify the inclusion of Dionysus among the Eleusinian deities. He was so close to them that he promptly became the son of Persephone. His wife Ariadne was sometimes identified with the queen of the nether world, and, according to a Theban version, his mother Semele was probably an earth goddess (cf. Semele – *zemlya* in the Slav tongue and *zemelo* in Thraco-Phrygian).

It is interesting to trace the route by which Dionysus reached Eleusis. The ancient sources are unanimous in that a Thracian, Eumolpus, was the founder of the Eleusinian mysteries. Then there was a battle between the Eleusinians and the Athenians, in which Erectheus, king of the Athenians, was killed and so was the son of Eumolpus. Hostilities were discontinued on condition that the Eleusinians would thereafter obey the Athenians in all things, but would continue to celebrate the mysteries on their own. This legend, conscientiously recorded by Pausanias, is reminiscent of what we know of the clash between the old and the new religions, in that Demeter was a newcomer to the Greek pantheon. She came to Greece from Crete. But why should her mysteries be founded by a Thracian? Not only that, but one of this Thracian's sons was held to be the founder of another cult of Demeter near the town of Tenedos.

It is thought certain that Demeter reached Greece along the route taken by Cadmus, whose sister, Europa, has been identified with her. Indeed, the temple of Demeter Eleusinia in Thebes used to be one of Cadmus's palaces. This legendary hero, Cadmus, was either a Phoenician or a Cretan. When Zeus abducted his sister (Europa), their father Agenor sent his children to look for her, enjoining them never to return until they had found her. They looked for Europa everywhere and failing to find her, decided not to return home. They settled in different places. Cadmus and Telephassa staying in Thrace, as did Thasos who founded the city of that name. Conon provides another version of Apollodorus's original story, according to which, the Phoenicians (Cretans) settled in Thrace. Now, among the legendary Thracian kings there was one, Phineus, whom Hesiod called the son of Agenor and brother of Cadmus and Europa. His very name links him to the Phoenicians and his knowledge of navigation makes him a typical representative of that race. All this shows that Thrace was affected by the Phoenician (Cretan) expansion even before Greece. It was from Thrace that Cadmus set out southwards and founded Thebes. But he did not sever his ties with the north. Strabo says that the wealth of Cadmus came from the mines of Mount Pangaeus in Thrace. It is clear that the Greek historian traced the route of the Phoenicians to Greece via Thrace, and it may be presumed that the cult of Demeter followed the same route. It is not surprising, therefore, that a Thracian should be thought to be the founder of her mysteries in Eleusis. It would seem that this was the route which Dionysus also followed. On his arrival in Greece he encountered no resistance at the places where Demeter had been welcomed.

According to what has been said so far, Orpheus was only indirectly linked with Demeter, but in ancient literature there is a great deal that points to his having participated in the establishment of her cult. Diodorus says that when Heracles came to Athens and took part in the Eleusinian mysteries, the rites were led by Orpheus's son, Musaeus. Euripides was convinced that Orpheus had been

one of the initiators of this cult. The Muse, lamenting the death of her son Rhesus, is made to tell Athene that the Muses highly respected her city and maintained friendly relations with it. Orpheus, a kinsman of Rhesus, the man the goddess had killed, had lit the torches at the secret mysteries there. This would explain why the singer is represented next to the rulers of the underworld in the frescoes by Polygnotes, though they are not depicting the occasion when Orpheus went down to fetch Eurydice. Rather he owes his place to his being the founder of the mysteries of Demeter and Persephone. It is not surprising, therefore, that that indefatigable traveller Pausanias should have seen an old wooden idol (*xoanon*) of Orpheus in the temple of Demeter Eleusinia in Therae. The same author maintains that in Sparta Orpheus was considered the founder of the cult of Demeter Chthonia. Thus the third representative of the 'Dionysian dynasty' in Thrace was closely associated with the cult of the Great Mother of Gods. We would be justified in asking if he were not an intermediary between the two cults, and whether it was not with his help that Dionysus joined the circle of the Eleusinian deities, since his son Musaeus inherited not the Dionysiac but the Eleusinian mysteries. It could very well be that the linking of the new religion with that of the Great Mother of Gods was one of the 'many things' that Orpheus changed in the mysteries of Dionysus.

RIGHT: *A depiction of the hero with three heads (the attribute of omnipotence). On either side busts of the sun and moon. By the horse's head are two women (mother and daughter). The hero's servant/attendant is holding the horse's tail; and in the foreground a hound is attacking a boar beside an altar.*

BELOW: *Dionysus and Hercules in a chariot, shown against a background of bunches of grapes.*

The ancient sources are unanimous about the god's reaction to the changes which his adept introduced: Orpheus had to be punished and punishment was duly inflicted by the women (Thracian and Macedonian) who tore him apart, and tossed the pieces into the sea, because he would not allow them to take part in the orgies, for, while the company of Dionysus consisted of women only, Orpheus would initiate none but men into his mysteries. His sanctuary was barred to women. His fate was the same as that meted out to the Theban king, Pentheus, and his killing typically Dionysiac.

According to Conon, the womens' decision to kill Orpheus was due to his having deprived them of their men by persuading these to accompany him on his wanderings. At first the women did not dare to act on this resolve for fear of their husbands; but when they got drunk on wine, they found the courage to do so, thus the intervention of Dionysus was practically direct, in that he emboldened the women through the wine, making them act like Bacchantes. The conflict between the deity and his former adept must have been really acute for Dionysus to treat the singer with the same cruelty he had shown to his enemies Lycurgus and Pentheus.

There is a story that Eurydice died from a snake bite; if so, this may have been a warning given to Orpheus before the god finally dealt with him. The point here is that the Bacchantes used to fasten

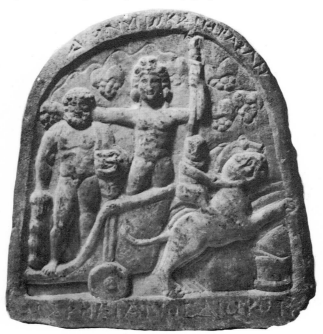

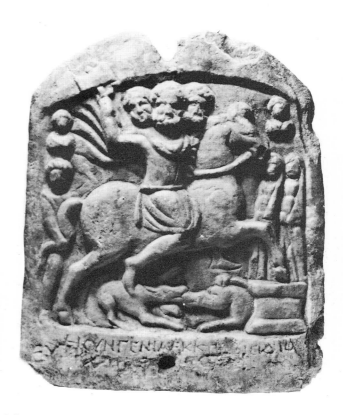

Symbol of the sun carved on the cliff face at Paleocastro.

their animal skins with snakes, wreath their heads with them or let them lick their faces without ever being bitten since they were protected by the god. Evidently Eurydice was not granted the god's protection, or had had it withdrawn, and so she died from her contact with the snakes.

It is possible that Orpheus may have reformed the Dionysiac religion by freeing it from the excesses of the orgies which characterized the Asia Minor cults. There is no evidence that the Dionysiac mysteries were celebrated in Thrace with such immoderate frenzy as in other countries. But would Dionysus have reacted so cruelly just because of a minor change in his cult?

The name of Orpheus today is symbolic of musical talent. This romantic notion dates back to Antiquity. 'He could so enchant with his songs, that even the wild beasts and the birds of prey, the trees and the stones would follow his delightedly.' There was just one other like him among the inhabitants of Olympus – Apollo, king of the sweet-sounding lyre. Orpheus's music was vastly different from the Dionysiac – it lacked that wild, passionate element which drove people into a frenzy. Its sereneness brought it closer to Apollo's music. That is why when the Lesbians found the lyre of Orpheus, they took it to the temple of Apollo.

The Thracian, however, was not only a singer, he was also a soothsayer and a sorcerer. It was said that when Orpheus's head and lyre were found near Lesbos, after having been thrown into the Hebrus, the head was still singing and uttering prophecies.

A coin of the Deroni. The figure is either the king or Hermes setting out to perform the sacred act of ploughing. Note the semi-palmetto, symbol of plant life, and the solar symbol.

Philostratus maintained that the force of these prophecies was destroyed by Apollo who saw in them an infringement of his own prerogatives. Orpheus was asked by the Argonauts to join them on their journey, because he knew the secrets of sorcery. He initiated them into the mysteries, interpreted the omens, told the story of the creation of the world and of the gods. In Antiquity, the gifts of music and soothsaying were interconnected. Orpheus was no exception, and here again his Apollonian essence is revealed.

Orpheus's qualities as a healer, which the ancients did not doubt, bring him even closer to Apollo. The Thracian's music calmed the passions of enemies and made people forget everything else. Pausanias was certain that he had acquired great influence because he was believed to have found cures against diseases. Euripides wrote about the medicines on the Thracian tablets, recorded by Orpheus. In general, Thrace was renowned for its healers, who insisted that the body cannot be cured before the soul has been healed. According to the Ancients, the very name of the country could be traced to the nymph Thrake, who was skilled in incantations and herb-healing. So the characteristics of Orpheus and Apollo were ascribed to a whole nation. There is a Roman relief in which the Thracian horseman is depicted holding a lyre, while the inscription names him Asclepius. Could this be a representation of Apollo or of Orpheus as healer?

These are the most striking parallels between the Thracian singer and the Greek god. There is other evidence to show that Orpheus was a zealous admirer of Dionysus, and in an inscription from Thrace he is termed 'a companion of Apollo'. The most important information is provided by Aeschylus, who wrote that Orpheus looked upon Helios as the greatest of the gods and began calling him Apollo. He used to wake up whilst it was still night and climb Mount Pangaeus to wait for the sun to rise, so that each day the first being he saw was Helios. There is no doubt that Orpheus was a devotee of the solar cult, and this explains some obscure symbols in his legends. He was permitted to lead Eurydice out of the realm of shadows on condition that he was not to turn and look at her before the sun had seen her. From Pausanias we learn the story of Orpheus's monument at Libethra. A prediction reached the city's inhabitants that when the sun saw the bones of Orpheus, Libethra would be destroyed. All this reflects the belief of the ancients in the similarity between Orpheus and the sun, that is to say, Apollo.

This would mean that by becoming an adept of the solar cult, Orpheus reverted to the religion of the time of Lycurgus. No doubt he carried his fellow tribesmen along with him. Support for this can be gleaned from the ancient writers. When the Bithynians had to take a decision on an important matter, they sat facing the sun so that heavenly body might predict their fate, the sun being considered an all-seeing and all-hearing deity. In Antiquity white horses were sacred to the sun god. Homer tells about the horses of Rhesus which were whiter than snow. There was also the ancient belief that the sun was a horse. Sophocles might have had this in mind when he wrote that Helios was the most revered heavenly body of the horse-loving Thracians. Nowhere else has Apollo been

represented as a horseman except on numerous Thracian votive tablets.

We see that the Apollonian principle was very strong in Orpheus. This the ancient writers saw as the reason for Dionysus's cruel revenge. 'He did not honour Dionysus, by whom he was raised to pre-eminence, and looked upon Helios as the greatest of gods, even beginning to call him Apollo . . . This greatly angered Dionysus and he sent the Bassarides. They tore him apart, scattering the pieces to all sides' (Aeschylus quoted by Pseudo-Eratosthenes). The new orientation, or rather the re-orientation of Thracian religion to the solar cult caused conflict. Unwilling to adopt the Dionysiac cult, the Thracians reverted to their old religion. Nonetheless, both written data and archaeological finds show that Dionysus was worshipped in Thrace; so obviously, Orpheus had not supplanted him altogether. He had only changed 'many things' in his mysteries. Does this not mean that the Dionysiac religion took on a new aspect in Thrace, different to that in Greece?

Archaeological finds have confirmed the ancient writer's statement that the Thracians erected their sanctuaries on mountain tops, where the sun's rays would touch them as soon as it rose. But such sanctuaries were dedicated to Dionysus, too. Herodotus tells of the famous oracle of Dionysus in the land of the Satrae, whose priests were chosen from among the Bessi. It was situated 'upon their highest mountain' (probably Rila). Eight centuries later Macrobius filled in the picture when he related how on the hill of Zilmisos there stood a temple in the form of a rotunda, with a roof that was open in the centre. Both the location and the shape of this Dionysiac sanctuary link it with the solar cult. The god of vegetation and the underworld was associated with the sun god. That is why Rhesus, who was to become its oracle, 'shall not into earth's dark lap go down', but 'in caverns of the silver-veined land a god-man shall he lie, beholding light, as Bacchus' prophet 'neath Pangaeus' rock, dwelt, god revered of them that knew the truth,' thus linking the chthonian principle (the cavern) and the solar principle (beholding light).

Even more striking is the myth about Maron. In the *Odyssey* he is a priest of Apollo and he makes Odysseus a present of 'twelve jars with wine, sweet and unmixed, a drink for gods'. This unmistakably points to Dionysus. Later sources link the Thracian priest to Dionysus. Some say that his father Evanthes was the son of this god, while others skip this intermediary stage and make Maron a son of Dionysus. The interesting thing here is that this member of the tribe of the Cicones could combine two mutually excluding principles – the Apollonian and the Dionysiac, and this at a time when in Thrace a cruel struggle was raging between the two cults, with Lycurgus, Butes and Orpheus among its victims. After they perished, Maron who had grown old, was appointed by Dionysus to be guardian of his cult and he was instructed to found a city that was named Maroneia after him.

On closer scrutiny, this corroborates Macrobius's statement that in Thrace the Sun and Liber (Dionysus) were one and the same god. But initially Dionysus did not have a solar aspect. There is a great deal of evidence to show how sharp was the struggle between his religion and the old solar cult. Yet it was in Thrace that a compromise was reached. One wonders if this was not what Orpheus's reform of the Dionysiac mysteries meant. It could not have been by accident that the lyre of the singer was placed in Apollo's temple in Lesbos, while his head was buried under the temple of Dionysus. This is splendid symbolic evidence of the god's duality as seen in the Orphic doctrine.

In Greece, too, the two deities were associated, in Apollo's temple in Delphi. It was believed in Delphi that in wintertime Apollo departed to the land of the Hyperboreans, and that in his absence Dionysus became lord of the sanctuary. This fusion of the two gods took place comparatively late, in the fifth century BC. There is some justification for wondering if this was not done under Thracian influence, if it was not a transplanting of Orpheus's reform to Greek soil. Many sources point to the Thracians having had a direct link with the sanctuary at Delphi from the very early days. In this most important religious centre of Greece, the main priestly family was the Thracidae. Herodotus, who was familiar with the practices at the Dionysiac sanctuary in Thrace, compared them to the Delphic rites. Dionysus had come to the Delphic oracle from Thebes, for he was believed to be the son of Semele. But in Thebes his cult had come from Pangaeus via Pieria; for this reason it is quite possible that the Orphic reforms may have had an early influence there.

One important feature distinguishes the Thracian Dionysus from the Greek. In Greece he was not associated with divination, while in Thrace he had the most famous oracles and all prophecies were made under his divine influence. Thus the priests of the Ligurians made their prophecies after they got drunk on wine. Orpheus's head, buried in Lesbos under the temple of Dionysus, went on making prophecies, whose force the jealous Apollo destroyed. Was this because they were inspired by Dionysus?

Many Thracian votive tablets from the Roman period show Apollo and Dionysus as horsemen, a representation which is not characteristic of Greece. This iconography was purely Thracian, as the Thracians believed that every deity was assigned the attributes of a mounted hunter. Zagreus (great hunter) is a well-known epithet of Dionysus. The second king of the 'Dionysian dynasty' was Oeagrus (lone hunter).

The association of Dionysus and Apollo with the

mounted Thracian hero is not only a result of the syncretism prevalent in the Roman period. It is rather one more proof of the complex, contradictory and universal essence of the Thracian deity. In the Thracians' awareness this essence had not yet crystallized into separate functions, nor had each of these functions been given a clear-cut image, as was the case in the Olympic pantheon. There was no distinctive deity of the sun, nor of the nether world. After Orpheus succeeded in making peace between Apollo and Dionysus, they became one and the same god in the Thracian mind. Relics from the pre-Roman period give an indication of this. The coins of the Derroni show an ox cart driven by a bearded man wearing a wide-brimmed hat. Could that be Hermes? The man resembles the deity as far as his attributes are concerned: a rosette, the solar symbol, is depicted above the ox and a palmetto, a chthonian sign, below it. Two symmetric chariots are to be seen on the Vratsa jug. Could this be a symbol of the sun's rotation between night and day? We could even ask whether the Thracians believed in a sun god or in his substitute – a demigod, an anthropodemon and son of the Great Mother of Gods – the hero. Such was the picture in Asia Minor, where Attis and Adonis were considered mortals and their death and regeneration were marked by annual mysteries associated with the cult of the goddess. We see Orpheus opposing Dionysus, and Zalmoxis proclaiming himself a god. It was no accident that both were believed to be cultural reformers, i.e. founders of a religious doctrine. What is more, Orpheus taught the Thracians how to farm, thus again showing his link with the goddess, just like Triptolemus and Arcas who learned the secret from Demeter in

Nereid on hippocampus (about 370 BC).

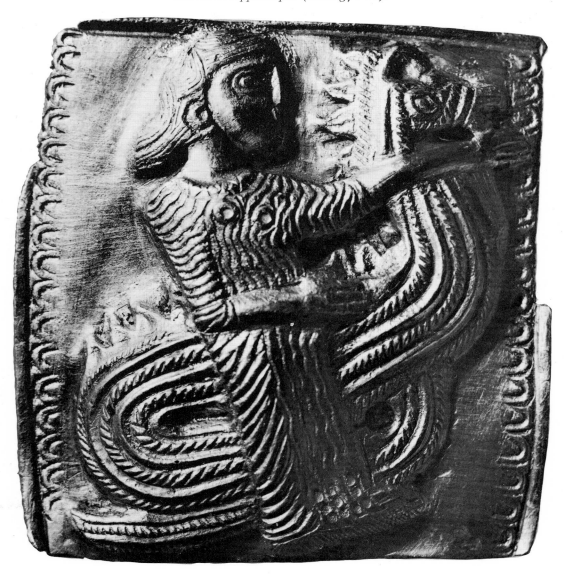

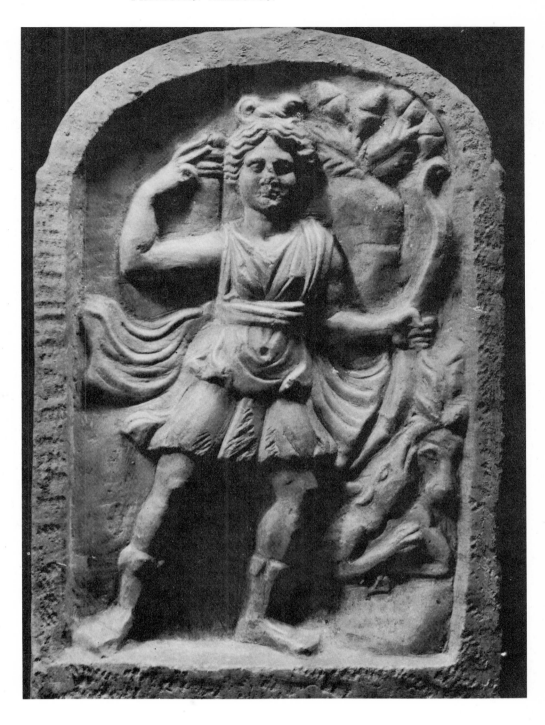

*A votive relief –
Artemis/Diana.*

order to impart it to their fellow tribesmen. Zalmoxis seems to have been the chief hero of the Getae; they also called him (was it actually him?) Gebeleizis. Orpheus was usually said to have been one of the Cicones, but his cult was also practised in Pangaeus and Pieria, by the Pontus Euxinus and elsewhere, which suggests that every tribe had a hero of a similar kind. Perhaps the myths about them differed in some points, but the general idea was the same. The hero had to be the son of the Great Goddess, he had to fight against the forces of evil and to protect the tree of life and thus maintain order in the world. Unfortunately, we only know the life-story of Rhesus, but it suffices to confirm the general pattern. The son of a Nymph (Muse), he was a hunter, warrior and horse-breeder. He fell in love with Arganthone, who was not a housewife like the rest of the women, but used to go hunting. This ancient form of emancipation makes one wonder if Arganthone was not a variant of the Mistress of the Animals, of Artemis, Atalanta, Aphrodite, Bendis, Cybele. Before she met Rhesus, she despised men, and had nothing to do with them. But she fell in love with Rhesus and when he

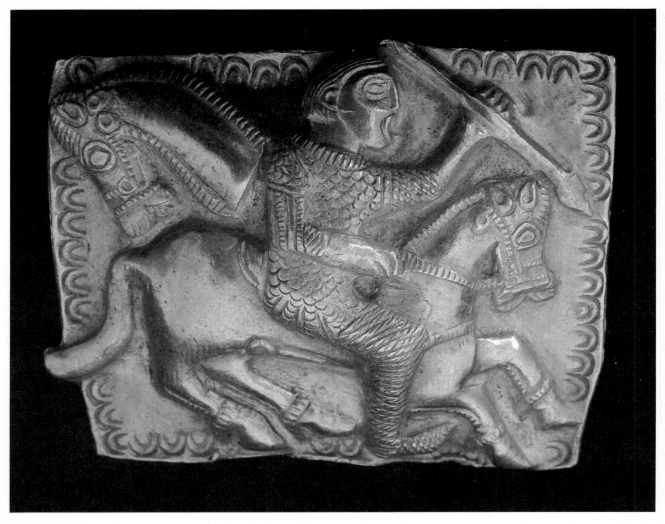

The martial aspect of the hero. The horse's head represents the gifts the people have given the hero for his protection, and this, too, is probably the significance of the woman's head on the appliqué opposite.

perished, mourned him long. Perhaps this poetic story by Parthenius follows the old Eastern pattern, according to which the goddess of life falls in love with a hero in order to lose him, so that the eternal swing between life and death could be maintained. The hero was no doubt the central figure in Thracian religion, the hope and faith of the people. Their hero was all-seeing and all-hearing, he was the sun and also the ruler of the nether world, he was the protector of life and health, and kept the forces of evil at bay. It is not surprising, therefore, that he was portrayed on thousands of votive reliefs, was worshipped at hundreds of sanctuaries and the Thracians carried his image to wherever fate took them. He was known under different names: Dionysus, Apollo, Asclepius, Ares, Silvanus and many more. But what did a mere name matter? he was the hero and always remained so. This heroic aspect of the Thracian religion is what lends it a strong touch of originality. The Great Mother of Gods and the hero, her son and lover, were the chief figures in Thracian religious thinking.

Ancient Thrace thus seemed far removed from Greece, although Olympus was close to Pangaeus. The Thracians were unable to give their god a distinctive name or image, as the Greeks had done for their Olympians. But if we compare Thrace of the Classical period with Mycenaean Greece, we shall find many affinities. During Pericles' time, the Thracians were still hearing the clash of swords as the ancient heroes fought. Archaism was an inherent feature of Thracian religious thinking. This also meant that it has preserved the intensity of passion which characterized the Mycenaean age. Illustrative of this were the nocturnal orgies, held by the flickering light of torches and accompanied by the beating of drums, the thud of horses hoofs, the piping of flutes when every one was heady from wine and the fumes of aromatic seeds dropped into the fire. The Thracians had no penchant for contemplation, for which the Greeks had such a strong predilection. To the Thracians the religious idea and the legend did not reflect the past, they were the actual present. Myths were not history.

[34]

The heroes still performed their feats of valour, perhaps on a different plane, but not at a different time. In general, the concept of linear time did not exist for the Thracians. They continued to think in terms of the mythical or heroic past. Orpheus, Rhesus, Zalmoxis or other anonymous heroes were not only distant ancestors, but contemporaries as well, not a model of action, but action itself. This archaic concept was kept alive by a specific and exceptionally important characteristic of Thracian religious thinking, a belief in immortality.

This belief was so striking and so strong that no ancient writer who devoted space to Thracian customs ever failed to mention it. To the Thracians the souls of the dead were not pale shadows in Hades. Rhesus's mother, for instance, was confident that her son would not 'into earth's dark lap go down', and that Persephone would give her back his soul. All Thracians respected death by one's own hand; some were convinced that the souls of the dead returned to this world, while others believed that the souls did not perish after death, but enjoyed greater happiness than they ever did on earth. That is why the soul was more important to the Thracians than the body. This is corroborated by Plato's account of the advice given by a Thracian healer, who said that all things good or bad for the body came from the soul, and that it was important, therefore, to heal the soul first; then it and all other parts of the body would be sound. The healing of the soul was effected with the help of chanting, and this chanting was good talk. Good talk brought wisdom to the soul, and once the soul had wisdom, it was easy to be healthy.

The Greek writers, beginning with Herodotus, were convinced that it was Zalmoxis who had taught the Thracians to believe in the immortality of the soul. Herodotus described the clever way in which Zalmoxis imparted his doctrine to the 'foolish Thracians'. He taught them that 'neither he, nor

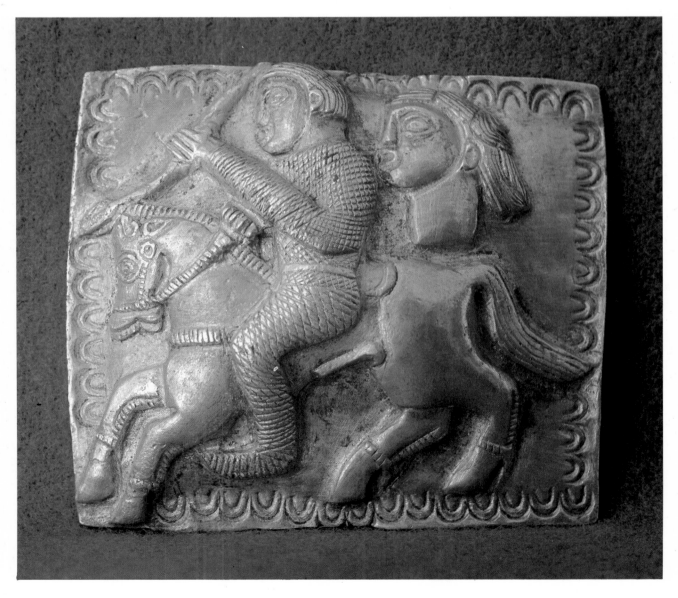

they, his boon companions, nor any of their posterity would ever perish, but they would all go to a place where they would live for ever in the enjoyment of every conceivable good. While he was preaching in this way Zalmoxis was busy constructing an apartment underground into which, when it was completed, he withdrew, vanishing suddenly from the eyes of the Thracians who greatly regretted his loss and mourned over him as one dead. He meanwhile abode in his secret chamber three full years, after which he came forth from his concealment and showed himself once more to his countrymen, who were thus brought to believe in the truth of what he had taught them.' In all probability, Herodotus described a religious rite, connected with the Thracian belief in immortality. His story is full of symbols, most impressive of which is that of the 'apartment underground'. It does bring to mind the thousands of mounds dotting the Bulgarian countryside. According to Strabo, Zalmoxis retired to a cave and stopped seeing outside people, that is to say, he disappeared from the eyes of the Thracians. But the cave, just as in the legend about Rhesus, is a chthonian symbol. The Odrysae buried their dead in caves hewn in the rocks. This is reminiscent of the abode of the Iranian hero Yima, far away from the glow of the stars. And as Yima conducted the souls to a happy haven, so Zalmoxis promised the Thracians a paradise, and they believed that they would not die, but would join him there.

In the awareness of the Thracians there did not seem to be an abrupt dividing line between the two worlds. The Scaeae and the Cebrenii believed the threat of their king-priest Cosingas that he would climb a ladder to heaven and would complain to Hera about them. The Getae, on their part, drew lots every five years choosing one among themselves to be sent to Zalmoxis with a message about what everyone of them needed. The one who drew the lot was dispatched in the following manner; several men, selected for the purpose, held up three spears, others took the man who was to be sent to Zalmoxis, and swinging him by the hands and feet, tossed him onto the points of the spears. In this passage of Herodotus, the dividing line between the two worlds was death. But the crossing of this line meant immortality. That is why the ancient historian used the world *athanatizo*, meaning to make immortal. This ritual expressed the hope of every Thracian to join Zalmoxis: The belief that after death man became an anthropodemon and a new hero was preserved up to Roman days, and is attested to by many reliefs which have come down to us.

When the ancient authors speak of the Thracian belief in immortality, they seem to have in mind all the tribes and all the Thracians. Was that so in actual fact? To answer this question, it is necessary to examine the ideology of Thracian society, i.e. the political meaning underlying religious ideas and social relations.

2

IDEOLOGY OF KINGSHIP

IN ANTIQUITY, religion and politics went hand in hand, as only religion could provide a justification for political power and the established order. The kingdom of the gods was modelled on the kingdom on earth, the order prevailing in the former being recommended as the ideal pattern for society on earth. Unfortunately, most of the relics and monuments which could throw light on Thracian religion are from the Roman period. After their conquest of Thrace, the Romans destroyed the country's traditional political and administrative system, thus depriving religion of its social base; so that, if we had to rely solely on information from Roman times, we would be in no position to understand the rôle assigned to the Thracians' deities by their political doctrine. That is why, in reconstructing the institution of royal power in Thrace, our chief source will be the written records and archaeological finds dating from before the Roman conquest.

The ancients' idea was that the first man and, as such, the progenitor of the human race, was the hero. In Iran and Scythia the first man was also the first king, thus Yima, Hoshang, Scythes, Targitaus or others were accorded the attributes of royalty. Some of them, being the first kings, gave their names to their tribes. In Thrace, too, tribes were named after their heroes and clan founders: Treres, Doloncos, Strymon, Odrys and so on, so one is entitled to suppose that in Thrace the concept of the first man evolved into the concept of the first king.

But to become king, the hero had to give proof of his prowess. Some Iranian and Scythian legends tell of objects that fell flaming from the sky and of how only the one for whom they were destined could possess himself of them and so prove himself the god's elect. In order to deserve the throne, the Scythian hero had to succeed in a contest, thus, before he left Scythia, Heracles gave the snake-limbed goddess a belt, a cup and a bow with instructions that whoever of his three sons could gird his waist with the belt and draw the bow, should be made king. There is a similar idea in a Thracian legend of how Sithon, son of Poseidon and Assa, king of the Thracian Chersonese, had a daughter, Pallene, by the Nymph Mendeis, and, as there were many young men courting her, it was decided that the girl and the kingdom should go to the one who could defeat Sithon in a contest. Meropses, king of Anthemusia, and Periphaetes, king of Mygdonia, both fell fighting for Pallene's hand. After this Sithon decided that the suitors should contend not against him but against each other, again for the same prize. Dryas and Cleitus fought. Dryas lost because of a ruse employed by Pallene. So, after Sithon's death, Pallene and Cleitus inherited the kingdom. This myth makes Sithon the first king, because he gave his name to his country. Sithonia. On his death, his kingdom went to the most deserving, the one who had passed the test of valour. In general, contests were a very popular form of testing the abilities of kings in the Greek epos; e.g. the story of Odysseus and the suitors and that of Oedipus and the sphinx.

In the East, the test of valour often took the form of a ritual fight between the hero and a monster. Iranian monuments invariably portray the hunter with the insignia of power. The most interesting of these are the reliefs decorating the famous gold cup from Hasanlu (ninth century BC) which are held to tell the story of the hero fighting the three-headed dragon. His vistory ensured nature's fertility and the continuation of the human race, while the hero was elevated to the rank of ruler, as is indicated by the bow, always an attribute of kingly rank in Achaemenian toreutics, glyptics and coin issues. The same attribute may be seen on oné of the Letnitsa appliqués – the hero is depicted on horseback, while behind him a bow is clearly visible. The figure is the same as that in the hierogamy scene in another appliqué of the same treasure, recognizable by the way his hair is combed. Hunting scenes are often depicted on Thracian monuments, too. In another appliqué from Letnitsa, the horseman is piercing a bear with his spear, while a slain wolf lies at the horse's feet. The iconography and composition of this scene are reminiscent of similar representations on Iranian seals. It is possible that the idea of this scene was purely religious, the hero being represented as a protector from evil forces. As in all other scenes, here too he is dressed accord-

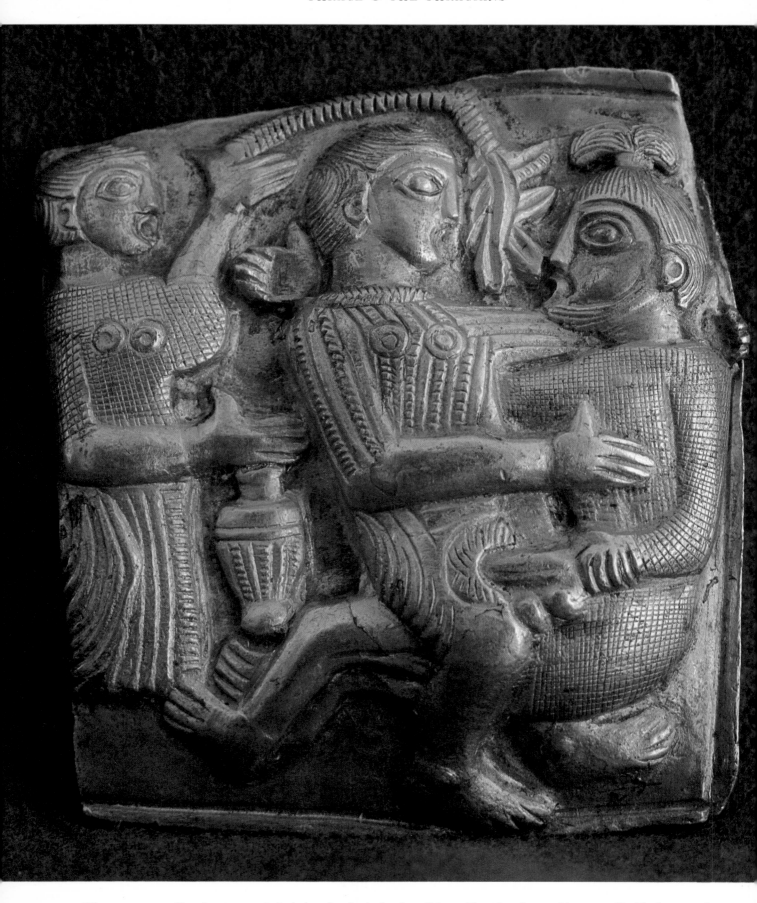

Hierogamy scene (Letnitsa treasure) depicting the physical union of the goddess-daughter and hero-son. Beside them stands the Mother of Gods (see page 40).

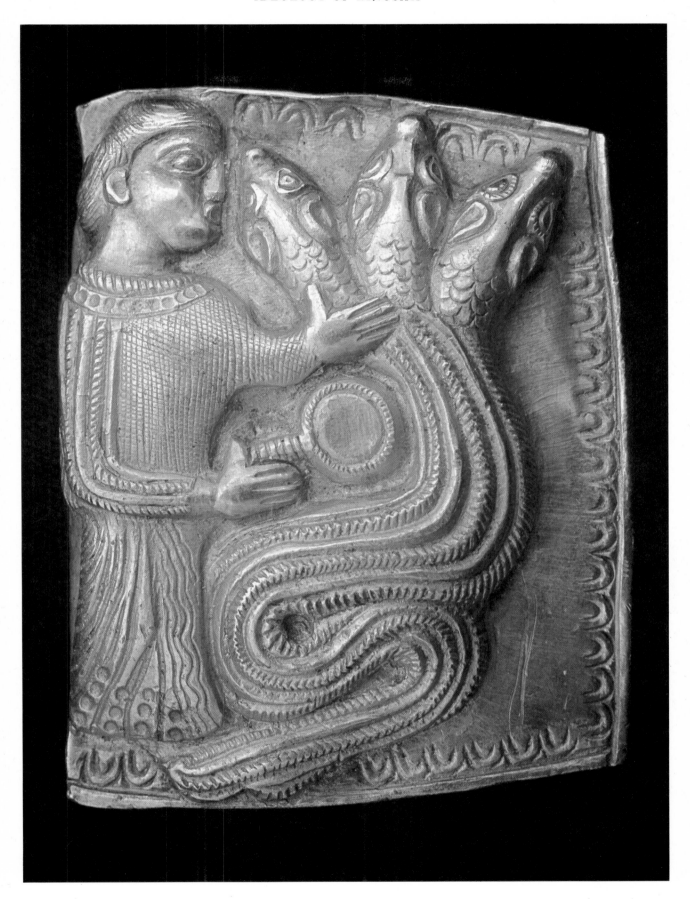

Woman captured by the dragon (three-headed monster). Part of the Letnitsa treasure (see page 19)

ing to the fashion favoured by the aristocracy of the day. His greave, featuring a female head, very much like those excavated in Vratsa and Agighiol, is itself a sign of royal rank. The political idea underlying the test of valour is also apparent.

Sometimes the fight ended in victory for the beast and the pretender to the throne lost his life. Conon tells us an interesting legend, which also contains genealogical elements: Strymon, the Thracian king after whom the river once known as Eioneus was named, had three sons: Brangas, Rhesus and Olynthus. Rhesus, who went to help Priam in the war at Troy, perished by the hand of Diomedes. Olynthus was killed while hunting, when he deliberately engaged in a fight with a lion. His brother Brangas shed many a tear over this dreadful accident and buried Olynthus at the spot where he had met his death. He then went to Sithonia, where he founded a rich and famous city, naming it Olynthus after his younger brother. Several points are of interest in this myth. First, Strymon founded a new dynasty supplanting that of Eioneius, who had been banished from the region. After him reigned Rhesus, whom we know to have been an excellent hunter, that is to say, he had passed the test of valour. When Rhesus died, Olynthus was the next in succession; however, he failed the test, perishing in a fight with a lion, and, as Brangas had gone into exile, this meant the end of the dynasty. Undoubtedly, this legend is analogous to the Scythian myth about Heracles' sons and belongs to the genealogical cycle of Thracian kingship.

The scene depicted on the belt from Lovets is also connected with the ideology of kingship. We know that the boar hunt near the tree of life symbolized belief in the victory of the divine forces over those of evil and death. But there is a political meaning here, too. All myths on this theme make the hunter a prince, i.e. the heir to a throne; thus the loss of the fight meant the end of the dynasty. The Calydonian dynastic line was cut short with the death of Meleager; after the failure of Attis, Croesus's son, the Lydian kingdom fell to the Persians; the boar (symbol of Cronus) tore the young Zeus to pieces, so that he should not found a new dynasty. In Iran and India the mythical king-heroes also fought a boar. The genealogical implications are beyond doubt.

The investiture, or presentation of the insignia of royal power to the hero by the deity, is a recurrent theme in Eastern art. Sometimes the insignia were of a supernatural order, for instance the flaming objects which fell from the sky. In other cases, they were objects, the possession of which had symbolic meaning. In the East, and also in Scythia and Thrace, such were the bow and the cup. Some of the earliest Thracian monuments with human representations show the act of investiture. The plate of the Brezovo gold ring represents a horseman riding towards a goddess who is about to give him a

rhyton. The scene depicted on the Rosovets (Rahmanli) ring is similar – the goddess, moving to the left, is followed by a horseman holding a rhyton she has just given him. On the helmet from Baiceni-Cucuteni is a seated hero. There is a snake coiled under his stool, a bow hangs behind his back, and in his raised hands he holds a cup and a rhyton. On one of the Agighiol greaves an identical warrior is offering a rhyton and an eagle to a horseman, who already holds the bow that has been given him. The horned eagle clutching a hare in its claws and a fish in its beak, a motive which frequently occurs on cups and helmets, is a zoomorphic parallel of the investiture scene. Here the eagle seems to be offering the hare and fish to a smaller eagle facing it. The Iranian political formula according to which a vanquished king had to appear before his victor bearing earth and water, provides an explanation of the symbolism: the fish and the hare are symbols of kingship. Another motif – that of an eagle holding a snake in its beak – which frequently occurs on Thracian relics, should be interpreted in the same way. The political meaning of all these representations is perfectly clear – the hero becomes king by the will of the god.

In the relics we have examined, the deity is often a woman and can be none other than the Great Goddess, whose cult was so widespread in Thrace. She was both the mother and lover of the hero, by virtue of which he became the founder of the tribe. But the incest between the hero and the goddess had a strong political motivation, of which the Greeks and the Romans were fully aware. The story of Oedipus conveys the idea that, in order to become a king, the son had to marry his mother. Naturally, the Theban hero acted unwittingly; it was fate that guided him. During the Persian campaign against Greece, the son of Pisistratus, who marched with the Achaemenid army, dreamt that he had shared his mother's bed. He interpreted his dream as a good omen foretelling his victorious return to Athens. Before one of his battles, Julius Caesar had a similar dream and his augurs interpreted it as an omen of victory, because of the belief that the mother personified one's native land. The Greek dream-books construed dreams of incest with one's mother as auspicious for those engaged in politics. The union of the hero with the Mother Goddess not only ensured abundance for the country, but was an indispensable act in obtaining royal power. This is how the hierogamy scene in the Letnitsa appliqué should be interpreted. In a legend about Musaeus there is an interesting episode which contains a slight hint at hierogamy. The singer was so proud of his musical accomplishments that he dared the Muses to a competition. The condition was that, if he lost, he should have his eyes put out, but if he won, he could marry each one of them; that is to say, he would qualify as king in the land of music. The dynastic marriage between the mythical

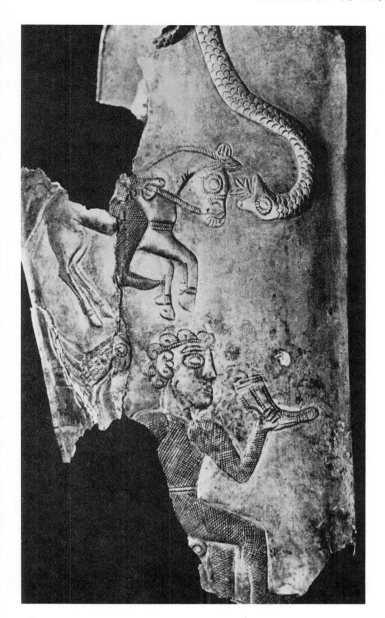

*Detail from Agighiol greave. The scene is an
investiture at which the hero is being given a
drinking horn, which is a symbol of royal
power, as is the eagle behind his head. Above is
the serpent symbolizing his divinity (see the
illustration on page 19).*

BELOW
*Detail from the Lovets belt showing two boars
around the tree of life (see page 21). The boars
are symbols of the destructive element.*

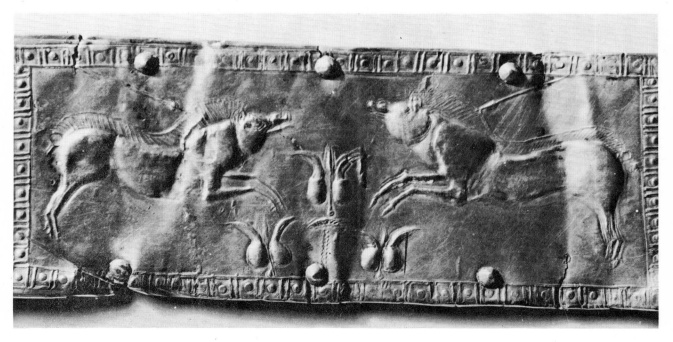

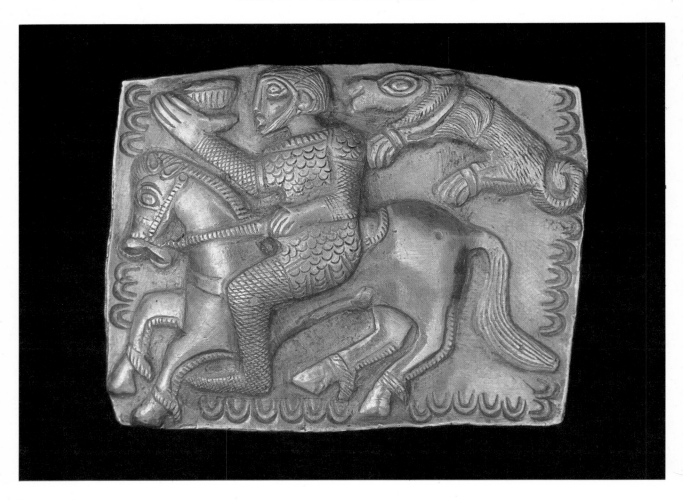

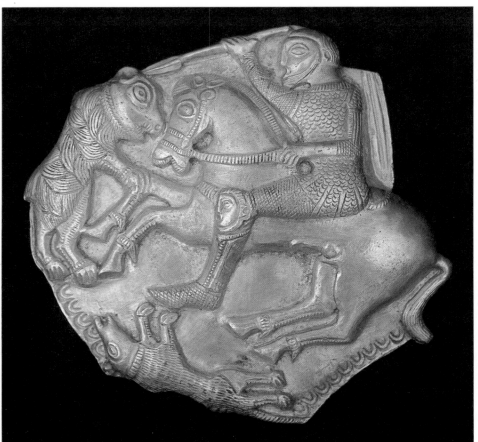

ABOVE
The hero is here shown holding a phiale, an attribute of royal power. He is accompanied by his dog.

LEFT
The hero is here fighting a wild animal in the test of valour, which all who would become king had to pass.

RIGHT, TOP
Painted cupola of the central chamber of the Kazanluk tomb depicting a sacred marriage (see page 47).

RIGHT, BOTTOM
Detail from the above. The tall figure on the left is that of the Mother of Gods handing food to the king-become-hero and his bride.

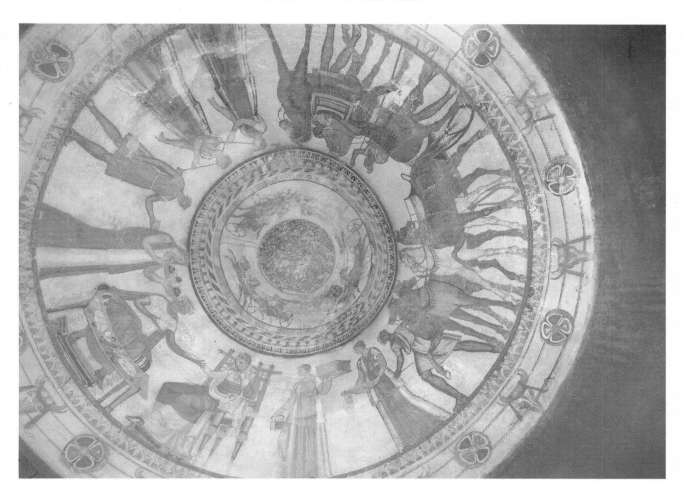

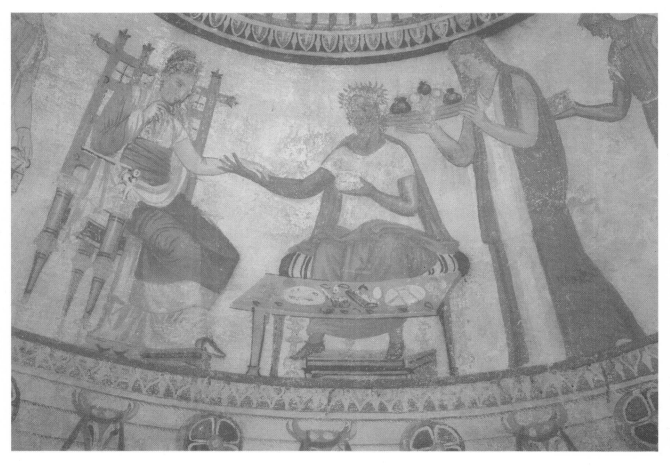

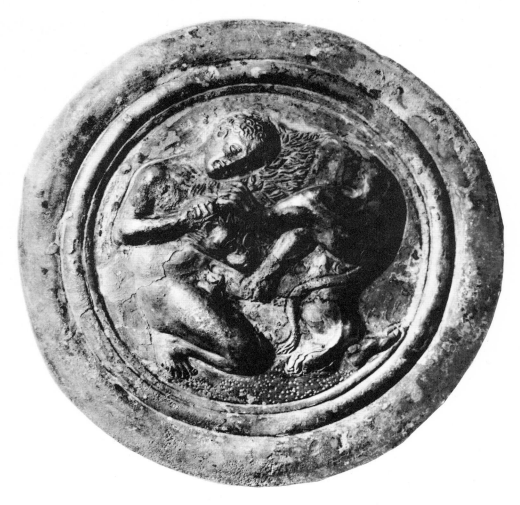

A silver phalera from the Panagyurishté treasure representing Hercules strangling the lion.

Thracian hero Tereus and the daughter of the Athenian king Pandion and the subsequent rape of her sister reveal the political claims of the Thracian. In the legend of Sithon and Pallene the winner of the contest was to receive as his prize both the kingdom and the princess (the two always went together), but the important thing was that Pallene herself helped her chosen suitor, for which she would have suffered death at her father's hands, if Aphrodite had not appeared during the night and saved her. The intercession of Aphrodite – the essence of the Mother Goddess – was no accident. What is more, the country, Sithonia, was renamed Pallene after Sithon's death, making the princess a personification of her country, and thus a local form of the Great Mother of Gods. Her rights were further enhanced because her mother was the Nymph Mendeis. As we know, the Nymphs in Thrace were closely connected with the cult of the Great Goddess. Also the name Mendeis is reminiscent of Bendis (Bendida). Bearing in mind that in the Thracian language the consonants 'b' and 'm' were interchangeable, one may assume that the one meant here was the Mother Goddess of South-

western Thrace. There is nothing surprising in this, because, according to Strabo, the Sithonians were a tribe of the Edoni and originally lived along the Strymon (the Strouma). In either case, Pallene may be regarded as a daughter of the ancient pair of Great Goddesses, and Cleitus could become king of her land only by marrying her. This again shows the dynastic implication of the hierogamy. The political need for incest between the hero and his mother was still there in Thrace at a time when Greece had quite forgotten it. The act was an indispensable episode in the mythical life of the hero. The test of valour and the incest were the steps that led him to the throne.

Ancient literary sources contradict each other about the Thracian heroes, for some call them kings, others high priests and prophets, and this has given rise to controversy. It is only recently that the majority of Bulgarian specialists in Thracian studies have accepted the theory that these legends convey the idea of a *sui generis* institution, which placed royal and priestly power in the hands of a single individual. Homer called Maron a priest of Apollo. We see that he also revered the cult of

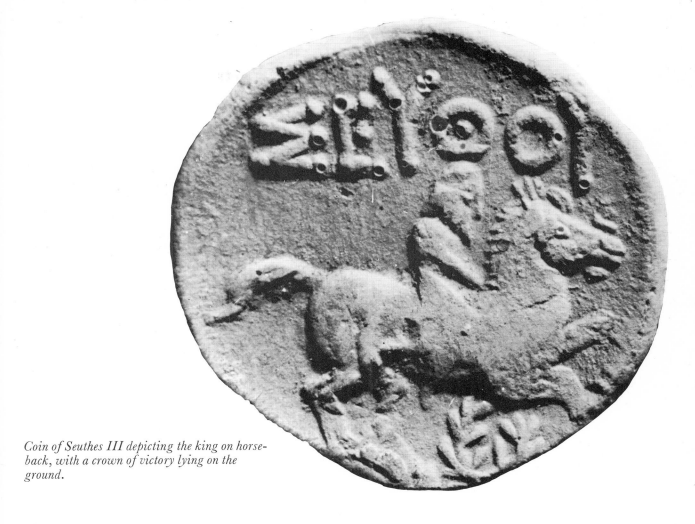

Coin of Seuthes III depicting the king on horse-back, with a crown of victory lying on the ground.

Coin of Patrajos showing the king dealing with an enemy prostrate, but still holding his shield.

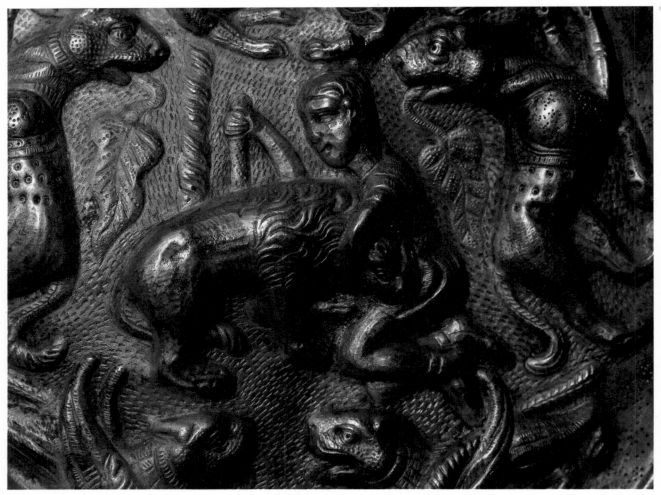

A phalera from Stara Zagora depicting Hercules fighting the lion.

Phiale with an inscription including the names of King Kotys I and Egbeo, the master-craftsman who made it (Vratsa treasure).

[47]

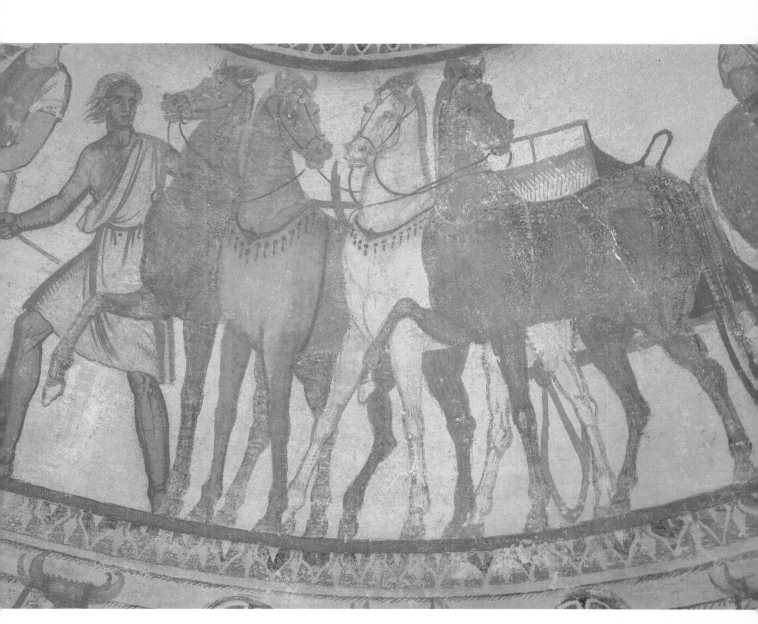

The bridal carriage from the wedding scene depicted on the painted cupola of the Kazanluk tomb.

[47]

Dionysus. But in the *Odyssey* we are confronted with a strange appellation for Maron's attendants. They are called *amphipoloi*, a term applied only to attendants in royal palaces. What is more, this priest gave his name to the city of Maroneia, but, as we know in Thrace it was the king-heroes who gave their names to cities. Finally, Homer explicitly states that Maron himself poured the sweet wine. Only his favourite wife and a female servant had a key to his cellar. This was not a sign of selfishness on the part of an inveterate drunkard. The symbolism of this strange caution is that, according to the notions of the ancients, the king alone had the right and obligation to offer wine and distribute food. Another mark of royal rank were the rich presents with which he returned the favours of his subjects or guests. Thus Maron gave Odysseus many amphorae of his divine drink, and much gold and silver. This high priest lived at the sanctuary, which was also a palace. So Maron was a typical representative of the king-high priest institution.

Rhesus should also be included in that category. He was king of the Thracians inhabiting the Western Rhodopes, and was most aptly described by Philostratus, who wrote: 'he bred horses, had weapons and busied himself with hunting'. The Iranian Yima was also represented as very rich: 'he had many fields and great herds of bulls'. Wealth, no matter in what form, was a necessary attribute of kings in the Heroic Age; it was the symbol of economic power. The hunt – a necessary test of valour for kings – became a royal privilege, while weapons were an important social distinction in those turbulent times.

The love between Rhesus and Arganthone was probably another example of incest between the hero and the local hypostasis of the Mother Goddess. But Rhesus was a high priest and, after his death, he became an oracle of Dionysus. There can hardly be any doubt that the institution of king-high priest was the most characteristic form of power in Thrace. When Dionysus placed Charops at the head of a new Thracian dynasty, he also initiated him into the secret rites of his mysteries, thus making him his high priest. From then on, both secular and religious power were handed down from father to son. It is clear that the supremacy of the ruler rested on this dual principle.

Orpheus was a member of the 'Dionysian dynasty' in Thrace. So much emphasis has been placed on his priestly functions that one often tends to forget his royal rank. He was an oracle, he was versed in the secret rites of the mysteries, he knew the path that led to immortality and he could guide men's souls. Zalmoxis, the hero of the Getae, is also described as a high priest. Plato himself quotes the Thracian healers as calling him 'our king, who is also a god', while Jordanes said that Zalmoxis who, according to most chroniclers had an insight into a most wonderful philosophy, was

known to have reigned supreme in Dacia, Thrace and Moesia. Both accounts present the hero as a king-high priest. Herodotus does not directly call him king, while Strabo dissociates him from this function: 'When he returned home, he commanded the respect of the notables and the people, because he could interpret the omens. He persuaded the king to take him on as a partner in government, because he was able to make known the will of the gods. First, he was appointed high priest of the god who was the most revered of them all, and later he was also called god. The king befriended him because he realized that, since he had begun issuing orders in accordance with the gods' counsel, the people obeyed him better than before.' The ancient geographer categorically dissociates the high priest Zalmoxis from the king. Perhaps this legend records the emergence of the new institution, the principles of which were initially the responsibility of two persons who were equal partners in government. One wonders thïs, because, when Zalmoxis was proclaimed god, he moved into a cave, inaccessible to others, and there he lived having no contact with anyone but the king and his attendants. This seclusion symbolized his death and his transformation into an anthropodemon. After Zalmoxis's death, the king took over his functions of high priest and he, and none other, went to receive the prophetic counsel of the hero. Zalmoxis provided the necessary ideological motivation of royal power. It is interesting that Conon assigns the same role to Orpheus: 'Midas reigned over the Briges with great skill because he heeded the advice of Orpheus on Mount Pieria.' Apparently Zalmoxis and Orpheus were regarded as anthropodemons who uttered prophecies to the kings-high priests, an institution that in all probability was founded by these great cultural reformers.

What was the nature of royal power in Thrace in the periods for which we have information from eyewitnesses? First, are we sure that the Thracians had preserved the archaic institution of king-high priest?

The famous Burebista reigned over the Getae when the latter were fighting the Romans. It was then that Dicineus came to the Getae. Burebista received him and invested him with almost full royal powers. Is this a parallel to the legend of Zalmoxis? Strabo records that Dicinius had visited Egypt and there learned all sorts of magic. Jordanes goes on to say that when Dicineus died, all the esteem that the Getae had for him was transferred to Comosicus, as he was his equal in title. He was respected by them for his experience as king and high priest. And when Comosicus departed from this world, Coryllus ascended the throne of the Getae. This makes it all clear: Dicineus might have been one of the two kings of the Getae, but both Comosicus and Coryllus are described as kings-high priests in whom the whole power was vested.

And, according to Strabo, Dicineus began to regard himself as a god, just like Zalmoxis. Therefore, the mythological and historical aspects of royalty had merged among the Getae too. Zalmoxis, the king-high priest and the god-king had became the model of royal power.

This goes for others as well as the Getae: Polyaenus tells us of the existence of a similar concept among the Scaeae and the Cebrenii, whose chieftains were high priests of Hera. Cosingas was another of these chieftain-high priests, as was Kotys I, king of the Odrysae and undoubtedly one of the most fascinating figures in Thracian history. Another king-high priest, Theopompus, would build a banqueting hall wherever he found a shady place with abundant water, while making the rounds of his country. He revisited these places as often as he could, and there offered sacrifices to the gods and enjoyed himself in the company of his retinue. The feast of Seuthes, as described by Xenophon who attended it, has all the appearances of a sacrificial rite conducted in a hall specially built for the purpose. Thracian ritual sometimes appeared rather cruel to the ancient writers. Diodorus describes an actual event at the court of Diegylis, king of the Caeni and a contemporary of Attalus II: the king on his way to celebrate a wedding after the ancient Thracian custom captured two young Greeks from Attalus's kingdom. They were brothers and both of great beauty. Diegylis garlanded the two like sacrificial animals and led them into the palace. He laid the younger brother flat on the ground, and assisted by his servants, prepared to slay him, calling out that kings must not use the same sacrificial animals as ordinary men. And as the older brother wept, showing his fraternal affection, and offered himself to the sword, Diegylis commanded his servants to prostrate him as well. With a doubly cruel, single blow he slew the two brothers, while the onlookers praised his skill and sang a paean. Here the king not only performed the sacrifice, but stressed that his offering had to be different from that of ordinary people. Another point that must be stressed is that the rite actually took place in the royal palace.

It is, however, the excavations at Seuthopolis, the capital of the Odrysian king Seuthes III, that provide the most convincing proof of the existence of the king-high priest institution in Thrace in the period of recorded history. Destroyed at the end of the fourth century BC, Seuthopolis was discovered by archaeologists in 1947. An important part of the king's palace was the sanctuary of the Great Gods, the Cabiri, and here was unearthed one of the largest cult fireplaces in the city. There is no doubt that the old tradition of a dual function of palace and sanctuary, was maintained here. The sacrificial halls of Maron, Orpheus and Zalmoxis are known from the legends, and those of Seuthes, Kotys and Diegylis are described in literary sources, but the palace of Seuthes III is undisputed archaeological evidence. This evidence admittedly refers to different regions in Thrace, but it is clear that everywhere political and religious power had merged and was embodied in the person of the king-high priest.

In this respect, the kings of the period of recorded history followed in the footsteps of the ancient king-heroes. This, however, is not the only parallel between them. After speaking about the religious triad of the Thracians, Herodotus adds: 'Differently from the people, the kings honour Hermes more than any other god, swear by his name and claim that they are descended from him.' This one sentence has even persuaded some scholars that the Thracian dynasties were of foreign origin. However, all that this amounts to is that the aristocracy worshipped a royal god of their own, so that they could be set apart from the common people by their cult. This seems a reasonable assumption, especially as Herodotus records the same thing about the Scythian kings, saying that they too had a god of their own – Thagimasadas. But one cannot be sure that it was Hermes the Thracian rulers worshipped. It is quite possible that Herodotus used the name Hermes for a local deity, who had a similar function of link between heaven and earth. On the other hand, he could have used the name of the god of vows, just because the Thracian kings swore by their deity. The important thing is that such a god existed in the Thracian awareness. Another important thing is that by claiming to be descended from him, the kings upheld the idea of their divine right and divine origin. And yet, with all that we know of Thracian ideology, it seems highly unlikely that there should be room for another god in the Thracian pantheon, with its two main figures, the Great Mother of Gods and the hero. There could be no political justification for separating the royal god from the religion of the people, as that would mean the isolation of the aristocracy; and for that reason we think that Herodotus's 'Hermes' was the hero. The hero was the first man or the founder of the tribe, but he was also the first king and founder of the dynasty, and so it was natural that the kings should be more closely related to him than their subjects. Therefore, this Hermes might have been no more than a royal aspect of the Thracian hero.

Xenophon has provided us with unequivocal evidence of this aspect of Thracian ideology. He writes that Teres, the great grandfather of Seuthes, was the founder of the Thracian dynasty. When the Greeks were about to enter the tower of Seuthes to partake in a feast, Xenophon ordered them to leave their weapons at the gate. On hearing this, Seuthes said that he harboured no mistrust of any of the Athenians, because he knew that they were his kinsmen. Why should the Thracian king consider the Athenians his kin? The only plausible explana-

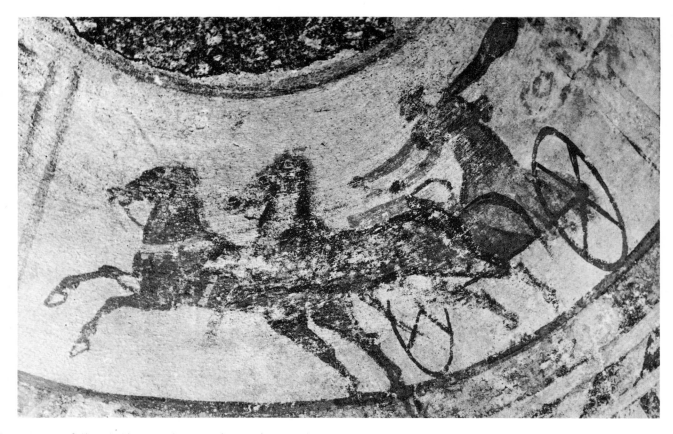

Horses at full gallop in a chariot race. A scene from the frieze on the Kazanluk tomb.

Detail from a frieze at Paestum showing a chariot very similar to that being used in the chariot race depicted in the Kazan-luk frieze (above).

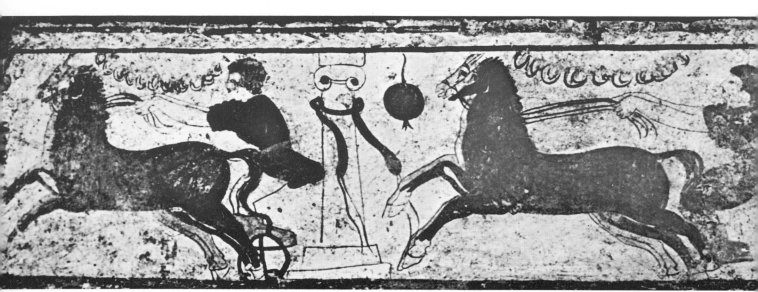

tion is to be found in Thracian mythology, which has it that the mythical Thracian king Tereus of Daulis married Procne, daughter of the Athenian king Pandion. If it was this marriage that Seuthes had in mind when he said that the Athenians were his kin, it means that to him the mythical Tereus and the historical Teres had become one and the same. Most probably this merger had been made in the genealogy of the Odrysian royal house, and one wonders if Thucydides was right in reproaching Sophocles for making Sitalkes the son of Tereus and not of Teres. Had Thucydides failed to grasp the significance of this idea of creating a mythical past for a new dynasty in order to assert its divine origin? The very etymology of the name of the first Odrysian ruler undoubtedly linked him with the mythical king of Daulis, whose name occurs in subsequent generations of Thracian kings, which is itself further evidence that the idea of the divine origin of the dynasty was intentionally upheld. So

the Odrysian 'Hermes' turns out to be the well-known hero Tereus.

If the Thracian kings traced their origin to the king-hero, they must also have been sons of the Great Mother of Gods. Indeed, several of the royal Thracian names are derivatives of her epithets: Amatokos, Medokos, Medosades, Maesades, etc. It has been proved that the prefixes Ama-, Ma-, Me- were connected with the Goddess's function of mother. The analogy between the names of Thracian chieftains such as Kotys, Kotylas or Kotyson and the goddess Kotytto has already been established. One wonders if in some way the name Teres did not originate in the epithet of the goddess Tereia, who was worshipped in a mountain near Lampsacus and whose name is also connected with that of the Nymph Tereia, whom some ancient authors believe to have been the daughter of Strymon. It would be quite natural for Teres to have the name of an embodiment of the Great Goddess.

A votive relief showing the hero, mounted, the tree of life, a woman beside the altar, and a hound attacking an animal.

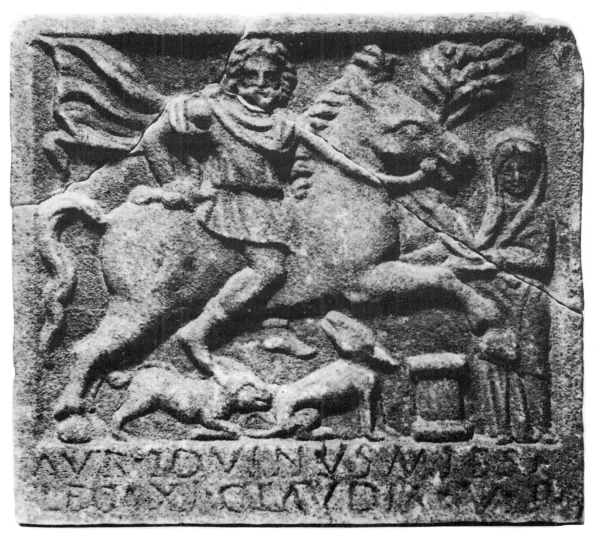

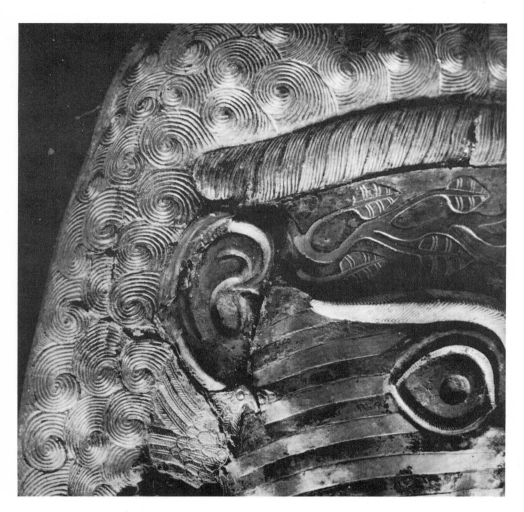

Detail from the Vratsa greave on which is ivy symbolizing religious power.

Of special significance here is the story Athenaeus tells of the blasphemous behaviour of Kotys I, one of the most fascinating figures in Thracian history. He apparently believed that Athena has consented to marry him and so arranged a marriage feast and prepared a bridal chamber, where he waited for his bride in a state of inebriation. This is invaluable information on the ideology of kingship in Thrace. We have here a ritual symbolizing marriage between king and goddess. In the case of Kotys, who was the terrestrial proxy of the hero, this made him both the son and lover of the goddess. To understand why Athena personifies the Great Mother of Gods, we must go back to the myth of Tereus, whose marriage to Procne and Philomela was an expression of his desire to possess Athena. Kotys substituted the Mother Goddess of the city for the Athenian princesses and assumed the rôle of Tereus. It should be borne in mind that it was Kotys who initiated the policy of ousting the Athenians from Aegean Thrace, and this act of his was an expression of his political intentions. Further proof of this can be seen in the fact that when Kotys was told that the Athenians had granted him honorary citizenship, he said that he too would give them the rights of his tribe, thus putting Thrace on a par with Athens.

Was this 'marriage' of Kotys an isolated phenomenon or was it accepted ideological practice? Bearing in mind the literary sources and the hierogamy scene on the Letnitsa appliqué, we are inclined to accept the story as showing that this was a characteristic of the ideology of kingship in Thrace.

There is a new interpretation of the murals in the main chamber of the Kazanluk tomb which should be mentioned. In the central scene, the deified chieftain is seated at a table laden with food. He is holding a phiale in one hand and has tenderly placed his other hand under that of his wife who is seated on a throne. A woman wearing a long *peplos* approaches the couple from the left carrying a tray of fruit. Her proportions are considerably larger than those of the rest of the attendants, so perhaps what we have here are the participants in the hierogamy scene on the Letnitsa appliqué. Naturally, the meaning of this scene is more veiled, but the gesture of the chieftain is reminiscent of that of Zeus drawing Hera to him that figures in a metope from Selinus. Here, instead of a twig or an amphora, the woman in the *peplos* is holding fruit and a jug. Thus, we have the chieftain, already deified and transformed into an anthropodemon, placing emphasis on his royal status through his union with the

Curls and coiffure similar to that in the silver
Attic head-vase illustrated on the opposite page.

deified woman in the presence of the Mother God-
dess.

Kotys' symbolic hierogamy was actually linked
with his military and political plans. When expand-
ing the territory of his state, Philip of Macedon
used to enter into conjugal union with a daughter of
the king whose lands he had conquered or was
about to invade. Athenaeus stated that Philip would
always contract a marriage in wartime. During his
reign of twenty-two years he first married the
Illyrian Audata and by her had a daughter,
Cynana. Then he married Phila, the sister of
Derdas. Then, in order to woo the Thessalians, he
had children by two Thessalian women. By marry-
ing Olympias he received the kingdom of the
Molassians as a dowry; and when he conquered
Thrace, the Thracian king Kotylas came to him,
bringing him gifts, among them his daughter Meda,

whom Philip married and had her for his wife as
well as Olympias. Finally, he fell in love with and
married Cleopatra, the sister of Hippostratus and
niece of Attalus. At the root of all these dynastic
marriages was the belief that incest with the Mother
Goddess, in this case a girl from the royal family,
sanctioned the rule of the new king over her land.
The numerous weddings of Philip are analogous to
Cleitus's marriage to Pallene. The very fact that the
Macedonian king always contracted a marriage in
wartime, increases the probability that this was a
ritual usage and an important feature of the
ideology of kingship.

By acting as substitute for the hero in the hiero-
gamy, the king seems to have taken over his func-
tion of tribal progenitor. Thus, when the Getic king,
Dromichaetes, captured the Macedonian Lysi-
machus, he arranged a feast for him and set before

Detail from the Rosolets rhyton with its Dionysiac scene. The figure here is a dancing satyr.

him and his commanders sumptuous vessels on silver tables. Then, as reported by Diodorus, who was well informed on the history of Thrace and Macedon, he made a speech to the Macedonian, who had been proclaimed king of Thrace, addressing him as 'father'. It may be that this form of address was prescribed by court etiquette; but in any case, it becomes significant when read in conjunction with the participation of the king in the hierogamy.

The etymology of the royal names and the practice of symbolic incest with the Mother Goddess are sufficient proof that the Thracian ruler took over the functions of the hero in real life. Archaeological finds and written sources contain a great deal more information about the king actually modelling his actions on the mythical hero.

There is no doubt that the iconography of investiture occupies an important place in Thracian art. The chief attributes of the deity used by the king-hero were the rhyton and the phiale, which explains why these were so widely used in Thrace. The deified chieftain in the Kazanluk tomb is holding a phiale in his hand. Thus the theme of hierogamy is here linked with that of investiture. Several vessels have been found in Thrace which have on them Kotys' name in Greek in the genitive case and another name, Eg(t, x)beo, in the nomi-

native. Kotys was a frequent name for kings, but its combination with Egbeo means that it cannot have been that of the vase's owner. It is to be assumed, therefore, that the names on these cups and rhyta are those of the Odrysian king Kotys I and his court artist. The genitive form of the king's name shows that he had offered these vessels as gifts to local rulers. The Achaemenian monarchs also used to send precious vessels to their satraps and commanders as marks of special favour. It is possible that the Thracian kings had borrowed this custom from them. The amphora-rhyton and a silver jug from Koukova Mogila near Douvanli were, however, a Persian gift to a local chieftain. This custom seems to have been widely practised at the Odrysian court and cups with the names of Amatokos and Xebanokos have survived. The ideological implication of this gesture of generosity on the part of Kotys goes deeper than his desire to unite Thrace. The ambitious Odrysian king was actually performing an act of investiture by presenting the royal insignia to the Triballian and Getic ruler and, by putting his name on them, acting the hero's part.

An important change in the representations on Thracian coins is also connected with Kotys. Long before the Hellenistic period, he had his image stamped on the obverse of the coins. Of course, one cannot be certain that the head shown in profile on

them was an actual portrait, as was that of Seuthes III on his coins. There is little doubt that Kotys had sought inspiration in Achaemenian ideology – the likeness of the satrap Tissaphernes appeared on his coin issues. Other Persian coins show the figure of a galloping horseman. Although this symbol was already known in Thrace, the idea of showing it on coins must have come from the East. The Greek craftsmen of the Cypsela mint apparently had to comply with the requirements of the Thracian king. Other coins from Kotys' reign carry a boar's head, the prototype of which can be seen on Lydian issues. The important thing here is that this ancient dynastic symbol of the test of valour and the protection of life did appear on the coins of the Thracian kings.

The written sources also mention the hunting exploits of the Thracian and Macedonian kings. Plutarch tells how Kotys made a gift of a lion to someone who gave him a panther. Probably there was a reserve at one of the royal residences, which supplied animals for the royal hunt. In Macedon, too, the hunt had a ritual character. According to Diodorus, king Archelaus was accidently wounded

by his favourite, Craterus, during a hunt, and so died after a reign of seven years. Curtius reports that Alexander the Great declined the help of Lysimachus and himself despatched the lion that had attacked him. It was said that Lysimachus had once killed a huge lion in Syria; another version has it that he strangled the beast with which Alexander had locked him up in a cage to punish him. Even if these stories should be parts of the glorified lives of chieftains, they still are a necessary component of the ideology of kingship. In this respect, the Thracians and Macedonians came closer to the Eastern peoples. The hunt is a constantly recurring theme on Assyrian, Achaemenian, Hittite and Egyptian monuments. Croesus's son persuaded his father to allow him to hunt the Mysian boar by saying: 'It used to be a great and noble pleasure for me and you to go hunting and warring.' There is no doubt that war and hunting were not only a privilege of kings, but also a periodic test of their valour. That is why Teres, Sitalkes' father, used to say that when he was idle and not engaged in war, 'he felt no different from his grooms' (Plutarch).

Being the hero, the Thracian king was respon-

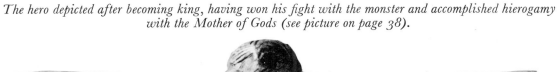

The hero depicted after becoming king, having won his fight with the monster and accomplished hierogamy with the Mother of Gods (see picture on page 38).

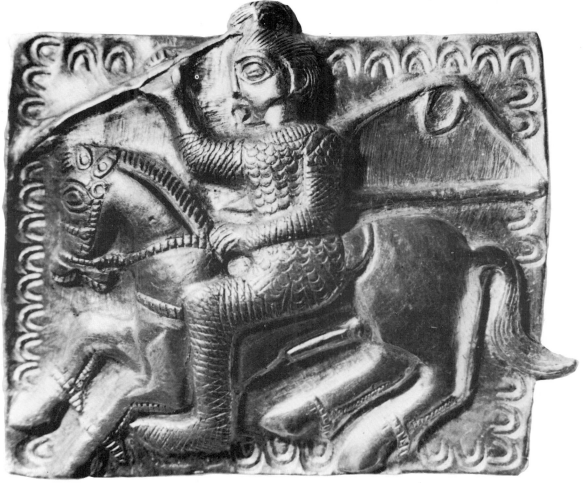

Detail from a silver vase (Roussé treasure) showing Eros dancing to Silenus, who is playing a double-flute, as he sits beside a fountain from which wine is flowing into a crater.

sible for order and abundance in the world. This idea was embodied in the ritual of hierogamy and hunting. On the other hand, the feasts which the Thracian rulers habitually held, and for which the Greeks often found fault with them, had a definite social significance. It was through them that the kings showed how powerful they were. This is also corroborated by Homer. He described Atreides as a high king who was expected to wine and dine the elders, and tells how in his tents he had a copious supply of wine that the Achaean ships brought across the seas from Thrace. According to Homer, Atreides had everything necessary for lavish entertaining, for he 'ruled over many'. Thus, the feast was another distinctive feature of kingship, as it had been since Mycenaean days. To it the king invited only the notables, whom Homer called the elders, and at it problems would be discussed and solved. Kotys invited only his high officials to his banqueting halls, and Seuthes summoned only the most eminent of his people. The guests belonged to a limited circle, and to be asked to a feast was a special privilege. Seuthes promised Xenophon that if the Greeks should help him, he would make of them his brothers and boon companions. Was this not another characteristic feature of the hero, and was it not true that Orpheus and Zalmoxis invited only notables?

The ancient sources are full of information about the Thracian rulers' partiality for splendid feasts. Xenophon describes at length the feast given by Seuthes; Diodorus and Strabo write about the

one which Dromichaetes gave for the captured Lysimachus. The lavishness displayed during the wedding of Kotys' daughter to Iphicrates was ridiculed in Anaxandrides' comedy *Protesilaios*: 'If you do as you are told, we shall have a reception for you and a splendid feast which will not be at all like the one for Iphicrates in Thrace, though it is said that it was very grand. The city square was carpeted with purple, and the feast attended by a host of dishevelled, fat-gobbling men. There were copper cauldrons that were bigger than a room for twelve beds. Kotys himself ladled the soup out of a gold vessel; what with tasting the wine in the mixing bowls, he got drunk before those whom he wished to treat.' (Athenaeus.)

This passage again shows how the Greeks judged the Thracians solely from their own point of view. They thought it ridiculous that Kotys himself should serve food and wine. Xenophon has a curious story about usages at the Thracian court: according to him Seuthes took the loaves that were set before him, broke them and threw the pieces to his guests as he saw fit. He did the same with the meat, leaving for himself as much as he needed. Here is yet another aspect of the ideology of kingship – the king as dispenser of food to his subjects. There are parallels in Mycenaean history, and in the case of Maron, who jealously guarded his wine and himself offered it to his guests.

There is another interesting point in Xenophon's account of Seuthes' feast: as the banquet proceeded, a Thracian appeared leading a white horse. He took up a full horn, drank to Seuthes and presented the horse. Another brought a young slave and presented him to the king in the same manner, that is, after first drinking to Seuthes. A third gave him garments for his queen. Timasion also drank to Seuthes and presented him with a silver cup and a carpet worth ten minas. Custom required each of the king's guests to offer him presents and the gift-giving was always accompanied by drinking the king's health. As the gifts were precious and there were also libations, one wonders if this was not a ritual deifying of the living king. It is very likely that Thucydides had this custom in mind when he said that one could accomplish nothing among the Odrysae without giving gifts. It is difficult to tell whether it was the person of the king that was deified or just the institution of royalty. Seuthes was presented with a white horse, the sacrificial animal of the sun god. Rhesus's great pride were his horses, 'whiter than the feathers of the river swan'. At his daughter's wedding, Kotys gave her as dowry, among other things, 'two herds of white horses'. Of special interest is Herodotus's story of how the Thracians who lived along the Strymon stole the sacred chariot of Zeus, which Darius had left for safekeeping with the Paeones and which was harnessed with eight white horses. Why did the Thracians do

that? Did they look upon the chariot as a symbol of their hero Rhesus, or did their king appropriate it as a traditional insignia of power? The white horse – a symbol of the divine origin of the hero and the ruler – was another characteristic element of the ideology of kingship in Thrace.

The last abode of the mythical Thracian heroes was invariably a place of worship. Shrines were built round them, where prayers were offered to the hero and protector and miracles occurred. The burial mound of Orpheus became such a shrine. Sacrifices were offered and other rites in honour of the god were performed there, according to the account given us by Conon. A shepherd once leaned on Orpheus's monument and fell asleep, and as he did so, he began singing Orpheus's songs, while the nightingales sang more sweetly at the singer's grave (Pausanias). The legends about Rhesus were also remembered and many of his miracles were recounted, as, for example, when the boar and the deer, as well as other animals that lived in the mountain, walked in twos and threes to the sacrificial place of Rhesus, offering themselves and submitted themselves to the knife without having to be tied. It was also said that the hero removed pestilence from the mountain. The Rhodopes were thickly populated and there were many settlements in the vicinity of his shrine (Philostratus). The burial mounds of the kings who had actually existed, also became cult places. Their funerals were accompanied by rites, of which the ancient authors have given a detailed description. The body lay in state for three days: sacrificial animals were slain and feasts were held; the deceased was first mourned and then buried after cremation or was simply interred. Then a mound was raised and games were held, the greatest prizes being set aside for single combat (Herodotus). But the veneration of the sacred place did not end with this. Sometimes statues of the deceased chieftains, of the type of the 'stone women' found near Belogradets, Kalishté and elsewhere, were raised on top of the mounds. A group of sculptured figures representing the well known boar-hunt scene was placed at the entrance to the Mezek tomb. Very likely, sacrifices were offered near the mounds on festival days. It is interesting that the tomb-builders took pains to make them easily accessible. An example is the recently investigated pyramidal tomb near the village of Tatoul, where steps have been cut into the rock, so that worshippers could climb to the top and pay homage to the members of the royal family buried here. A burial complex in the Eastern Rhodopes, the biggest and most impressive of its kind in Thrace, lay on the territory of the Odrysian state, below the Thracian fortress on Mount St Marina. A staircase cut into the rock led to the deified chieftain's tomb, situated at a considerable height. This shows how quickly a Thracian ruler was transformed into an anthro-

podemon. So, there is nothing surprising in the fact that only a few decades after his death, Teres, founder of the Odrysian dynasty, came to be associated with the mythical hero Tereus, or that a paean was sung in honour of Sitalkes, and that there was a Zalmoxis song and dance. Once dead, the ruler became one with the mythical hero and could not be distinguished from him.

According to Pausanias, twenty stadia along the road leading from Dium to Mount Pieria, rose a column on top of which was a stone urn that the local people said contained the bones of Orpheus. The ashes of the singer were there laid between earth and heaven, while Rhesus was buried in the 'silver-veined' mountain, and all notable Thracians had their eternal abode on the high cliffs of the Rhodopes. Orpheus's urn was exposed to the sun, Rhesus beheld light from his cave, and the rock-hewn tombs and the Tatoul pyramid were so placed as to face the heavenly body all day long. The chthonian and solar cults were associated in these monuments so as to embody the Thracian idea of the oneness of hero and king.

In the Greek religion, Dionysus was semi-heroic, semi-divine. He was Zeus's son by a mortal. The ancient writers often represented him as a king, who won over new peoples for his religion. Consequently he was a form, though a higher one, of the king-high priest of the Orpheus and Zalmoxis type. Whether the level was higher or lower is of no import here, it is the resemblance as to type that is significant. Of Zalmoxis we know that from a king-high priest he became a god-king.

The political and religious conflict between Dionysus and Lycurgus decided the fate of the old Thracian dynasty. The god placed Charops on the throne, thus changing the religious orientation along with the dynastic line; thereafter the secret rites of the mysteries were handed down from father to son as an essential condition of retaining power. What we have here is a myth which codified the divine origin of kingship. The secret rites of the mysteries were the attributes of investiture. In this Thracian legend, Dionysus was represented as a deity of kings.

A closer scrutiny of the literary sources and of the archaeological material available will reveal other facts to support this supposition. The oracle of Dionysus in the land of the Satrae was well known as early as Herodotus's day. It seems to have been famous for its dynastic prophecies. Suetonius tells how Octavius, the father of Augustus, was told that his son would 'become lord of the world'. After the libation was poured, a big flame rose high above the top of the sanctuary, an omen which only one other had received when he made a sacrifice at this same altar, that other being Alexander the Great. The sanctuary must have had the reputation of giving reliable oracles on dynastic problems for Alexander to have decided to seek its counsel. Actually the

prophecies, i.e. the approval or rejection of a person as a ruler, were believed to have been given by Dionysus. The asking of the question, therefore, was a sort of investiture, while the flame rising high on the altar was the insignia of power. That is why it was a matter of crucial importance to the Thracians in whose hands the sanctuary was. It seems that from the beginning it never belonged to a single tribe, and later became a real bone of contention. The fact that the Romans took it from the Satrae and gave it to the Odrysae, provoking the rebellion of the Bessi high priest of Dionysus, Vologæsus, shows that the Romans realized the political significance of the sanctuary.

These are historical facts that are corroborated by mythological evidence. Maron, king-high priest, was the son of Dionysus, who thus originated yet another dynasty. Orpheus, the king-high priest of the reformed Dionysian cult, offered advice to king Midas. The legend, told by Herodotus, of how the Macedonian dynasty was founded, is of special interest. According to this, Perdiccas, Alexander's grandfather of seven generations back, came to rule over the Macedonians in the following manner: he and his two brothers had fled from Argos and found employment as bakers at the court of the king of Lebaea. (Obviously this was their test of valour.) Every time the three lads baked bread, young Perdiccas' dough rose twice as high as the others'. The king realizing that this was a portent of significance, first thought that it would be best to get rid of all three. They told him, however, that in all fairness he should first pay them and then they would go. Hearing their request, the king, whom the deity had deprived of reason, pointed to the sun, whose rays were making their way into the house through the chimney, and said: 'Here is the reward which I give you and which you deserve.' The youngest brother who chanced to have a knife on him, said: 'We accept what you give us, my lord' and drew a circle around the spot of sunlight with his knife and scooping it up thrice, put it in his bosom and departed with his brothers. Later Perdiccas conquered the whole of Macedon and became the founder of a dynasty. One should be grateful that, although he was a historian, Herodotus did not dismiss the legends he heard, if only because this story contains several important points. Who was the deity who deprived the king of his reason? This is the kind of punishment inflicted by Dionysus, who alone could strike people with madness. It was, therefore, Dionysus who sent the omens to Perdiccas and took charge of the situation. We have already emphasized that the Thracian Dionysus was not only a chthonian, but a solar deity as well. Here, the sun's disc acts as the symbol of investiture.

When the king of Lebaea realized his mistake, he sent a posse after Perdiccas. But the latter had already crossed a river, which his pursuers found in spate and were unable to ford. This is another case of Dionysus intervening. He had predicted that the city of Libethra would be destroyed by the waters of a river in spate. In the Macedonian genealogical legend, Dionysus, the solar, is clearly revealed as a dynastic god. That is why Alexander the Great was regarded as the new Dionysus, and almost all rulers of the Hellenistic period honoured him in a special cult.

But even before this, the Thracian kings Amatokos and Teres II were stamping the likeness and attributes of Dionysus on their coins. This means that they shared these points in the Macedonian legend. The figures on the vase from the Roussé treasure should also be seen in this light. It is very likely that the hierogamy of Dionysus had the same political meaning as was generally attached to it in the Thracian ideology of kingship. One of the chief cults in Seuthopolis was that of Dionysus. On many of the sacrificial altars found in the palace and in the homes of the aristocracy, the main decorative element is ivy, which is also found on a multitude of precious objects. The goddess on the Vratsa greave has a wreath of ivy on her head. Pliny reported that ivy was used to decorate the Thracians' helmets and shields during religious celebrations. The silver helmets, excavated in Romania, are also decorated with ivy. The ivy symbolizes political and religious power, and its use here reveals the presence of Dionysus once again.

The ancient Greeks often attributed the introduction of the mystic cults into Greece to the Thracians. The names of Orpheus, Eumolpus and Musaeus are closely connected with the mysteries of Dionysus and the Eleusinian deities. Unfortunately, very little is known about the mysteries held in Thrace. There is a general description by Diodorus according to which, among the Cicones, the tribe of Orpheus, initiator of the mysteries, these were conducted in secret. This means that the number of participants was limited. But who could be initiated? From his conflict with the women, we know that Orpheus's mysteries were open to men only. Even his sanctuary was barred to women. The same was true of Zalmoxis's mysteries: only men came to him. One wonders if there is not a connection here with Poseidonius's statement that there were some Thracians called Ctistae who lived without women-kind and were held in great honour. They were dedicated to the gods and lived free from every fear. These Ctistae and Capnobatae could have been members of sects which organized the male mysteries. If they were held in honour and led a carefree life, it was because they were initiated into the secret rites of the mysteries.

Man's dominant rôle in the social and economic life of his day is quite obvious; but there are indications that differentiation went beyond that of sex where the mysteries are concerned. The participants left their weapons at the entrance before

going inside the hall where the Orphic mysteries were conducted. During the Mycenaean period, a man's weapons were an important social and economic attribute. Thus one can conclude that only warriors were initiated. The social base of the Thracian mysteries becomes still more apparent from the legend of Zalmoxis. Herodotus is emphatic that Zalmoxis summoned only notables to his mysteries. The messengers to the deity had to be elected, and in a heroic epoch, social origin being one of the criteria of valour, it is obvious that it was first and foremost aristocrats who took part in the mysteries. They foregathered in a hall specially built for the purpose and were there instructed in the tenets of Orpheus's and Zalmoxis's teaching.

The essence of their doctrine was the concept of immortality. Herodotus is explicit that Zalmoxis preached this to his guests. The lives of both Orpheus and Zalmoxis were clear examples of man's ultimate passage to the other world. The dividing line was death and according to the ancient writers, this was the reason why the Thracians calmly and even of their own will accepted death, for they actually believed that they were going to a better world.

Could we then assume that the idea of the transmigration of souls, which inspired Orphism and Pythagoreanism, already existed in Thrace? No categorical answer can be given, but the ancient writers throw some light on the question. Poseidonius characterized the Ctistae, Capnobatae and members of other secret societies as follows: 'In accordance with their religion, the Moesians abstained from eating any living thing including the animals in their flocks; they used as food honey, milk and cheese, living a peacable life.' Homer called the Thracians 'milk-drinkers'. Demosthenes says: 'The Thracians were not in the habit of killing each other,' a statement that at first sight seems rather strange.

The nature of the mysteries helps to explain some other strange customs. Each Thracian man had several wives. As soon as a man died, there was great competition among his wives to decide which the husband had loved most dearly. Friends eagerly pleaded on each wife's behalf and she to whom the honour was adjudged, after receiving the plaudits both of men and women, was slain over the grave by the hand of her next of kin and buried with her husband. It was considered a disgrace to be one of the survivors. This is further proof of the Thracians' belief in immortality. The only way for a woman to share this privilege, intended for men only, was to be slain over her dead husband's grave and be buried with him. In this custom we see also an analogy with the ritual of immortalization in the Zalmoxis cult.

The Thracian mysteries seem close to the assemblies of the secret male societies of Iran. Only warriors were eligible to join these, which practised chthonian cults at their assemblies. Both Orpheus and Zalmoxis had a pronounced chthonian character. The most remarkable elements of the Iranian mysteries were the fight with the dragon and the fertility rites, elements that can also be found in Thracian religion. The rites in Thrace centred on the idea of immortality. This was a privilege of the aristocracy and it was from among its members that the messenger to be sent to Zalmoxis was chosen. If after being tossed on to the spears, he died on the points, it meant that the god had heeded their prayers. If he remained alive, he was pronounced evil and another one was selected to replace him. Zalmoxis did not welcome bad souls. The same idea is found in the Persian mysteries, in that, according to Iranian literature, the hero Yima took only the souls of the good to paradise. But were the terms 'good' and 'bad' used in the ethical sense? In those days, the words may well have had a specific social overtone; possibly this was a differentiation between initiated and uninitiated, between those who had learned the secret of immortality and those who did not have the privilege.

Ancient sources are unanimous in presenting Thrace as the country of great musicians and singers. Linus, Orpheus, Thamyris and Musaeus were the most famous among them. It is possible that nature had so endowed the Thracians, but there must have been other reasons for these legends. The etymology of the name Eumolpus (singing finely) was probably connected with his rôle of hierophant. In Thrace religious and political power was indivisible. The king was also the high priest, who performed the cult rites. At his feasts Seuthes was the first to get up and perform the war dance. Xenophon provides information about this dance and the song of Sitalkes. It is possible that this song was in honour of the hero Sitalkes, or of the Odrysian king, the son of Teres, or of them both. We also know that there was a dance and a song of Zalmoxis. All this helps to confirm the assumption that Thrace had a rich epos, embodying in a mythical form the historical memory and ideas of its people. The song and dance form in which it was handed down, helped people to remember the story. Orpheus was represented as an incomparable singer because, in all probability, his cultural reform was codified in chanted poems of the type of the *Iliad*. The fame of Thracian musicians, however, was not just a legend, but an authentic fact. The high priests of the Getae came out to welcome the Macedonian army, singing and playing lyres. Thracian doctors prescribed incantations as an efficacious cure for the soul. The Agathyrsi best remembered their laws in the form of chants. It is clear that what we are told about the musical talent of the Thracians is not only recognition of a special gift, but points to a characteristic way of preserving their historical, ideological and religious concepts.

3

THRACIAN ART

CLASSICAL BEAUTY is no longer regarded as the acme of perfection, as it was in the post-Renaissance era. It has ceased to be the sole criterion of aesthetics and artistic expression, so now we can take an unprejudiced view of arts that differ from those of Greece. At long last we can appreciate the true worth of Thracian art.

The works of Thracian art that we have excavated or discovered by accident have revolutionized our ideas about the Thracian genius. The theory that it was a branch of Scythian civilization or that it was directly dependent on the Greek masters, is no longer valid. The finds made near Panagyurishté, Lovets, Vratsa, Loukovit, Agighiol, Băiceni-Cucuteni, Peretu, Oguz, Krashni Kut, Kozel, Homina Mogila and elsewhere demonstrate that in those distant days an art of similar iconography and style had developed over a vast area. This means that there were centres of creative activity and a lively exchange of artistic ideas all over the vast territories of Thrace.

Some superb examples of early Thracian art are what we know as the Vulchitrun treasure. This consists of a large drinking cup (*cantharus*), a medium-sized cup and three smaller cups of the same shape, seven lids and a vessel with three partitions. They are all of pure gold and together weigh 12.5 kg. All the vessels are simple in form, their only decoration horizontal grooves and incisions and the rivets by which the handles are attached. The same kind of grooves decorate the axe-sceptres which were widespread in Thracian territory at the end of the Bronze Age. The grooves on the sheath of an axe, found near Razgrad, end in a fishtail, as do those on the handles of the Vulchitrun drinking cup. This fact, and certain analogies with pottery have made it possible to date the treasure between the fifteenth and twelfth centuries BC. Its exquisite craftsmanship speaks of a long tradition of artistic working in gold by highly skilled masters.

A large gold vessel found near Sofia a few years ago has shed new light on toreutics between the tenth and sixth centuries BC. The body of the vessel is decorated with crude vertical grooves and its mouth with horizontal grooves and incisions, below

which is a band of half-circles with a dot in the centre. A spiral design of dots between concentric circles forms a simple but beautiful design at its base. This vessel, although of a later period than the Vulchitrun treasure, is ornamented with fairly old motifs. A gold drinking cup (*cantharus*), found in Biia, Romania, and ornamented with dotted triangles, beads and raised concentric circles, has been dated to the Early Iron Age. A decorated iron dagger, discovered in a tomb near the village of Belogradets, Varna district, has been dated to the end of the seventh century BC. Its raised geometric designs are made of wire soldered on and subsequently incised.

These finds confirm the accounts of the ancient writers about the wealth of the Thracian kings. Homer mentions a beautiful Thracian cup as one of the gifts offered to Priam, describes how the Achaeans competed for a handsome Thracian sword, and admires the rich gold and silver decoration of Rhesus's chariot. Odysseus, he tells us, was given seven talents, exquisitely worked from gold and silver, and a mixing vessel (*crater*) of solid silver, the gift of Maron. Would this not permit us to assume that at the end of the Bronze Age and in the Early Iron Age Thrace was on a par with Greece in artistic achievement?

During the Early Iron Age bronze continued to be the basic material used in arts and crafts. Jewellery, amulets, royal insignia, cult figurines, appliqués on horse trappings were all cast in bronze. The range of motifs was limited – heads, front parts or figures of domestic animals (goats, rams, bulls, horses), birds and stags. The decorative designs were very simple and geometric: concentric circles, diamonds and triangles, dots and spirals. These decorations were in harmony with the simplified forms of the animals figures, while the simplicity and purity of their lines lent them a great deal of sophistication.

The use of ritual axes was widespread in Ancient Thrace. Usually the edge was decorated with peaceful scenes, a procession of animals symbolizing the wealth and power of the chieftain. Such axes have been discovered over a vast area including the

*Detail of the handle
of the cantharos below.*

Cantharos from the Vulchitrun treasure.

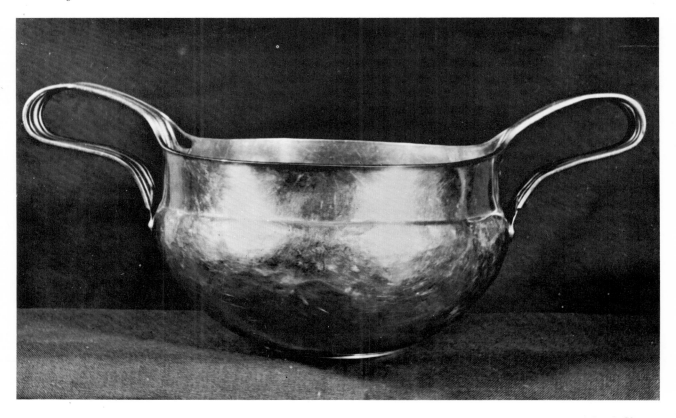

Near East and Central Europe, Thrace probably serving as the connecting link. In the East they retained some of their functional use, but in Thrace the axe was purely symbolic. The Thracian axe was decorated with figures in relief and had a small hole through which a string was probably threaded so that it could be worn, probably on the chest.

There are certain affinities here with contemporary works of art from Central Europe, the Balkans and especially Macedon, which seems to have been an important centre of the geometric style. In Greece proper, only the bronze figurines have the same characteristics. One of the masterpieces of this style in Thrace is the exquisite figurine of a deer from Sevlievo, Northern Bulgaria. Its body and neck are slender prisms, the head is a truncated pyramid, the eyes are round holes and the antlers shaped as arcs. Only the chest and thighs are rounded, but here too there seems to have been a preference for geometric simplicity. In spite of this schematic treatment, the artist has achieved the desired effect – an alert pose, elegant proportions, and a proudly raised head.

Few relics from the geometric period have been

Reverse of the triple container on opposite page, showing the two little connecting tubes.

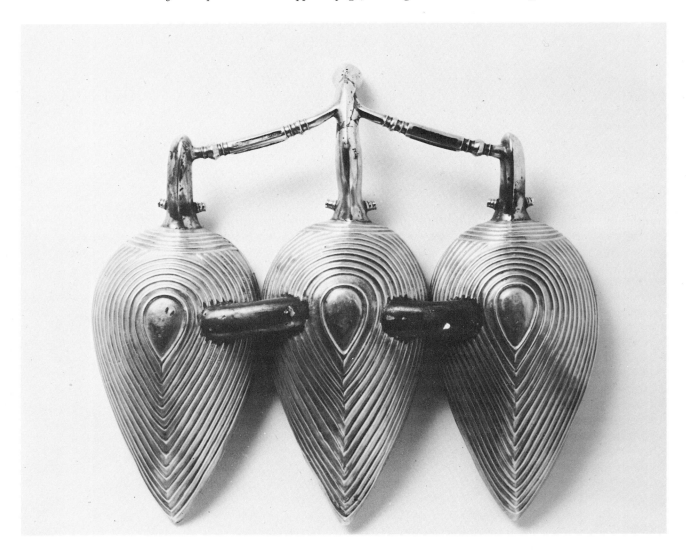

found in Bulgaria. This may be just a coincidence, as is often the case in archaeology. It is, however, possible that Thrace produced little in the way of art between the tenth and sixth centuries BC. From then on, however, the picture changes dramatically. Rich burials were no longer an exception, but rather the rule, ushering in a new era in Thracian art.

The finds from this period have yielded the greatest treasures of Thracian art. The custom of placing many objects of daily or decorative use in graves has been a boon to archaeologists and art historians. The excavation of every new mound offers further insight into the Thracian world, or rather nether world. But who can tell which of these two worlds the Thracians regarded as more important: the uproarious feasts held in their palaces or the endless silence of the tomb? Large settlements sprang up around the ruler's palace, and the cult of a new hero started round the mound in which he was buried. A king may have had several residences, but he had only one tomb. The Thracians lived fully and eventfully in this world, but their belief in the immortality which awaited them

Triple container from the Vulchitrun treasure. A vessel used, perhaps, in a brotherhood ceremonial or in the cult of the Mother of Gods.

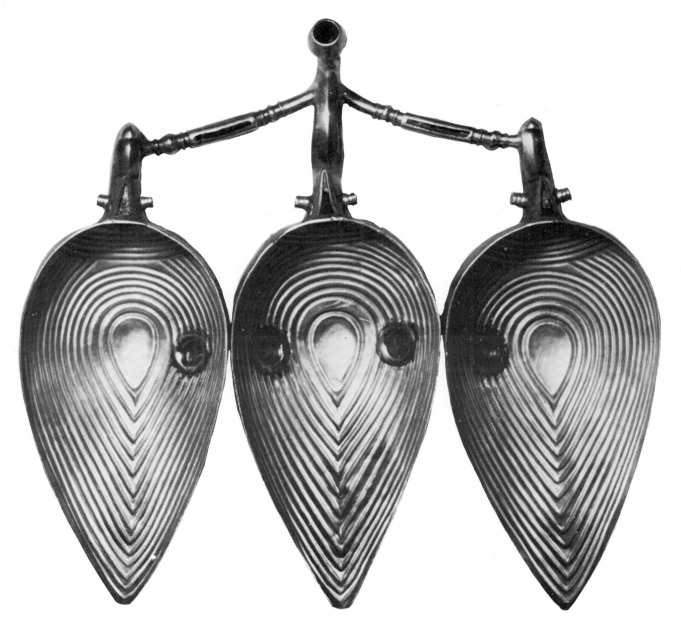

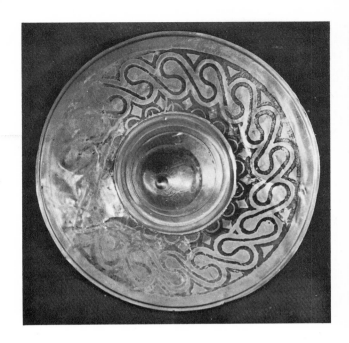

Another item from the Vulchitrun treasure: perhaps a lid, or a cymbal. It is made of gold, but has bronze inlay in the handle that might give it resonance.

in the other, was never absent from their minds. This duality was reflected in their architecture: they built palaces and tombs with an equal zeal.

The site of the royal residence was chosen with care. Maron raised his in a fine grove, Kotys built a feast hall at Onocarsis, a well appointed place in Thrace in a big forest where it was agreeable to live. In fact, as he went about his country, he would build a banqueting hall wherever he saw a shady place, rich in vegetation and water. Very likely the choice of place did not depend solely on aesthetic and hedonistic considerations, but was equally governed by religious criteria. One should not forget that these halls were also sanctuaries and the king a high priest, which latter circumstance largely determined the particular character of palace architecture in Thrace.

The palace or *tursis* (tower) was the religious and political centre around which a settlement would grow and develop. This is well exemplified by the capital of the Odrysian king Seuthes III. His residence occupied the north-eastern part of the town and was very like a citadel. It had a spacious court paved with stone slabs. The palace itself was built of mud bricks on a stone foundation. On the outside it was decorated with antefixes. The inside walls were painted in imitation of coloured marble, a feature of Hellenistic interior decoration. But local elements were also used. There was a shrine of the Cabiri in the living quarters. In the reception hall were two large fireplaces (altars) which had the cult purposes we are familiar with from the Minoan civilization. The principles of palace architecture laid down by the mythical king-high priests of the Mycenaean period (Maron, Orpheus and Zalmoxis) were adhered to until much later.

That is to say: those close to the king and the aristocracy built their houses next to the palace, for it was they who formed the ruler's entourage and took part in his frequent feasts and sacrificial offerings. The Thracian city of the Hellenistic period was very reminiscent of the Achaean city-kingdoms of the Mycenaean epoch.

And just as the mythical Mycenaean heroes believed in a life after death and built imposing tombs, so the Thracian rulers hoped to go to the other world by being buried under mounds or in rock-hewn tombs. Funerary architecture had a long history in Thrace, undergoing an interesting evolution. Its earliest examples were the dolmens, which have been dated to the end of the Bronze Age and the Early Iron Age. These were megalithic structures made of large blocks of stone. They had a rectangular burial chamber, topped by a saddle roof. More often than not, one or two antechambers led to it. Ordinarily an earthen mound was piled on top of the dolmen, the layout of which (chamber, antechamber and passage) was adopted for later Thracian tombs, as was its style of roofing. The majority of dolmens are concentrated in the relatively small area of the Sakar and Strandja Mountains, while the new funerary architecture first made its appearance in South-eastern Thrace, indicating a certain continuity.

The round tomb appeared during the Classical period and is the basic form of the numerous rock-hewn tombs in the Eastern Rhodopes. It had a beehive chamber and, sometimes, an antechamber and a passage, the entry to which was walled. Most probably, this was an Odrysian tradition, because it was not until the middle of the fourth century BC that the round tomb became widely used in

Thrace. It was built of square stones or bricks – a technique characteristic of the tombs in the capital of Seuthes III and its environs. Typical examples are the tombs of Mezek and Kazanluk. The former consists of a round chamber with a beehive dome made of ashlars, two antechambers and a long saddle-roofed passage leading out of the mound. Its interior was finished with great care. The floor is covered with finely polished slabs, the round chamber has a bronze door and the antechambers have stone doors; in the main chamber there is a stone couch with two urns beside it. Apparently this was the family tomb of one of the last Odryssaean rulers. There is evidence here of a second burial. The Kazanluk tomb has a round main chamber with a false beehive dome, a passage with a saddle roof and a large antechamber. Judging by the rich offerings and the remarkable wall paintings, it, too, must have belonged to a royal family, perhaps to someone related to Seuthes III. The Kazanluk tomb is more modest in size than that at Mezek, and shows a tendency towards simpler planning, with the antechamber and passage gradually disappearing. There is a tomb at Belovo which has a single round chamber built of square stones, in which a sarcophagus had been placed, while that at Tatoul, in the Eastern Rhodopes, is an interesting example of a round rock-hewn tomb with a beehive dome. Here, the chamber was cut into the rock and the sole entrance to it was the square keystone of the vault, over which a stone slab had been laid. It is impossible to tell from the outside that this was a burial chamber. Dating this monument to the end of the fourth century BC, would indicate a reverse influence – from built tombs to rock-hewn ones; but in actual fact the two types must have existed side by side.

The round tomb was an old method of building, known from the Mycenaean civilization, and found throughout the ancient world – in Asia Minor, Italy, the Ukraine, Thessaly, Thrace. Its appearance in Thrace at such a late date can scarcely be considered a survival of Mycenaean times. Most probably, the Thracians borrowed it from Caria and adapted it to their own needs. From the East, perhaps from Phrygia, came a more economical technique of tomb construction, which became popular in Thrace. Here the chamber was built of wood and the space between the two wooden partitions of the walls filled with gravel (Toros, Vratsa, and so on).

In the sixth and fifth centuries BC, the majority of tombs built in Thrace were rectangular. The most interesting example of this type is that found in the village of Tatarevo, Haskovo district, which shows that a complex plan (main chamber, passage and ante-chamber) was used there as far back as the fifth century BC. The chambers are roofed with a false vault and dome made of square stones.

Even more interesting is the tomb near the village of Tatoul, already mentioned. This has been cut into a 4 metre high rock that had itself been shaped like a truncated pyramid. There is also a platform in the centre in which a grave has been hollowed out. A niche has been cut in its western side and this has the shape of a half dome. Rough steps cut into the rock lead to the tomb. This was probably a family tomb, which was open for worship, unlike the burial mounds, which were covered with earth. The niche appears to have had no functional use. This was probably a feature of this particular kind of Thracian funerary architecture. There are other tombs shaped like pyramids in the same district and it can be inferred that that type of burial was widespread in the Eastern Rhodopes.

Many of the Thracian mounds excavated were found to be empty, having been plundered in Antiquity or later. However, the greater part of the 10,000 mounds has still to be excavated. Even so, the basic material which has enabled us to assess Thracian art, has come from the mounds. The little already discovered is of enormous value. When one thinks that only a few of a ruler's possessions can have been put in his tomb, the rest being wanted for use by the living, it gives one an idea of what a wealth of gold and silver articles the Thracian rulers must have owned. In times of danger, the rich resorted to the earth as a hiding place for their treasures, hoping to be able to recover them later; but many of these hoards have remained in the earth for thousands of years before being accidentally discovered.

The increasing luxury of the Thracian aristocracy's life-style is reflected in the change of the materials used in art. In the fifth and especially in the fourth century BC bronze was entirely replaced by gold and silver. Even if some appliqués were made of bronze, they were always silver-plated. The kings loved brilliance and splendour, even if it was only skin deep. Silver, too, was often gilt and this is characteristic of Thracian toreutics. Usually the repoussé technique has been used, the details being engraved later. Casting and stamping were more rarely used. The new materials and techniques began to be employed in all toreutic genres. From the functional point of view, the Thracian grave goods may be divided into several large groups: vessels, armour, jewellery and appliqués for horse trappings. They include some unique masterpieces.

Archaeological finds show that the Thracian king's table was laid with exquisite silver and gold ware. Characteristic were round jugs with protuberant bodies becoming narrower at the neck and bottom. They had a wide border at the mouth, a solid base and a single handle. Fine examples of this type of jug have been found in Boukyovtsi and Loukovit. Their ornamentation, consisting of geometric designs, is simple and beautiful. Other kinds of jug have pear-shaped bodies, low necks and wide mouths. Some of them are decorated with

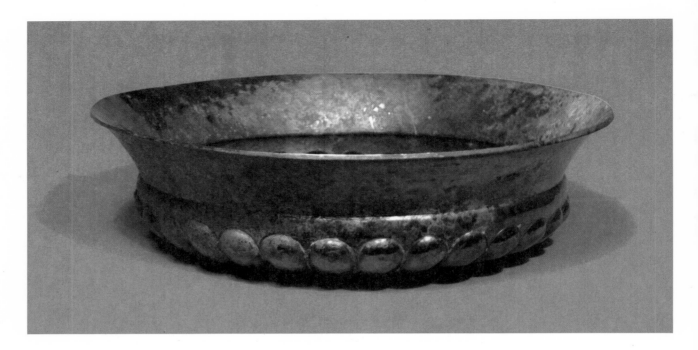

Silver phiale from Kukova mogila.

LEFT
*Silver appliqué from Panagyurishté treasure showing
Hercules and the lion, griffins and a siren playing a lyre.*

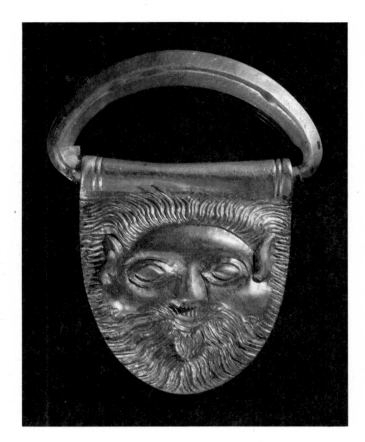

Head of Silenus on the handle of a vase from the Roussé treasure (see picture on page 83).

BELOW
The gold vase, that comprises the third item in the symbolic burial mentioned on page 21.

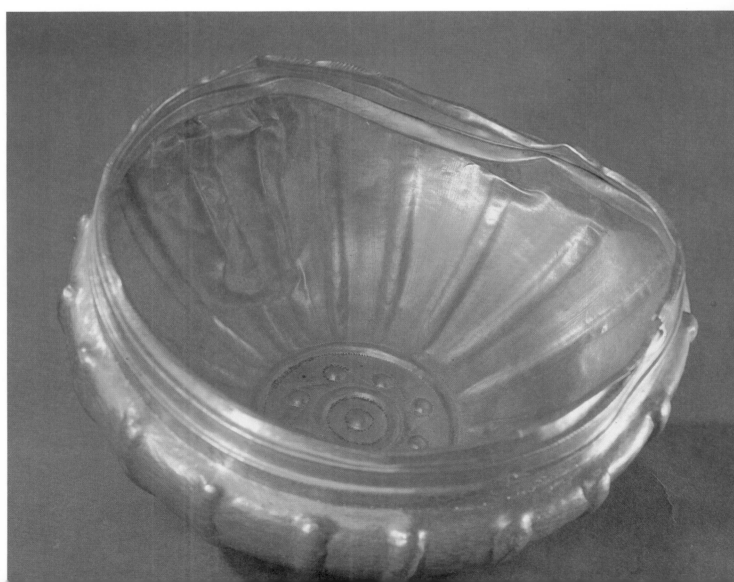

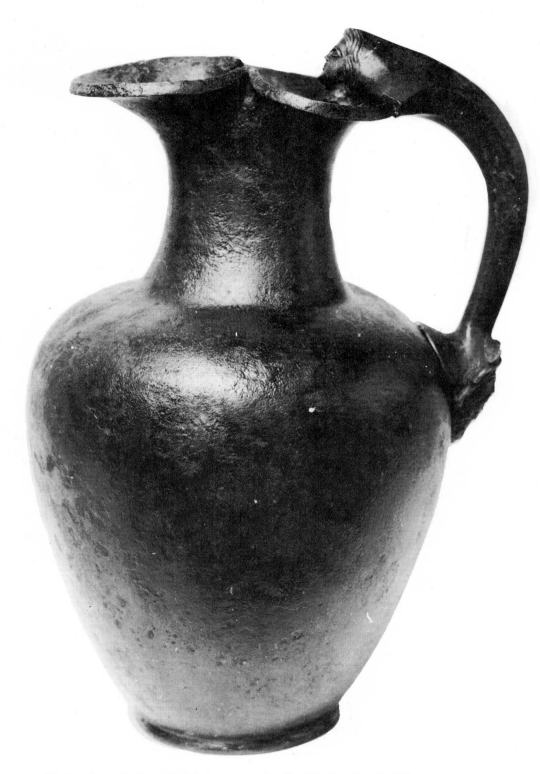

*The jug from the Panagyurishté treasure, details of the handle of which are
shown on the opposite page.*

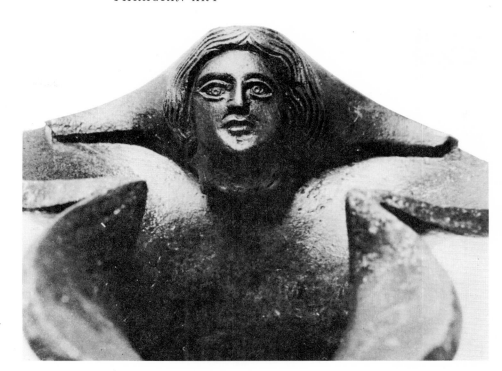

*Detail of the head on the top of the handle of the jug from the Panagyurishté treasure (*OPPOSITE*), perhaps that of a maenad. At the bottom of the handle is this head of Silenus (*BELOW*).*

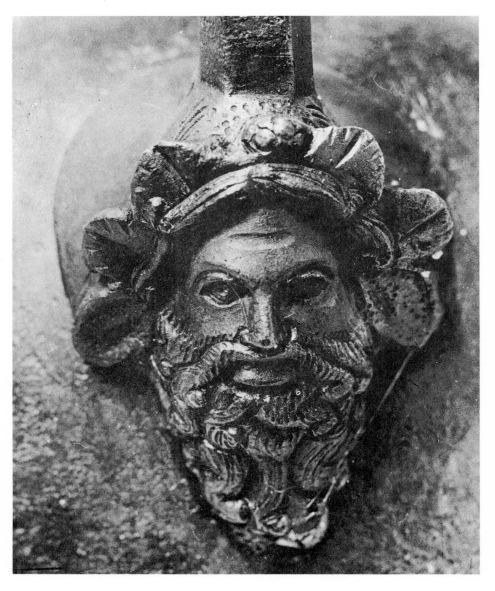

A silver jug found in Bashova Mogila.

BELOW
Silver phiale from Brnichevo.

RIGHT
Detail from the Kazanluk tomb painting showing women bringing presents to the bride.

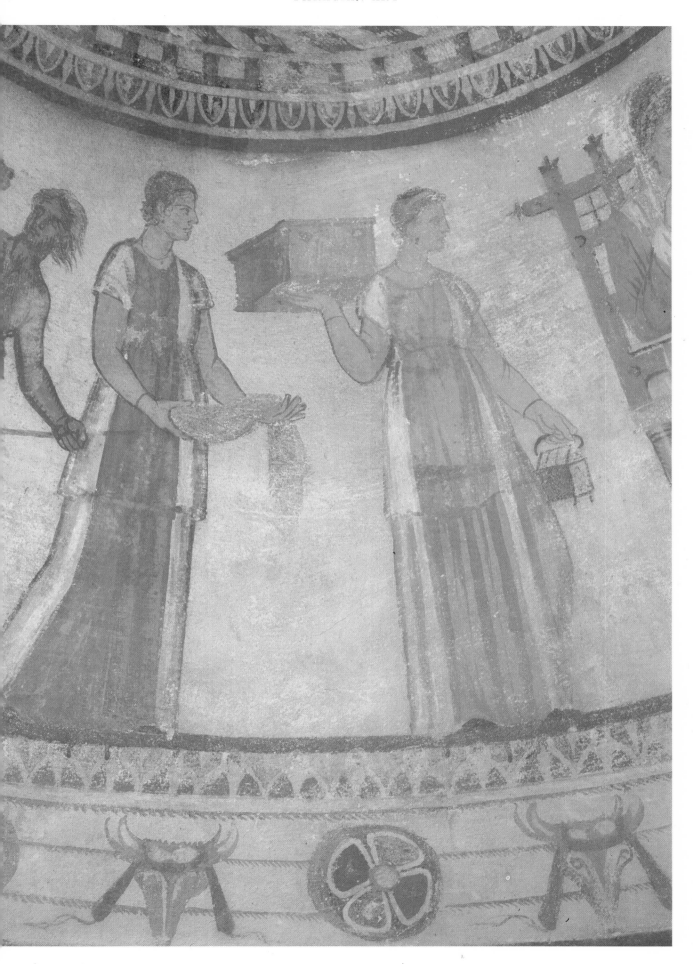

Bronze brow-piece from Sofronjevo. At one end is a bull's head and at the other a knob with a triskele on it. This is the earliest example of a Thracian brow-piece. There is a ring at the back through which the strap passed.

[73]

Bronze deer from Sevlievo.
Geometric style (see page 62).

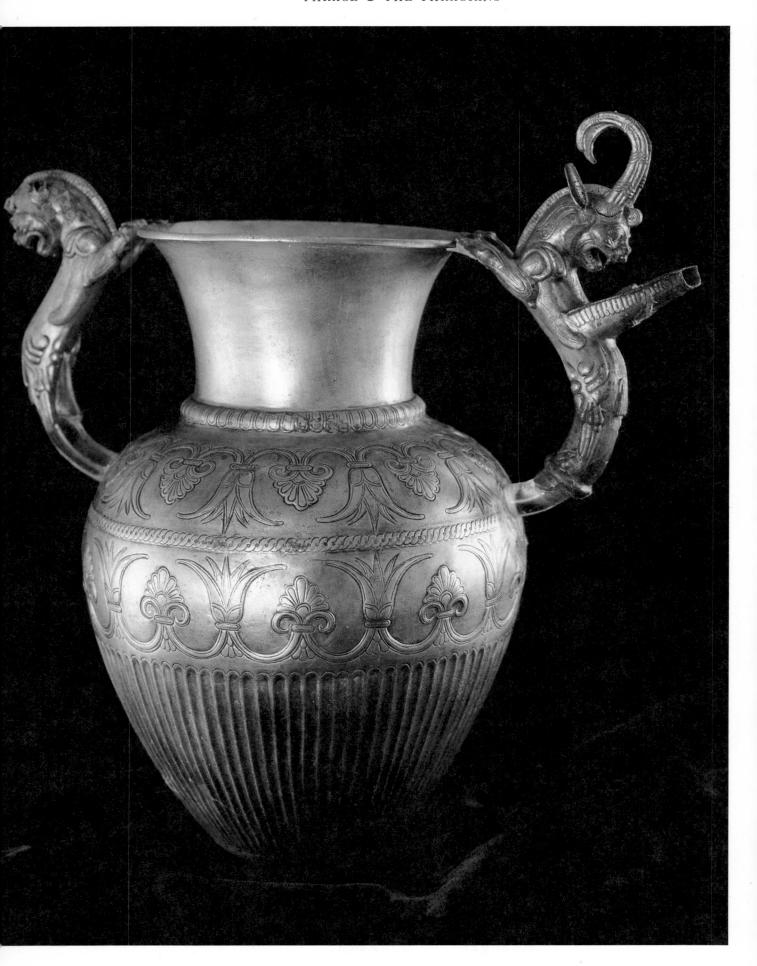

LEFT
A lovely silver amphora-rhyton, a Persian's gift to a Thracian ruler.

A gold amphora-rhyton from the Panagyurishté treasure with handles in the shape of fighting centaurs. The body of the rhyton depicts the story of the Seven against Thebes.

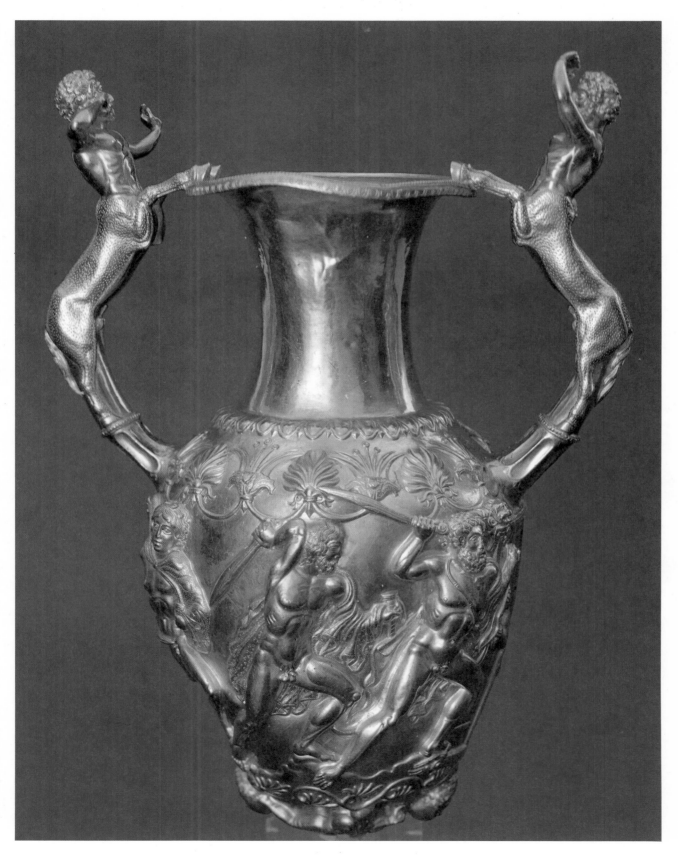

Dolmen at Strandja.
Rock tomb at Sakhar.

Corridor in a tomb at Mezek, illustrating the false vault technique.

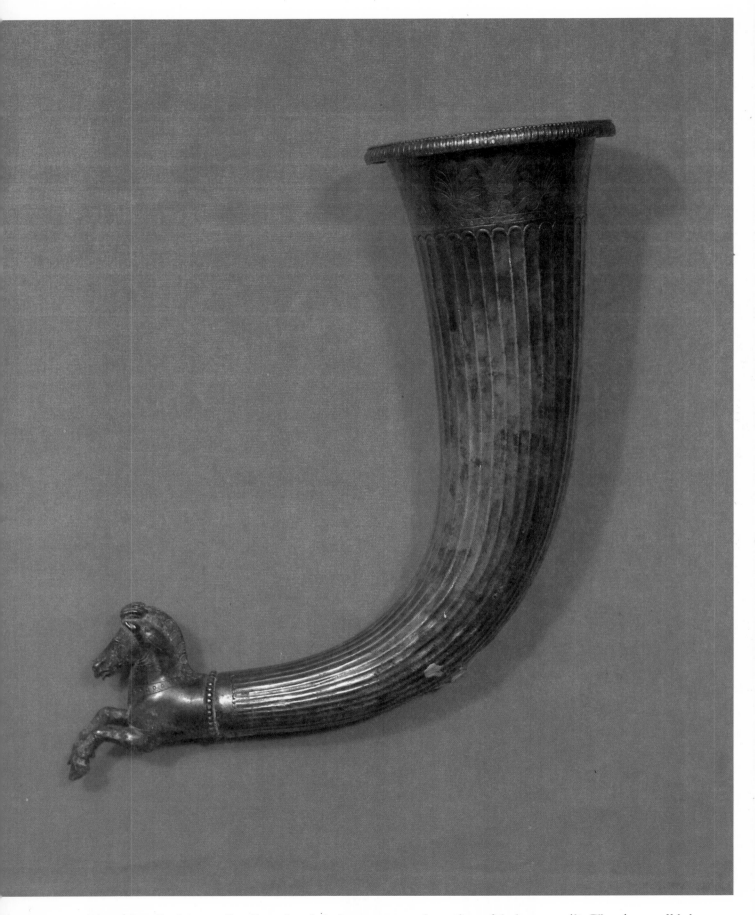

Rhyton from Bashova mogila, silver, though the hooves, mane and trappings of the horse are gilt. There is a small hole between the horse's legs through which the liquid was poured. Height: 20·6 cm.

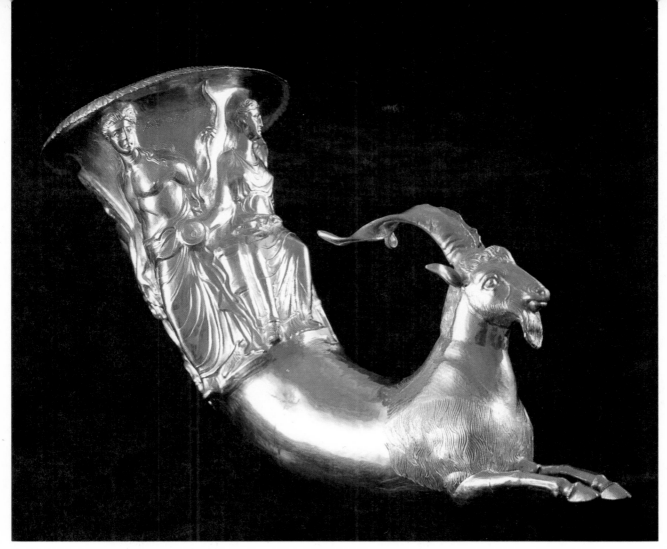

Gold rhyton from the Panagyurishté treasure ending in the protome of a billy-goat, the pouring hole being between its fore legs. The figures on the neck are those of Artemis and Nike, Apollo and Hera. Height 14·9 cm.

Rhyton from the Roussé treasure ending in the protome of a sphinx. On the sphinx's belly is an inscription in Greek: ΚΌΤΥΟΣ ΕΤΒΕΟΥ (See page 100).

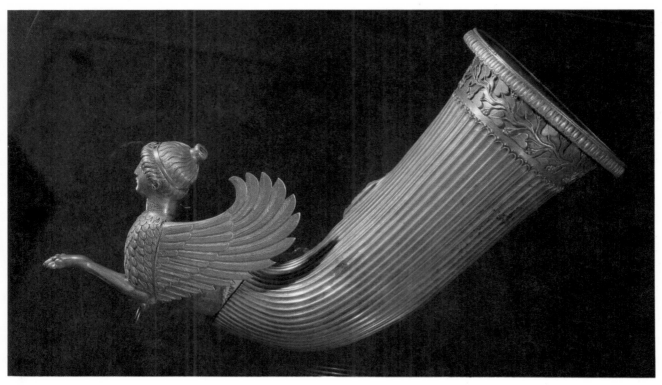

Ornamentation of the top of the sphinx rhyton. The lotus and palmetto are typical and evidence of Eastern influence.

vertical grooves or bands of plant motifs; they all have handles. The phialai constitute an important group of Thracian vessels; they have a raised knob (*omphalos*) which had both a decorative and a functional purpose. Some of these phialai are shallow, some very deep; their diameter varies between 5 and 30 cm. Almost all of the thirty or more found in Thrace are lavishly decorated, the ornamentation being vertical grooves, bands of lotus flowers and palmettos, broad leaves, almond-shaped or scale-like designs and human heads, the latter so far only in the Loukovit and Panagyu-rishté treasures. The Bashova Mogila phiale has engraved scenes of a chariot race. There is considerable variety in craftsmanship and in the materials used, but placed side by side, the bowls make an impressive sight.

The most striking of all the Thracian vessels are the rhyta, metal drinking cups shaped like a horn and ending in the head or fore-part of an animal. So far twenty-five of them have been discovered, all made of either gold or silver. They can be classified into groups: those with the front part of a galloping horse and a long horn, decorated with grooves and a band of plant motifs below the wide mouth, belong to the first group. There are six of them, their dates ranging between the end of the fifth and the early third centuries BC. One can see how, gradually, the local Greek and Thracian artists have developed a taste for Iranian models. The proportions of the horn and protome become heavier, the horn is bent almost at a right angle, and the decorations are more lavish. The rhyton with the fore-part of a galloping horse seems to be a Thracian contribution to this type of vessel. In Iran the protome was so sculpted that the animal's legs were folded under its body, while the galloping horse appeared in Asia Minor only in the third century BC. This shows how important the horse was in Thracian religion.

There are only a few examples of the second group of Thracian rhyta: vessels with a short horn decorated with figural friezes and ending in the

head of an animal and often having handles. Of the fourth century BC, they have iconographic and stylistic similarities, though differing in the quality of craftsmanship. The scenes on the horn's frieze are invariably mythological, showing deities or heroic exploits. A rosette, the solar symbol, is placed on the brow of the animal. The Thracian artists who employed the realistic methods of Greek art in rendering human figures, have used more stylized forms in the treatment of animal heads. This was a compromise to meet the wishes of their barbarian customers, who had a preference for Iranian forms. Several rhyta show a combination of the two styles. Thus the horn of one rhyton ending in the front part of a horse is covered with battle scenes. Three rhyta of the Panagyurishté treasure are shaped like women's heads; they have handles and the orifices have been made to look like decoration of the neck. The Roussé rhyton with the fore-part of a bull is a copy of an Iranian model. The massive proportions, the bent head, the legs folded under the body, the stylized mane and leg muscles in the form of a lotus flower – all these are reminiscent of capitals in Persepolis and of the

Syro-Hettian rhyta in the British Museum and the Cincinnati Art Museum. The most beautiful Thracian rhyton, however, is the one from the treasure found in 1974 in the village of Borovo near Roussé. Remarkable for its workmanship and exquisite proportions, this lavishly gilt rhyton has an elegantly shaped horn which ends in the austerely beautiful face of a sphinx. Made during the reign of Kotys I by the court artist Egbeo, it is really one of the most perfect examples of ancient toreutics.

Based on Persian prototypes, the Thracian amphora-rhyta are also very beautiful. The earliest among them was found in Koukova Mogila near Douvanli. Its delicate shape is enhanced by its ornamental bands and grooves. Its handles are lion-like gryphons with high, curved horns, their heads tossed backward. The figures and ornaments show that the amphora was made in Iran and was probably given to a local chieftain by an Achaemenian commander during the Persian's stay in Thrace. The amphora of the Roussé treasure, the body of which is decorated with a figural frieze, is of a later date. The sculpted figures on the gold amphora-rhyton of the Panagyurishté treasure are the dom-

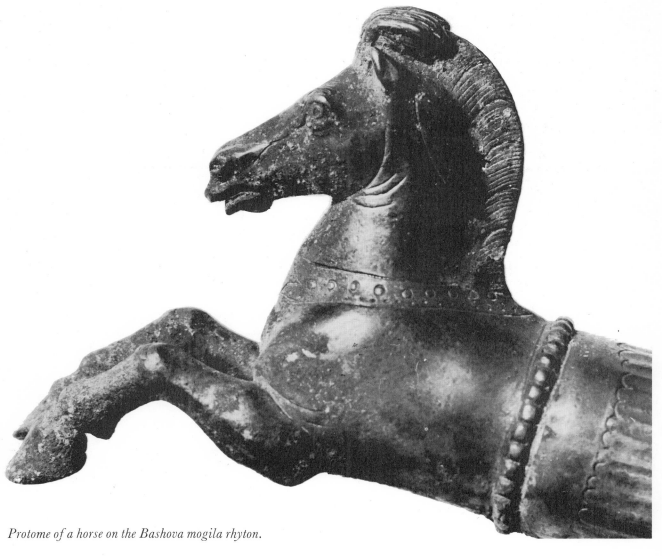

Protome of a horse on the Bashova mogila rhyton.

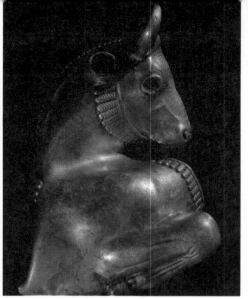

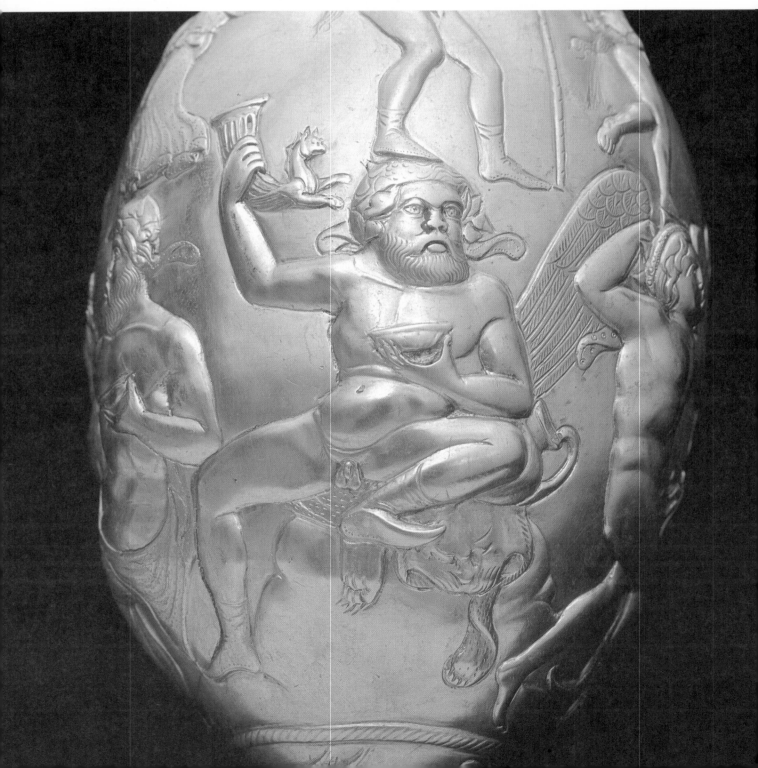

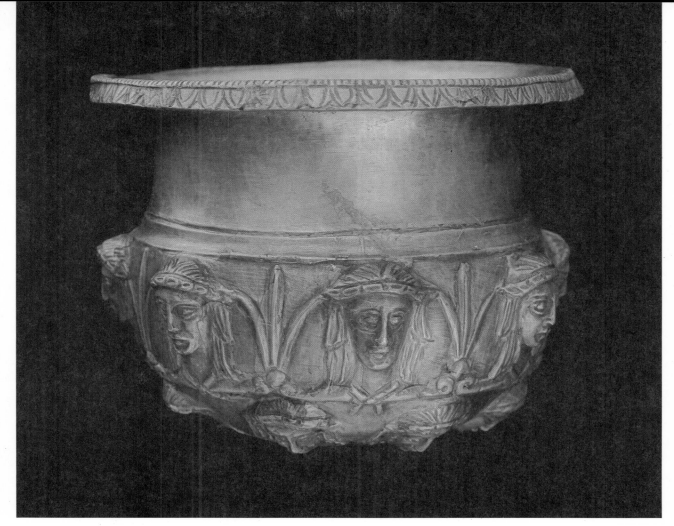

ABOVE
Phiale from the Loukovits treasure with women's heads and lotus.

RIGHT
Gold rhyton from the Panagyurishté treasure, 20·5 cm high. The shape is that of an Amazon's head with a necklace on which is a medallion in the form of a lion's head. The pouring hole is the animal's open mouth.

OPPOSITE, TOP LEFT
A gold ring from Ezerovo with an inscription in Thracian.

OPPOSITE, TOP RIGHT
Protome of a bull from a rhyton in the Roussé treasure. The rendering of the mane is evidence of the influence of Persian art.

OPPOSITE, BOTTOM
Detail from a vase of the Roussé treasure showing Silenus about to drink from a phiale which he has filled from the rhyton he is holding aloft in his right hand.

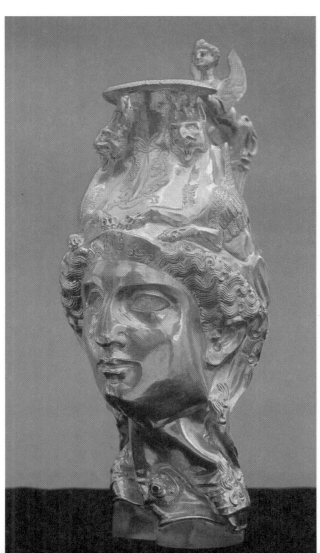

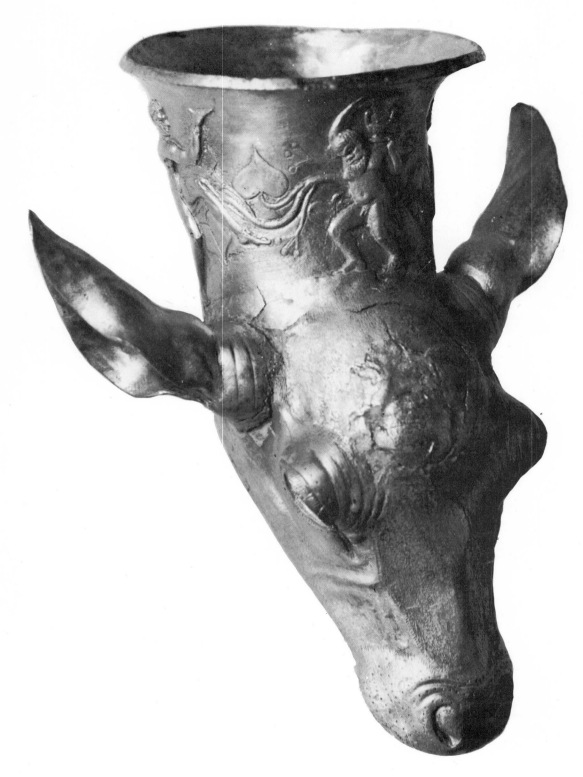

Rhyton from Rozovets on which are depicted Dionysiac scenes with dancing Silenus and Silenus carrying a crater shown against a background of ivyberries.

inant part of the vessel. It weighs 1,696·25 g and is one of the wonders of ancient toreutics. The scene on the frieze tells the story of *The Seven Against Thebes*; while the child Heracles with the serpents and a Silenus holding a double flute and a cantharus are portrayed on the bottom. The handles are shaped like centaurs and the two orifices at the bottom, like Negro heads. The growing recourse to anthropomorphism in decoration clearly shows Greek influence, but also reflects the processes developing in Thracian art, in which the human likeness gained in importance during the fourth century BC.

The Thracian rulers paid a great deal of attention to their armour, buying from the Greeks bell-shaped bronze chainmail on which the muscles of the body were outlined schematically. During the fifth century BC the geometric designs were supplanted with the zoomorphic detail characteristic of armour in other parts of the ancient world – helmets from Urartu and the archaic chainmail of Crete. The Thracian chieftain wore a chainmail tunic, a helmet and greaves, and he carried a shield. So far, about fifty bronze and some iron helmets have been found in Bulgaria. Some are Chalcidian, some Attic and some Thracian. In most cases they have no decoration, but some have eyebrows painted on them, others have tight curls of silver foil at the back, and still others have scenes depicted on the cheek-pieces or gryphons on the upper front part. The Thracian type of helmet, well known throughout Antiquity, was original in design. The bronze greaves fitted the legs and schematically outlined the muscles. The ancient writers provide descriptions of the Thracian shields that confirm the archaeological evidence: they were oval and decorated in the centre with an oblong appliqué surrounded by symmetrically arranged circular plaques. Sometimes they were covered with ornamental or figural designs. Mostly, however, the Thracian warrior used the light leather shield (*pelta*).

On ceremonial occasions the chieftain appeared in splendid armour made of precious metals. Taking the Attic helmet as model, the Thracian craftsmen designed a high helmet with fixed cheek-pieces. Its entire surface was engraved: it was ringed with an ivy wreath with locks of hair above it; a pair of huge eyes with long, curving eyebrows were painted above the front, and the cheek- and nape-pieces were decorated with processions of animals, men on horseback and sacrificial scenes. The greaves were of silver ornamented with gilt appliqués. The upper part had the shape of a human face, an idea borrowed from the Greek *knemis* with its Medusa head. The Thracian, however, showed greater imagination and a barbarian taste for ostentation. It is easy to imagine what impression the king-high priest made when he appeared before his subjects in all this splendour. His appearance must have been dazzling, an adjective that Hesychius himself used in describing the Thracian aristocrats.

The ceremonial dress of the 'dazzling' Thracian was rich in jewels. His bronze or leather mail would be ornamented with gilt phalarae and a pectoral would hang round his neck. Gold pectorals were worn as a mark of social distinction. It is interesting that most of those found have come from south of the Balkan Range, and hardly any from north of the Danube. This supports the assumption that the Thracians borrowed the pectoral from Asia Minor and Macedon. The moon-shaped pectorals from Mezek, Dulboki and Anabadjiiska Mogila show an affinity with those of Urartu, while the diamond-shaped plaques can be traced back to Macedon. Adapting these two forms, Thrace developed its own small elliptical pectoral. The gold plaque was invariably decorated with circles, rosettes, palmettos, lotus flowers, conventionalized trees of life, ivy and so on, with Eastern and Greek motifs interchanging. The noble Thracian also wore an ornate belt with plates made of precious metal and decorated with figures. Thracian women were famed throughout the ancient world for their beauty. Those who had the means, enhanced it by wearing elaborate jewellery. Some of the necklaces, rings, bracelets and earrings found in tombs, must have cost a fortune. The gold earrings of the princess buried in the Mogilanska Mogila in Vratsa, weigh all of 37 g and they are of intricate and exquisite workmanship: a crescent decorated with rosettes, spirals and a siren is attached by gold filaments to a similarly ornamented disc; tiny acorns suspended from delicate chains provide the finishing touch. Recently, a pair of earrings was excavated near Varna; each is a tiny figurine of Nike in flight, in her hands a rhyton and a phiale. The necklaces are usually made of elliptical and spherical beads and have pendants ornamented with fine wire, imitating filigree. More often than not, the bracelets are simple solid bands of silver, decorated with engraved geometric designs or with twisted wire ending in a volute or spiral, their tips shaped like a serpent's head. The relics found in Bulgaria are among the finest examples of ancient jewellery.

The horses of the Thracian nobles were no less lavishly geared than their masters. Often the plaques on horse trappings constituted real treasures, as, for instance, those of Letnitsa and Loukovit. Among them are circular plaques which joined the various leather straps of the bridle, oblong appliqués for cheek-straps and curved plaques for the brow-bands and chest-straps. The chief ornaments, however, were on the chest-strap. The typical shapes of the phalerae were the swastika and the three-armed triskele, dating back to the geometric period. Another important part of Thracian horse trappings was the crest-piece. Typical crest-pieces had a flat base like a figure of eight with another part representing a head, front

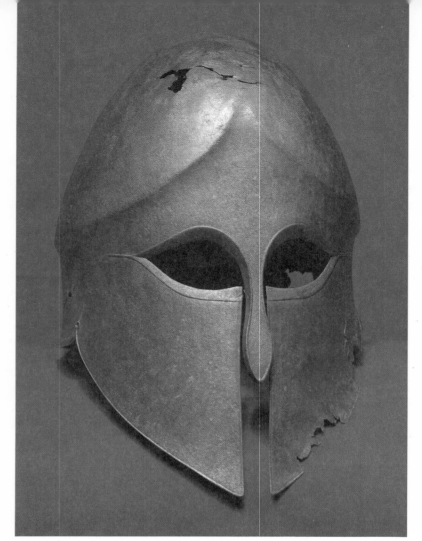

Corinthian bronze helmet, 20·9 cm high. Plain and serviceable.

OPPOSITE
Silver and gold ceremonial greave, 46 cm high. The part covering the knee is in the form of a woman's head, the hair curled and gathered in a plait over the forehead, beneath which is a wreath of ivy. The right cheek is ornamented with parallel gold stripes.

BELOW
Bronze Attic helmet, typical of those found in Thrace.

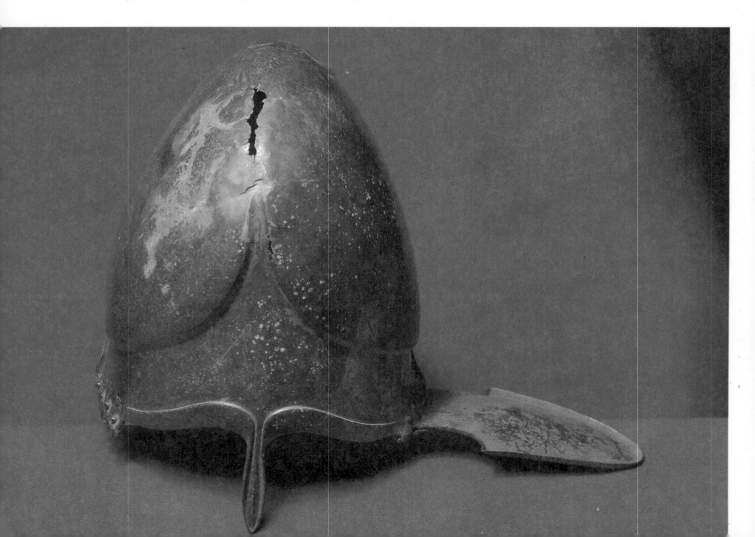

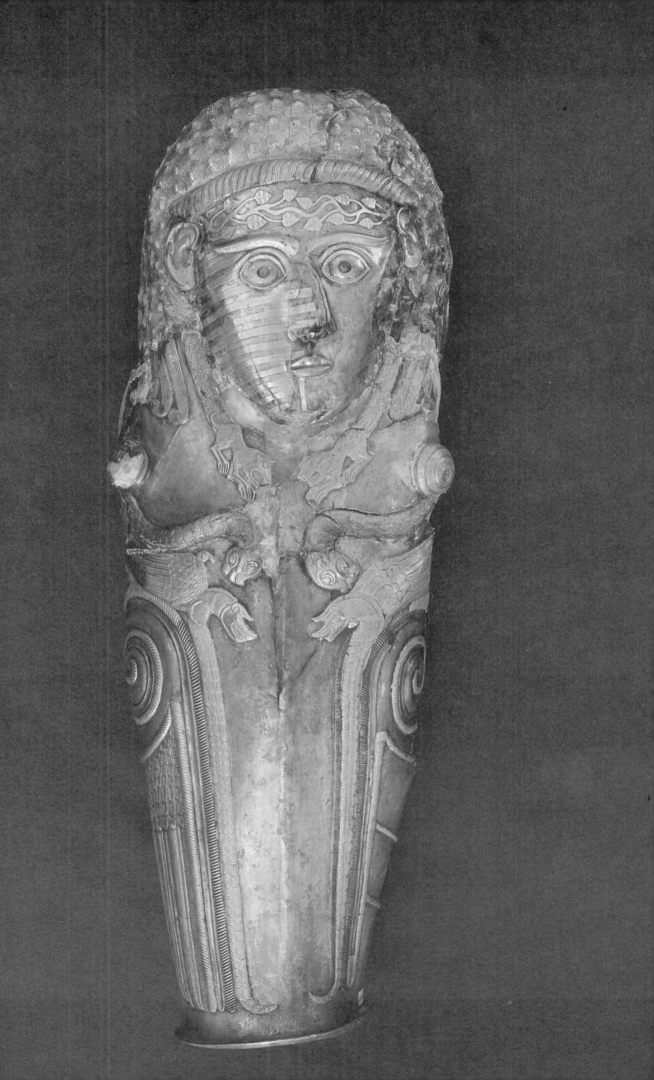

Detail from the rhyton shown on page 84.

or entire figure of an animal soldered or riveted to it. An example of an earlier type of crest-piece is that found in Sofronievo, Vratsa district, which dates to the sixth century BC. It has the same structure and basic decorative elements – an animal head and a bird's tail.

This link with the geometric style continued into the new epoch, with its teratological and anthropomorphic designs. The treatment of animal figures in the matrix from Gurchinovo shows that the artist was still observing some of the principles of the geometric style – the bodies and necks are triangular volumes with a rib in the middle, while the chest and buttocks are well rounded. These figures are reminiscent of the small deer from Sevlievo. This style persisted into the fourth century BC finding expression in the schematic treatment of animal form and in rendering parts of the body as geometric motifs. Thus the animal heads on the Vratsa appliqué and on the urn from the village of Bolyarovo, near Elhovo, were depicted as lotus flowers. This is characteristic of Phrygian art and

the Greek geometric style. So strong a tie with the old traditions can be explained by the conservatism of the Thracian craftsman and the schematic character of his work, this latter being more apparent in finds to the north of the Balkan Range.

Important in Thracian, early Greek, Iranian and Scythian art is the teratological style, by which is meant the representation of animals (not necessarily monstrosities). The term has academic approval and we shall use it, with the proviso that it refers to subject matter only. Mostly, it is used in connection with ceramics, toreutics and miniatures, being hardly ever applied to monumental genres, and then usually in the discussion of barbarian, that is to say, non-classical art. Consequently, the style is looked upon as typical of the non-classical arts, and as a distinctive feature of a specific stage in artistic evolution in general.

At one time, the teratological style was believed to be a typical feature of Scythian art. The important discoveries in the Ukrainian steppes at a time when no archaeological work had been done in

Bulgaria or Romania and, last but not least, the great prestige of M. Rostovtsev firmly established his theory of pan-Scythianism. The relics which were afterwards discovered here and there in South-eastern Europe, were said to be either the work of Scythianized Thracians or Thracianized Scythians, while the 'Thracians themselves, 'the most numerous nation on earth after the Indians', (*vide* Herodotus) were all dismissed as 'Western Scythians'. However, the numerous finds made in their lands have contradicted this theory and it is no longer tenable. Obviously, the Thracian and Scythian styles have a great deal in common; what is more, they influenced each other for centuries. They rested more or less on the same social base and drew from the same source – the Eastern civilizations, in particular that of Iran. Nonetheless, the arts of these two peoples have their strikingly distinctive features.

The horse was very much a characteristic figure of Thracian art; while bears, eagles, wolves and bulls figure frequently. So, too, do lions and gryphons, and these were undoubtedly borrowed from Persian art. The connection with Eastern art is obvious in those scenes where animals are shown round the tree of life, and one can scarcely believe that there is a difference of two centuries between the Panagyurishté phialai and some of the Luristan fibulae. Fights between animals are also depicted: lions attacking a bull (Vratsa, Letnitsa), a gryphon tearing a deer apart (Letnitsa), a stag succumbing to a lion (Loukovit), and sometimes two beasts of prey, one real and the other mythical, are locked in a life-and-death struggle (Letnitsa). If one includes the frequent representations of eagles, fishes, serpents and various mythical creatures, one gets a good idea of the iconography of the Thracian teratological style.

Detail from the rhyton shown on page 84.

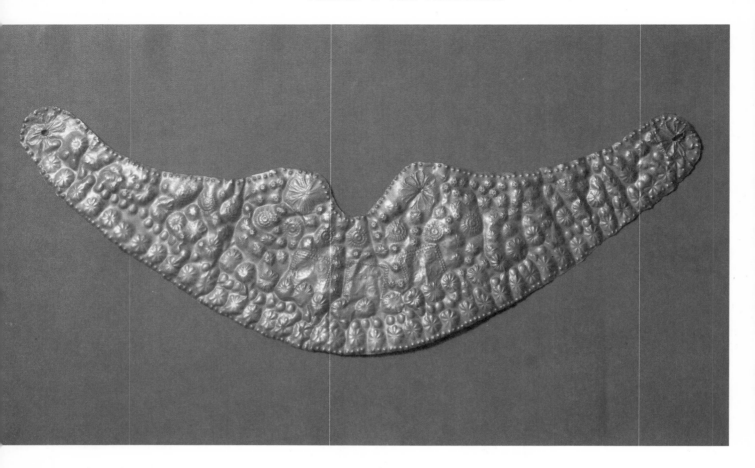

Pectoral from Duvanli. This is one of a set of two, the second of which is shown below. They were worn one on each side of the chest.

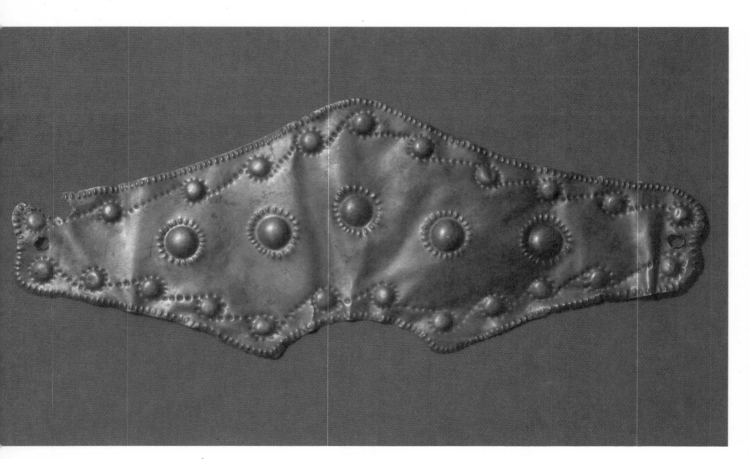

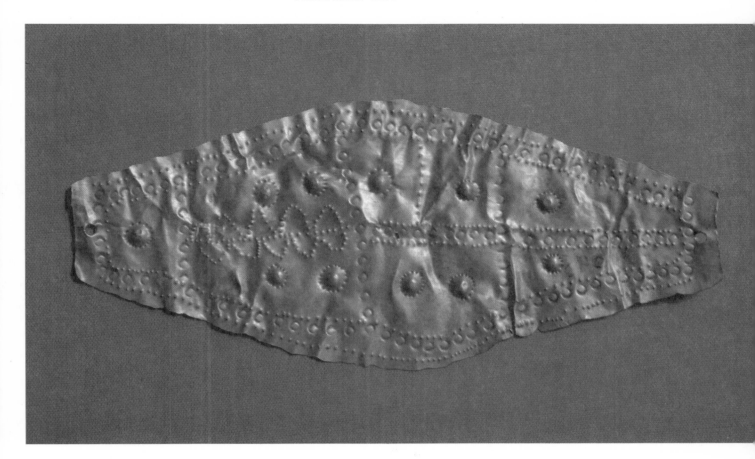

Pectoral from Duvanli.

Pectoral from Kukova Mogila.

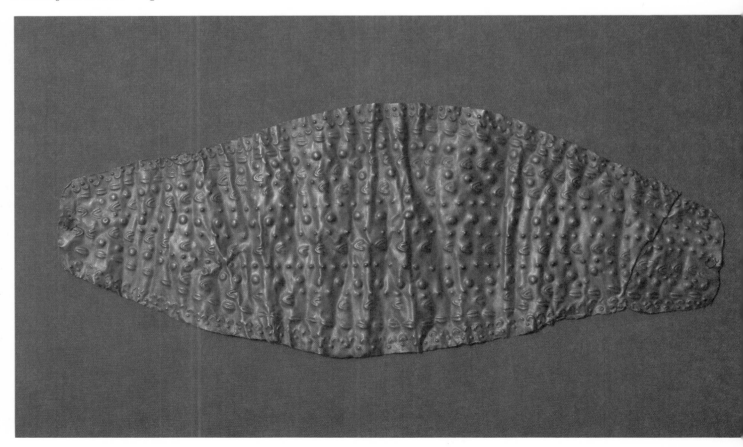

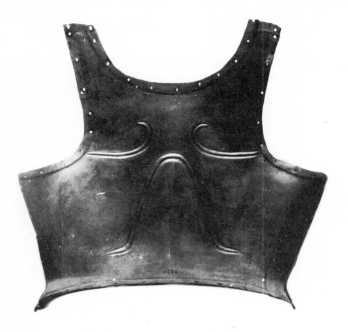

Bronze breastplate from Tarnichane. Stylized muscles indicated.

BELOW
Bronze Thracian helmet with decoration very similar to that on the helmet of the Amazon (rhyton) on the preceding page.

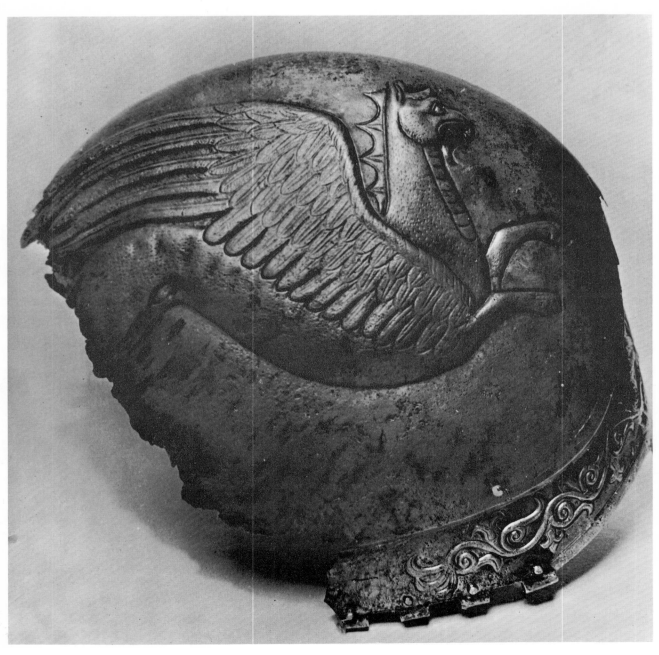

Two trends can be observed during the Classical period. In the monuments on which animals figure or those parts of them that symbolize them, they are stylized according to strictly defined rules: the figures are geometric, reduced to a flat or slightly convex surface, and their contour-lines are straight. The delineation of shape by means of a band of incisions is a characteristic technique; often the whole figure is surrounded by such a band. The shoulder was conventionalized as a figure of eight, a bird's head as an arch, a lotus flower or a spiral; the eye was depicted by a concentric circle or an ellipse; the ear became an inverted comma. Both ears were shown even when the head was in profile. The mane was represented by a row of incisions; the lion's head was rendered in full face and the four Achaemanian folds figured on both sides of the nose. The animal figure was not reproduced in its entirety, but was built up by a mechanical addition of its parts, each one of them rendered according to a set pattern. This technique made it possible easily to replace one part by another, which was characteristic of the Thracian teratological style. Thus the most fantastic creatures sometimes appeared. One may see serpents covered with feathers and having a lion's head or the front of a gryphon. What is more, the composition had to fit the shape of the appliqué. This made it necessary to render the animals in weird poses, to abandon natural forms and build a figure out of disparate parts. There was yet another requirement: the appliqué had to be set as open work. All these rules made the Thracian examples most decorative and expressive and lent them a great deal of vitality.

On the other hand, there was an attempt to portray the animal's characteristics. The artist simplified the forms, but did not use the conventional ones. One can see that he has tried to imbue it with life and movement, to lend volume to the somewhat coarse forms. The animals of the second group are less refined, but they are imbued with greater vitality. Perhaps the masters were not so experienced or highly qualified, but it is more probable that this was a new trend in the general taste, rather than a difference in quality. There are numerous appliqués of this period, however, on which the animals are depicted in the Greek manner. The Letnitsa treasure includes phalerae demonstrating all these trends which seem to have developed simultaneously. However the Greek craftsman has also borrowed the characteristic features of local art and so enriched his skill.

The trend to greater realism in Thracian art can hardly be explained by the influence of Greek artists. Quite the contrary, in portraying people, the Thracians turned to Achaemenian rather than to Greek art. From Persia they also borrowed iconographic motifs and stylistic principles. Both teratological motifs and anthropomorphic subjects were used in Thracian toreutics. Sometimes, man's

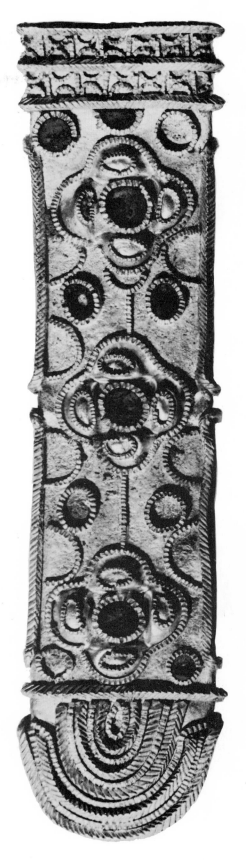

Sheath, gold studded with amber some of which has fallen out. 20·1 cm long. Eighth to seventh century BC.

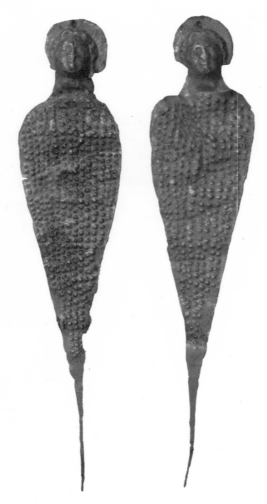

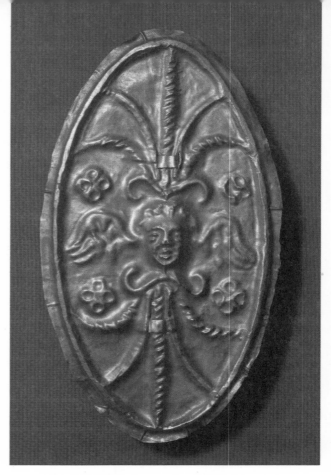

Brooch from Messambria showing personification of Zeus' thunderbolt in the head.

Two gold ornaments of the mid third century BC (Nessebur). Function unknown.

Gold ring in the form of a dragon (Messambria).

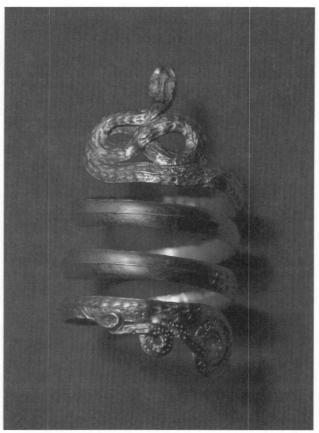

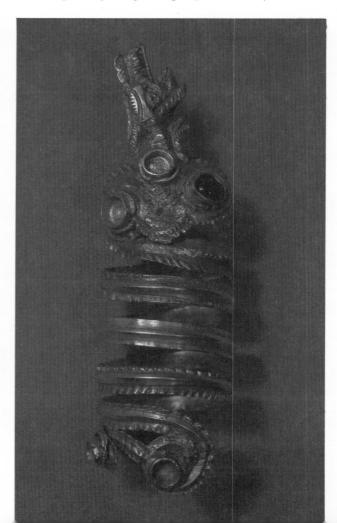

Gold ring in the form of a serpent (Messambria).

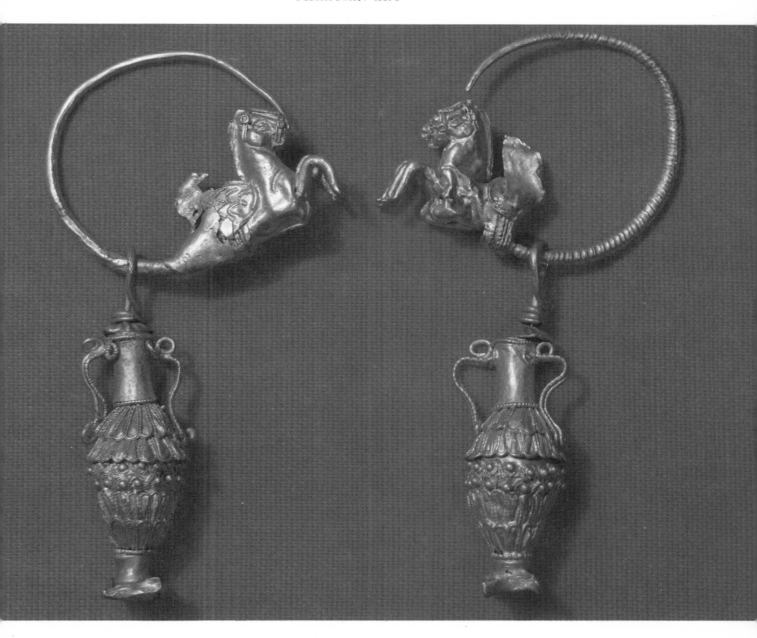

Gold ear-rings (Pegasus).

Gold ear-rings. *Gold ear-rings with maenad heads.*

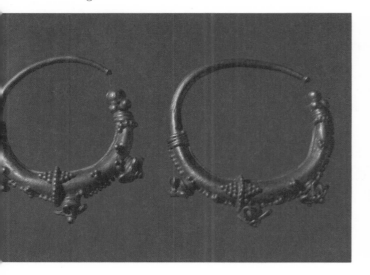
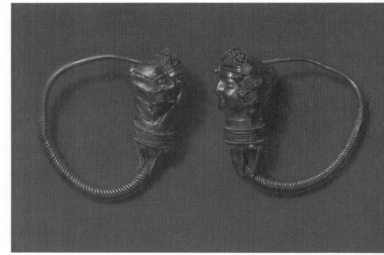

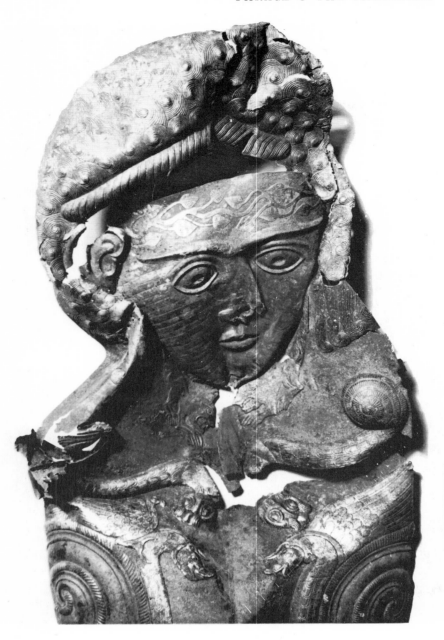

Detail of the head on the greave illustrated on the preceding page, probably that of the Mother of Gods.

Bronze greave for use on active service.

[96]

likeness was only a decorative element replacing an ornament, or was even used as a symbol. But there are a number of works in which he was included in the scene, most often fighting animals or as the central figure of an investiture. The precise ideological requirements made of toreutics led to the creation of an anthropomorphic style of representational art, which is found over a considerable area. This explains the similarity of subject between the Letnitsa appliqué and the figures on the helmets from Agighiol and Băiceni, for all their differences in style and technique. As the details are various attributes prescribed in iconography, they recur in almost all relics, thus strengthening the impression of unity of style.

There was, however, greater freedom in the latter style. Rectangular plaques appeared for the first time in the Letnitsa treasures as surfaces carrying figural compositions. The figures filled the entire surface and the scene had a border of ovules. This was a sign of freedom; until then the images were made to fit the shape of the object. In quite a few cases, the artist had had to take account of the overall decorative scheme – he placed the spear in the hero's left hand so as not to break the law of symmetry. Symmetry was the basic principle in composition, yet another analogy with Eastern art. As far as space was concerned, the artist did not observe the laws of perspective. He was prepared to break the natural flow of movement in order to show that the hero held a spear in his hand, or to exaggerate a gesture so as to indicate the significance of the offered phiale, even to place the running dog above the horse. His aim was to achieve a good visual distribution of figures and objects. The viewer was prepared to see a certain idea expressed, and that is why the master sought to achieve a picto-ideogram rather than a truthful portrayal.

Gold ceremonial helmet from Cotofeneshtill with eyes and eyebrows indicated. On the cheek pieces is a scene of a ram being sacrificed. The studs indicate curls.

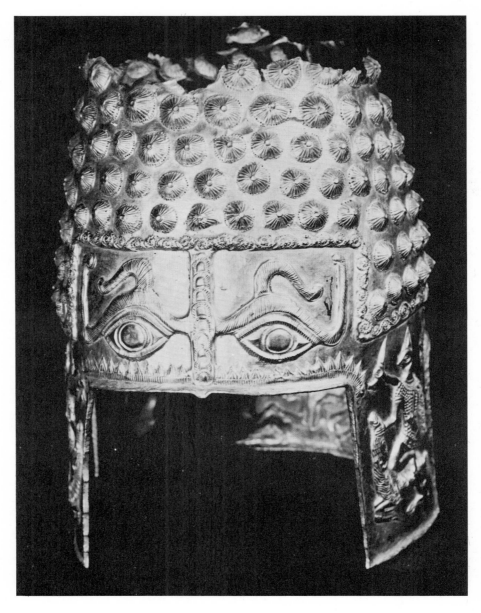

RIGHT
Bronze bracelet.

BELOW
*A necklace from Duvanli that is one of the best examples
of ancient jewelry.*

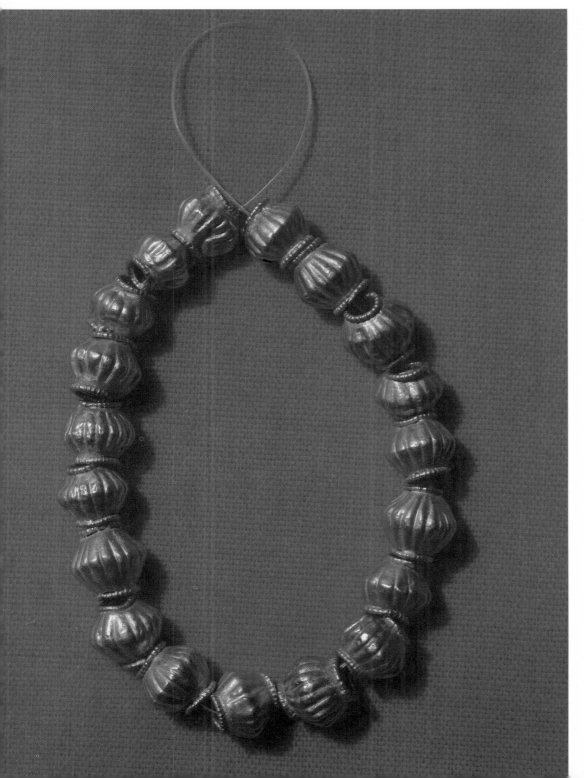

Perhaps his attention to detail was an expression of a preconceived artistic scheme. Every object in his picture was an attribute and he had to render it accurately. That is why he was less interested in portraying the figure correctly, than in depicting every detail of the chainmail and the ornaments on man and horse. To the Thracian artist and his patron it was more important to reproduce the symbol and convey its precise meaning than to have a realistic portrayal.

Thracian art is remarkably homogenous in style and iconography. Some of the pieces have been discovered in the big Scythian burial mounds, which shows that Thracian metalwork was prized in Scythia in the fourth century BC. On the other hand, the farther from the centre, i.e. Southern Thrace, these works were produced, the more they have changed. In some the iconographic types have been so simplified as to lose their original meaning and become mere ornaments. Schematization instead of stylization and an inferior technique were evidence of this remoteness from the centre. The objects found north of the Balkan Range and beyond the Danube seem crude in comparison with the exquisite appliqués from Brezovo. Compare the cruciform phalerae of the Loukovit treasure with similar finds from Agighiol, Peretu and even Craiova, and you see that the craftsman who made the latter reproduced the form without any attempt to achieve an aesthetic effect. The high aesthetic value of Thracian toreutics lies, above all, in its perfect workmanship.

As well as the works of Thracian artists embodying local tastes and ideas, many by Greek artists have also been discovered. The question is: do we have the right to regard these as Thracian? The same goes for a large number of Scythian treasures. Are the vessels of the Panagyurishté treasure Greek because a Greek master made them, or are they Thracian because they belonged to a Thracian chieftain? This is tantamount to asking if the canvases of Van Dyck's last period belong to the English school, or if the works of Picasso are a part of French culture. Particularly in those distant times the ethnic origin of an artist could scarcely have been of any great significance. The craftsmen who made the Panagyurishté vessels were well versed in the technique and standards of Greek art, but they also tried to marry them to the Achaemenian stylistic principles. Their fellow craftsmen who worked for the barbarian market used materials, forms and subjects which would please their clients. What was the nationality of the mysterious and prolific Egbeo, who spelt his name in Greek and in several different ways? He may not have been a Thracian, but it is hardly possible to exclude him from Thracian culture. His works are an integral part of the Thracian heritage, not only because in their day they functioned as religious and political attributes, but also because strong Iranian

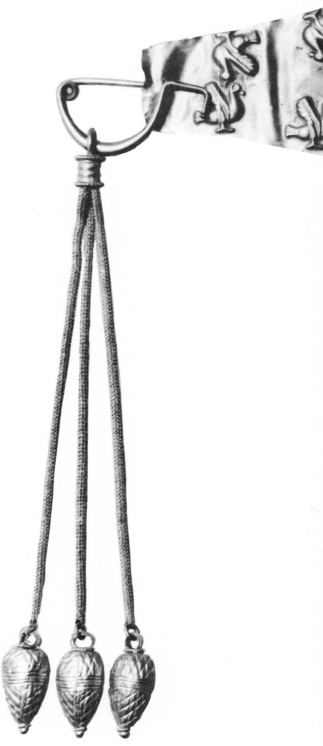

Gold pectoral from Moushovitsa decorated with pigeons and pendant acorns. There are twice eight pigeons, eight being the sacred number of Aphrodite and the pigeon her sacred bird.

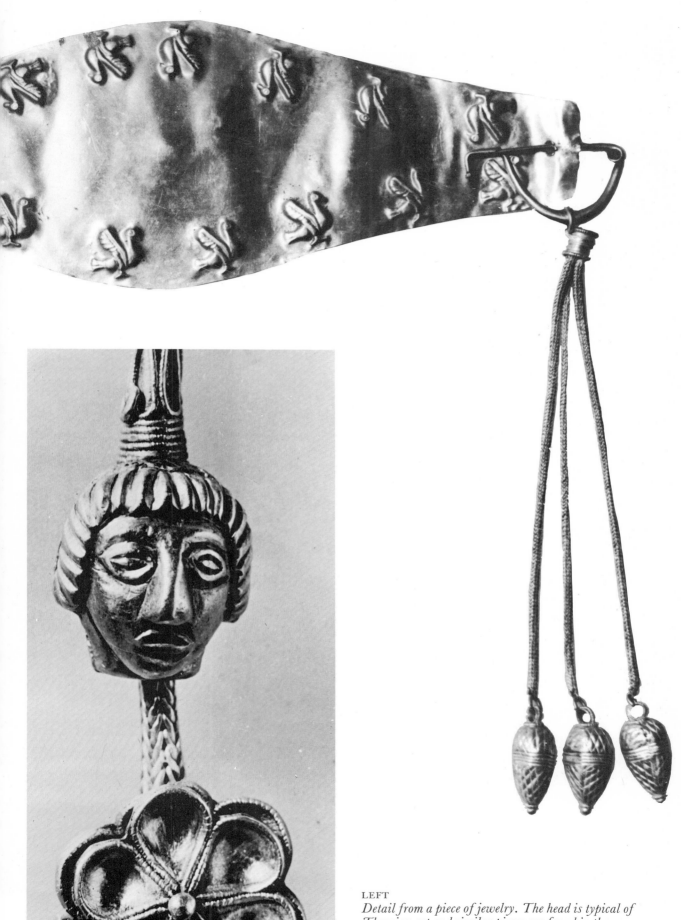

Detail from a piece of jewelry. The head is typical of Thracian art and similar pieces are found in the Loukovits, Vratsa and other treasures.

A princess's gold crown – part of the Vratsa treasure. The leaves are laurel and the veining on them is beautifully reproduced and so, too, are the growth rings where the stems have been cut. 24 cm in diameter.

stylistic elements are inherent in them and they reflected the ideological concepts of the Thracians. The same could be said of the famous murals in the Kazanluk tomb. The artistic concepts are Greek, but the main composition, arranged in the manner of a ceremonial procession, and also the difference in size between the figures, which is indicative of their hierarchic status, suggest Eastern influences. Murals conveying a similar idea and having similar stylistic features have been discovered in Asia Minor. It is obvious that when the Greeks worked for Eastern patrons they leaned towards the Persian principles, because their idea of a barbarian was equated in their art with that of a Persian. The Persian wars were a turning point in the consciousness of the Greeks; for it was then that they set themselves apart from the barbarians culturally, rather than ethnically. This, however, was not the only reason for the appearance of a Graeco-Achaemenian art in Thrace. The Greek craftsmen who worked for the barbarian market were well aware of the ideological and cultural closeness of Asia Minor, Thrace and Scythia. For this community they consciously created the syncretic style which is to be seen in the Roussé and Panagyurishté treasures, the stele of Saplidere, the murals of the Kazanluk tomb and so on. The Greek masterpieces that have been found in Scythia demonstrate the ability of the Greek craftsmen to adapt subject-matter rather than style. There are no works of art in Thrace which depict scenes of local life. All imported objects show scenes from Greek mythology, albeit ones that are connected with Thracian religious practices. The important thing is that the Greek craftsmen tried to suit the stylistic tastes of their rich patrons and were less concerned with their own preferences in subject matter. In this exchange, which gave rise to the syncretic style, the Thracians were by no means a passive party.

The Thracians began erecting stone statues of their deified rulers on their burial mounds as early as the seventh century BC, and the practice continued into the fourth century BC. Later, the material used was bronze. For example, a bronze group representing a mounted hunter slaying a boar was placed in front of the Mezek tomb. It is quite probable that many of the tombs had murals. But this scarcely entitles one to say that Thracian art was essentially monumental. Monumental art is public and meant to influence people, and is therefore placed where it can be seen. That is why it can develop only where there is urban life, a centralized government and institutionalized religion. In Thrace, these existed only in a rudimentary form. The centre of public life was the king's residence, which was often moved from one place to another. Some cult ceremonies were no doubt held near the deified rulers' mounds, but one cannot possibly speak of an organized religion of the type known in Greece and Egypt. The most important events in Thracian political and religious life were the hunt and the sacrificial rites and feasts. The central figure in all these was the king-high priest, and only a chosen few participated. This gave toreutics the widest scope of all the arts, for its products fulfilled a basic function in that they symbolized the economic and political power of the chieftain. Even the precious metals of which they were made became a sign of distinction. That is why the Agathyrsi wore gold jewellery (Herodotus). The prestige of a chieftain would suffer, were he to be deprived of the precious vessels on his table, or of the pectoral and

The Lovets belt: at either end are two mounted hunters with attendant archers hunting two boars around the tree of life (see pages 21 and 41).

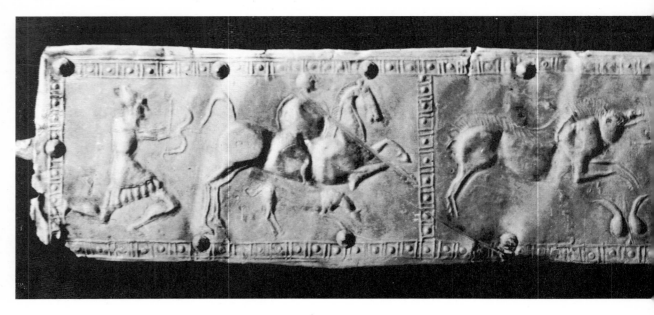

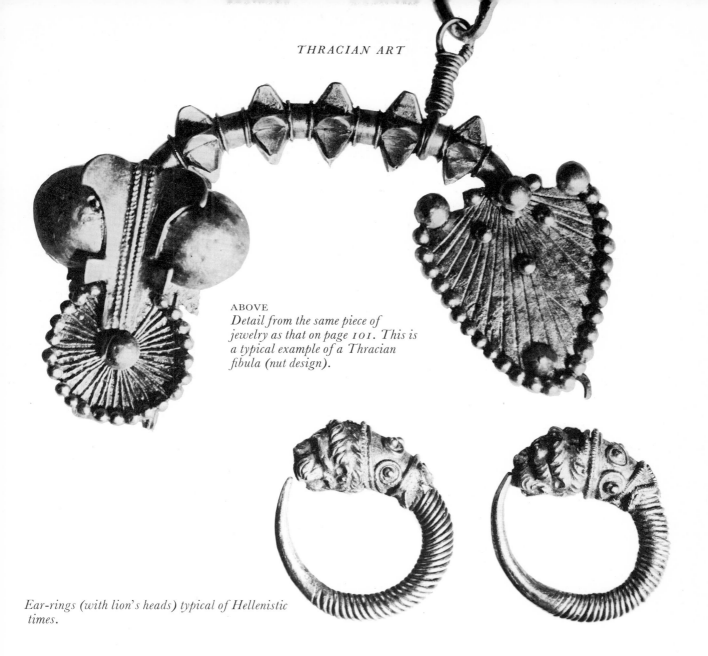

ABOVE
Detail from the same piece of jewelry as that on page 101. This is a typical example of a Thracian fibula (nut design).

Ear-rings (with lion's heads) typical of Hellenistic times.

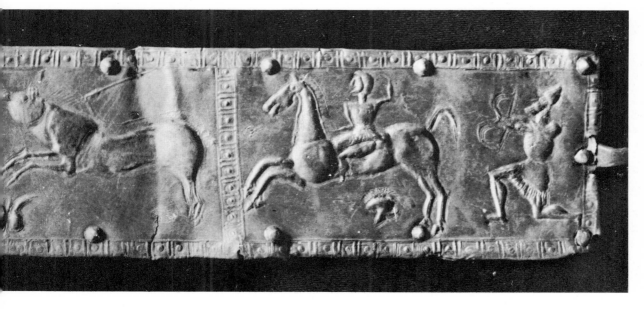

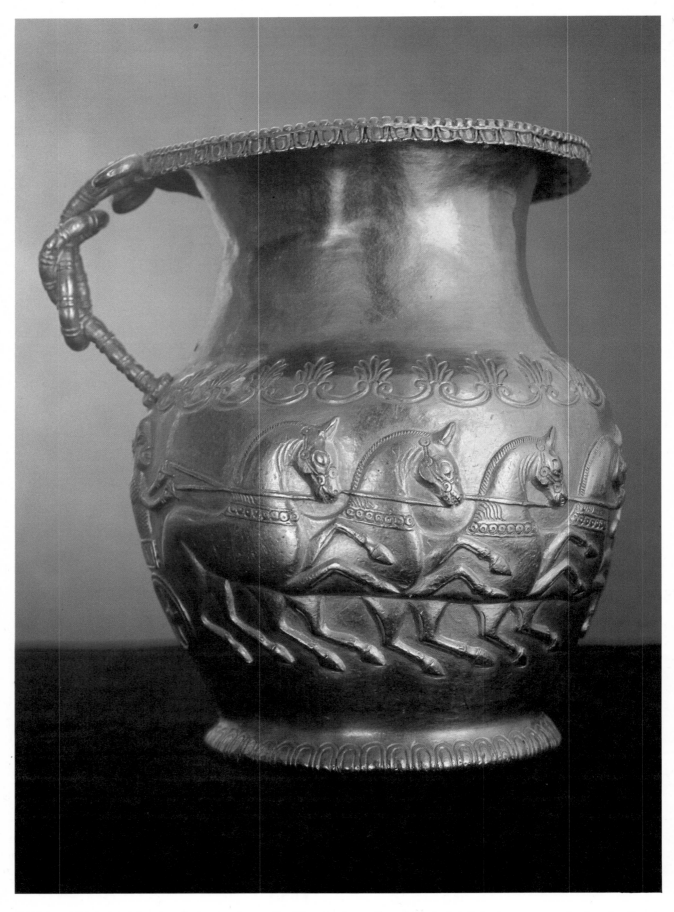

Gold jug (Vratsa) with a handle in the shape of a Hercules knot. Round the body of the jug are two chariots heading in opposite directions. The horses' bridles are ornamented with round plaques.

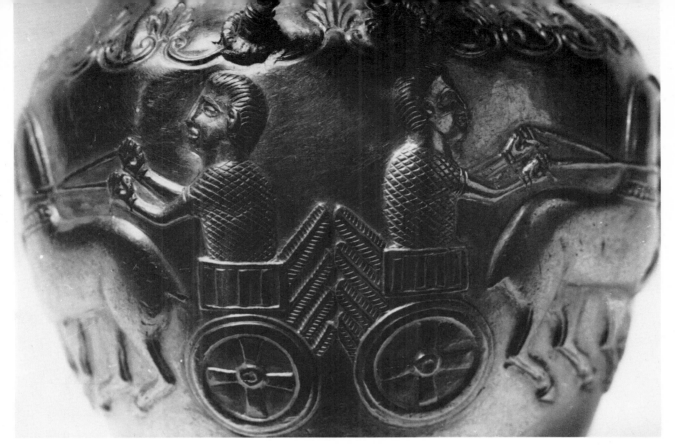

Detail from the jug opposite showing the two chariots (winged), perhaps that of the solar god.

A further detail of the Vratsa jug.

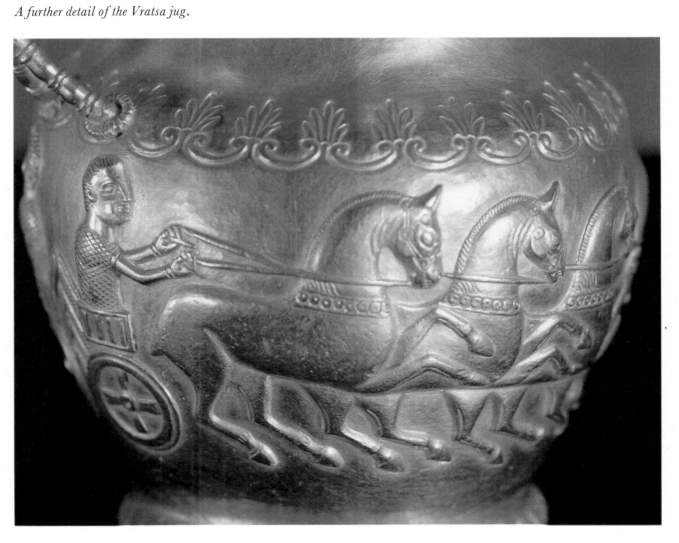

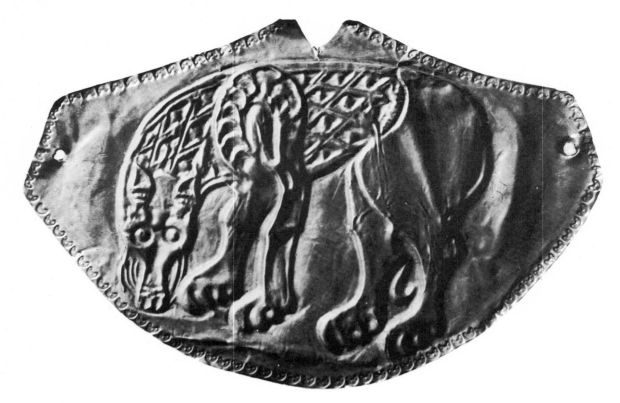

Gold pectoral from Duvanli that is one of the best examples of the Persian influence on Thracian art. The mane and tail show the animal to be a lion.

Detail from the bronze matrix from Garchinovo. A splendid example of the animal style.

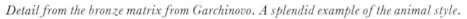

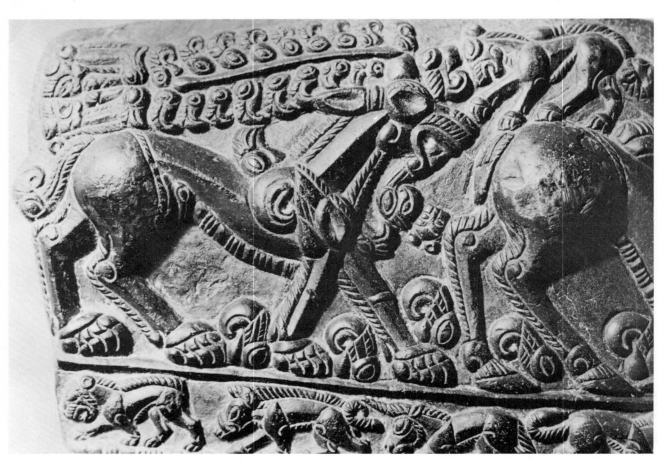

Appliqué, one of two plates that went on either side of a suit of chain mail. In the centre was a third appliqué with the head of Medusa.

Plate from the Roussé treasure depicting an
animal fight.

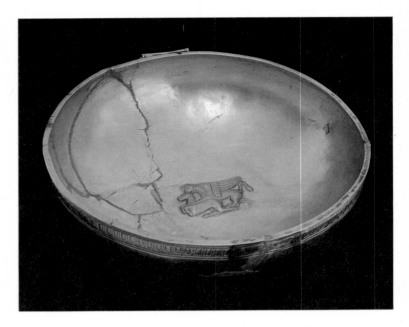

BELOW
Silver cup from Yakimovo, depicting the
Thracian horseman.

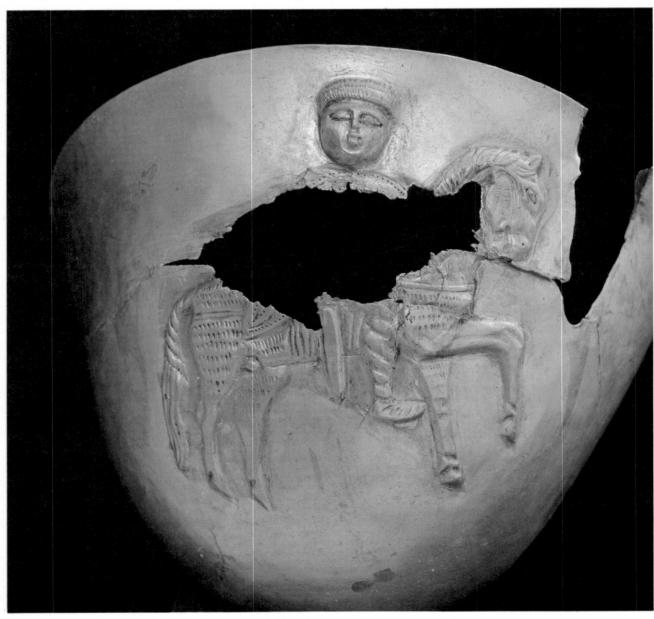

Detail from a gold phiale in the Panagyurishté treasure. The negro heads are evidence of the interest in different peoples that is typical of Hellenistic art.

Silver phiale from the Loukovits treasure.

Silver jug in the shape of a pine cone (Vratsa). Height 14 cm.

Details from the Dionysus rhyton (Roussé treasure); Silenus with his thyrsis carrying, perhaps, a wine-sack.

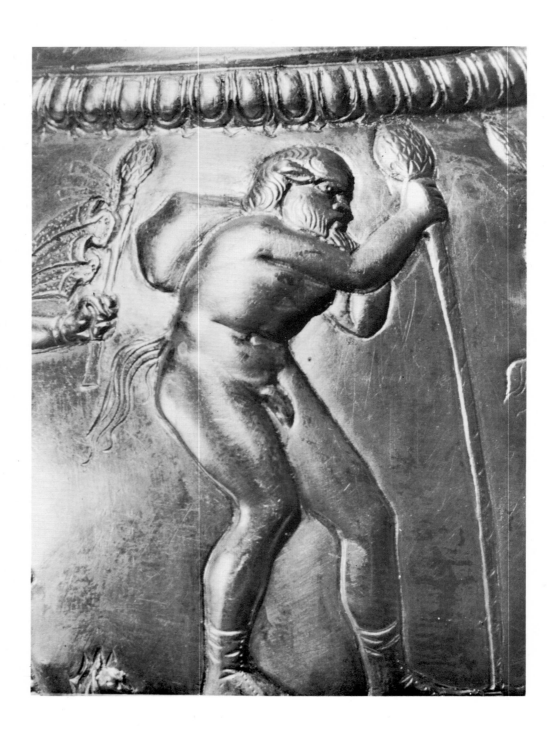

Running satyr with a branch of ivy in either hand, next to him a maenad playing a flute. Below, Ariadne is holding a ribbon (perhaps of marriage). Beside her is winged Eros.

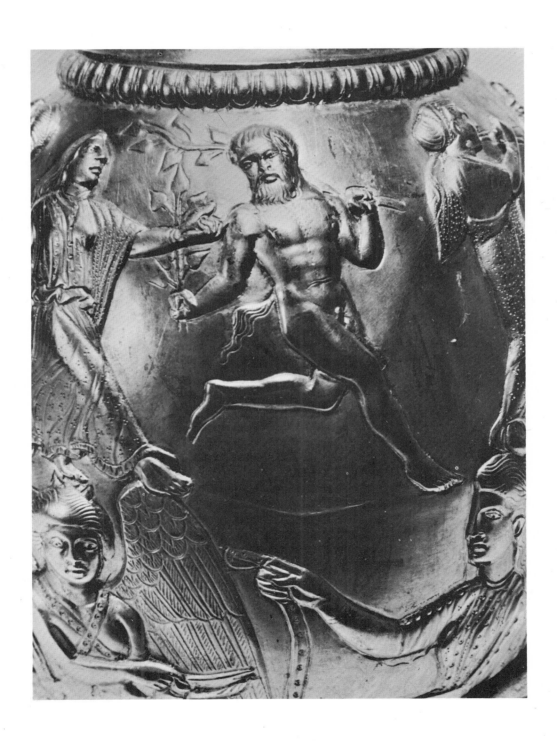

Satyr with thyrsis pursuing a maenad with a sword, while (below) Eros dances.

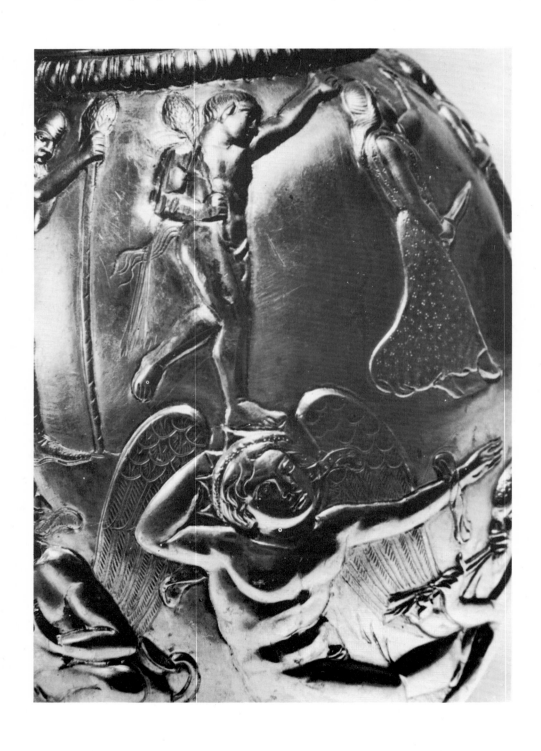

Probably Dionysus and Ariadne with two participants in the mysteries; then a
maenad pursuing a Silenus. Beneath, Eros with a jug is preparing to fill a phiale.

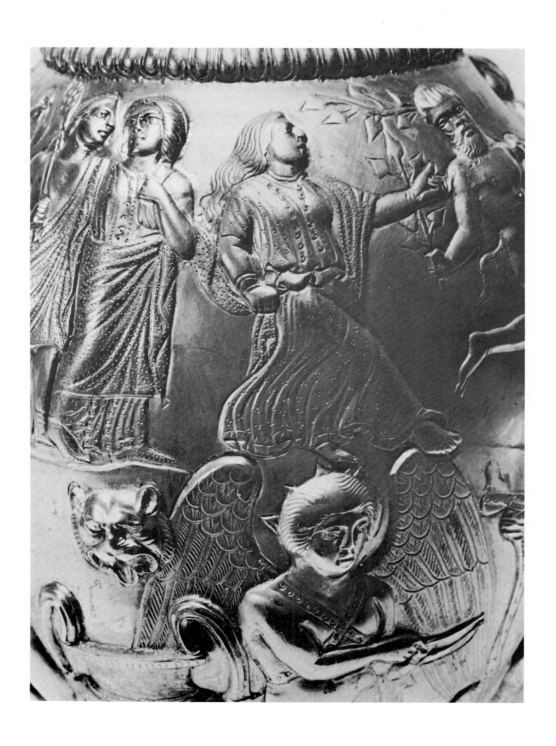

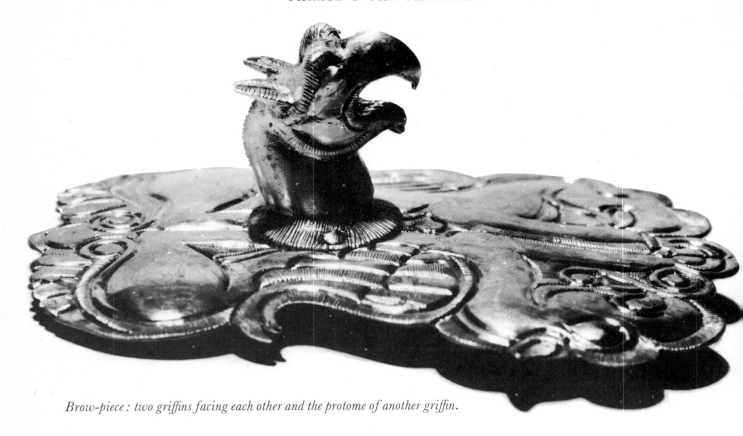

Brow-piece: two griffins facing each other and the protome of another griffin.

phalerae that added brilliance to his attire, or of his ceremonial helmet and greaves and the rich trappings of his horse. This is the picture which Homer paints for us of the Thracian king Rhesus: 'I saw his coursers in proud triumph go, swift as the wind and white as winter snow. Rich silver plates his shining car infold, his solid arms refulgent, flame with gold. No mortal shoulders suit the glorious load, celestial panoply, to grace a god.' The noble Thracian had to present himself in the other world with all these valuable possessions, and so he was willing to pay a fabulous price for them. Just the gold that went into the making of the Pangyurishté treasure would have paid for a year's maintenance of 500 soldiers.

As the ideology of kingship developed, both the objects associated with it and their ornaments became signs of social status, and so one finds, alongside the teratological motifs which originated in the old clan relationships, the anthropomorphic style making its appearance because its subject-matter expressed the enhanced role of the aristocracy. It was natural that such images should be incorporated into the insignia of power, and that was the reason why it was only toreutics that were thus decorated. Images appeared on pottery, too, during the Classical period, but only occasionally. Works of art were made for the aristocracy and therefore reflected its ideology.

The Achaemenian elements whose presence has

been correctly pointed out by I. Venedikov, were in no way an indication of backwardness or of a lack of artistic genius, but proof that Thrace was part of the ideological world of Asia Minor, Persia and Scythia. There were many analogies between the religious and political concepts of the Thracians and those of the peoples inhabiting these regions. What is more, Thracian trade was mainly oriented towards the Persian world. The standard of Thracian coinage was adapted to that of Persia. Many coins from Asia Minor have been discovered in Bulgaria, and Thracian coins have been found in Asia Minor. Having accurately grasped the similarities between Thracian and Persian commerce, Thucydides described Thrace as having the economy of a satrapy. There is no doubt that the Thracian kings modelled themselves after the Achaemenian King of Kings, and that they took over many characteristics of the Iranian ideology of kingship. Because of this similarity in economy and ideology, Iranian art had an influence on Thracian art. It was not so much a direct influence, as an analogous way of visualizing ideas.

The social base of art in Ancient Thrace was very restricted. If the small circle of the ruling aristocracy had disappeared all of a sudden, Thracian craftsmen would have been out of work, for there would have been no one of political or economic consequence to need the insignia of privilege. This, in fact, did happen about 280 BC, when the Celts

invaded the Balkan Peninsula. Thrace was ravaged and subjugated and its social structure replaced by the kingdom of the Celts. It is quite probable that most of the treasures that have been found were buried in those turbulent days. Several decades of this foreign domination spelled the end of an art tradition of long standing.

Some of the Thracian aristocrats salvaged some if not all of their wealth by fleeing with it to the Greek colonies. It is possible that this influx of Thracian money saved some of the Pontic colonies from economic ruin at what was a time of general crisis in South-eastern Europe. But, as was so typical of Thrace, quite a few assets were frozen in tombs as grave goods. The stone tombs of wealthy Thracians discovered in the Mesambria (Nessebur) necropolis have yielded a fair number of gold earrings, clasps and rings. These jewels are made in the old traditions and, in many cases, show affinities with contemporary pieces found in Thessaly. The rings are shaped like coiled snakes, the earrings have pendants showing the front part of Pegasus and the clasps are decorated, some even with scenes. Many are obviously of local craftsmanship. The figures in the scene on one clasp are rather heavy and their movements clumsy. The composi-

Cheek piece (horse-trapping) depicting a fight between a lion and a griffin, with snakes.

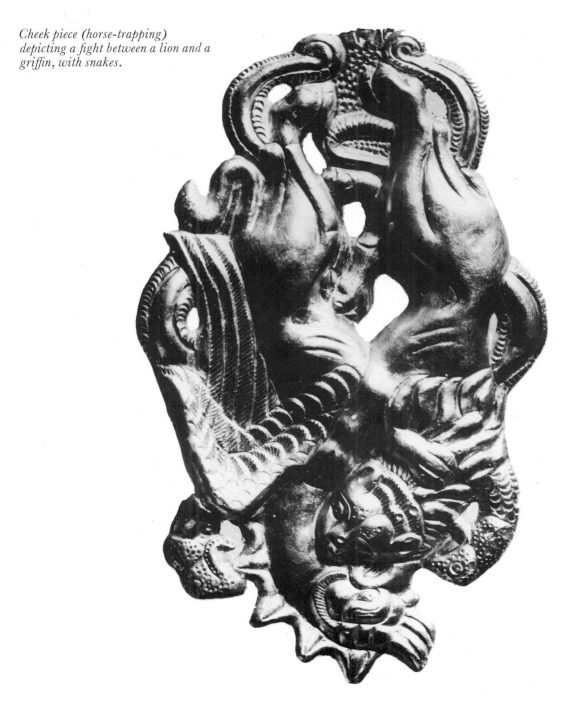

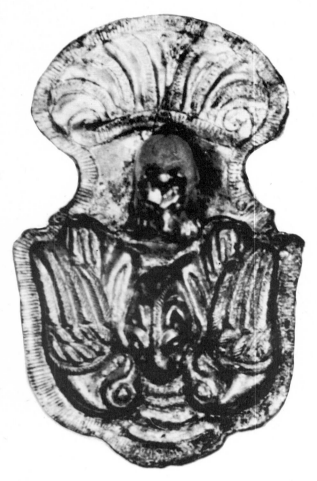

Brow-piece from Chomina mogila in the USSR and another (OPPOSITE, TOP) from Sveshtari, where the motives are the hero (or the Mother of Gods) with two eagles (symbolizing royal power) and a lion's head.

tion is arranged horizontally and all the figures are depicted in profile, that is to say, the craftsmen have resorted to some of the principles valid in Thracian toreutics early in the third century BC. Some objects discovered in Apollonia (Sozopol), and dated to the end of the third century BC, show iconographic types and stylistic features which were to be used widely in Thracian toreutics a century later. There are two gold phalerae with busts of Athena and Aphrodite, the appliqués fringed by a cord-like ornament, that are particularly noteworthy.

By the end of the second century BC, this type of work was widespread – from Macedon in the west, to the Crimea in the east and the Carpathians in the north. The appliqués from Yakimov and Galiché (Bulgaria), Herăstrău (Romania) and Yanchokrak (Ukraine) show female busts in full face, with heavy features, wide open eyes and full lips. The representations of the hero on horseback was also very widespread, only now he was not depicted in action. Also his weaponry had changed: instead of a spear, he carried a long sword. His garments, too, were different: he wore a long cloak, leggings and torques around his neck. Some stylistic changes can also be seen. The figure is three-dimensional, but inexpertly constructed and without much artistry. The sculptors have paid too much attention to the detail which they often rendered in engraved or dotted lines. In contrast to the simplicity of the Classical period, these appliqués are overcrowded, as if the artists felt obliged to fill every available space. They probably believed that this made the plaques look richer and more splendid. This was the reason why they also gilded the entire surface. Gilding was no longer used to emphasize the main aspect of what was being represented, but as a simple decorative device. These changes, however, were not only due to a deterioration in taste and craftsmanship. In that period, the image had lost its significance as a sign of social distinction, for it had now begun to appear on pottery, which was considerably cheaper. To maintain its social function, toreutics had to enhance those of its aspects which gave the impression of splendour, brilliance and wealth. All this can be seen in the phalerae from Stara Zagora, with their intricate scenes in the teratological style. One of these appliqués depicts a fight between a man (probably Heracles) and a lion. The hero is not only strangling the lion, as on Greek representations, but is also thrusting a knife into it, a characteristic feature of Eastern art. There are similar phalarae in several museums in Western Europe and they must have come from Anatolia.

Cone-shaped silver bowls were common during the late Hellenistic period and many have been found in Thrace. Some are devoid of ornament (Bohot), others (Sîncrăieni, Romania) are decorated with engraved and gilt braiding, spirals, acanthus leaves, feathers, beads or dots. The

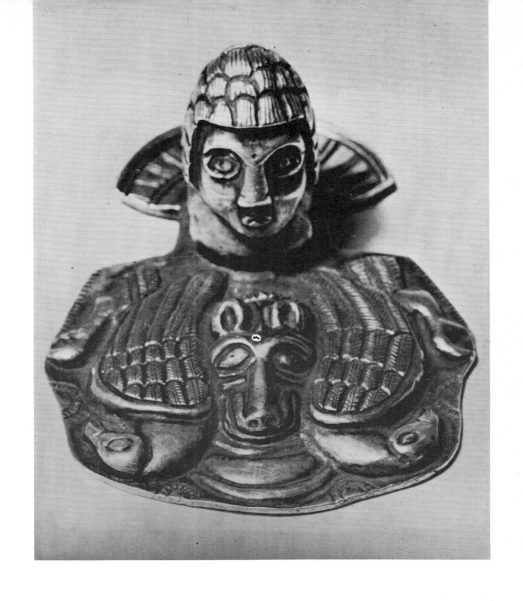

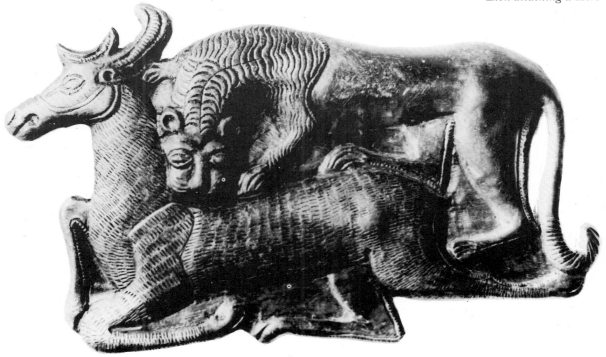

Lion attacking a deer.

Appliqué on a bronze hydra from Messembria depicting the rape of Oreiteia by Boreas.

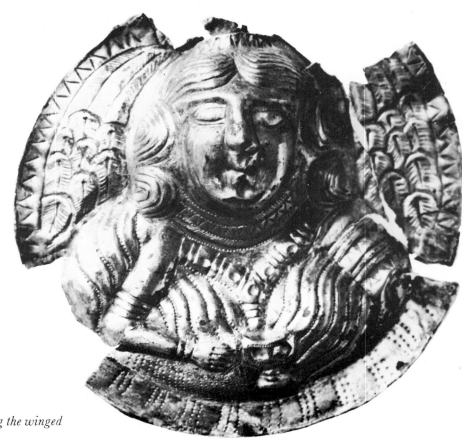

Another appliqué, this one depicting the winged Mother of Gods.

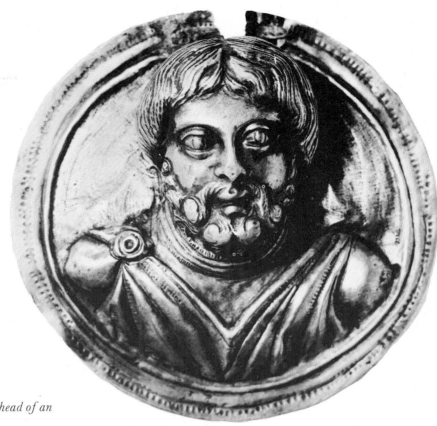

Appliqué from a metal cup, showing the head of an unknown man.

Phalera depicting the Thracian horseman.

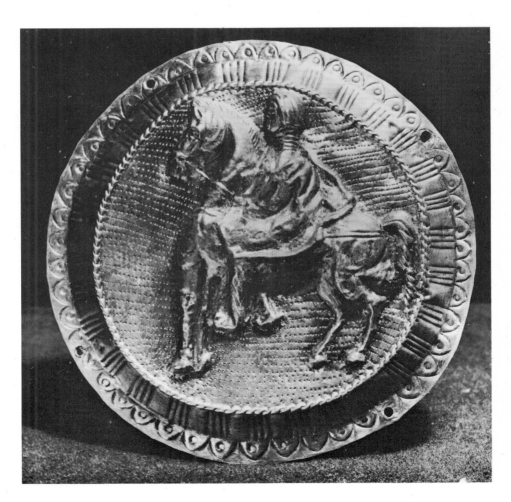

[124]

The Thracian horseman, depicted on a gold ring.

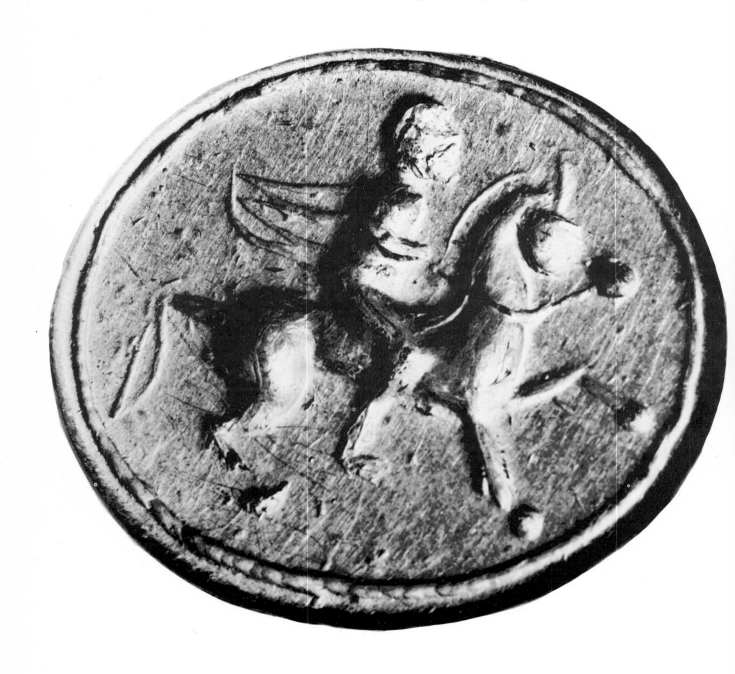

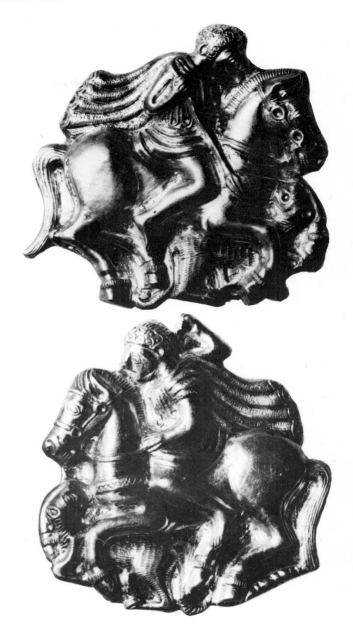

Two appliqués showing the Thracian horseman.

numerous phalerae are decorated in much the same way. These, too, are often convex in shape and resemble the bowls. They also have a wide border. Their ornaments are very lavish: acanthus leaves or a wealth of overlapping rosettes, spirals or cymes, a type of decoration borrowed from pottery. The ornaments on the Megara cups, very popular during the period, are like this. Jewellery (fibulae, torques, bracelets and rings) is simple in form and decorated with the same plant motifs, conventionalized animal forms or geometric designs.

For a long time the toreutic objects of the late Hellenistic period found in the Carpathians and north of the Danube were called Sarmatian, as occasionally they still are. It was thought that the Sarmatians, who had invaded the region, had brought this art with them. This was a repetition of the error which led to the pan-Scythian theory. Then another theory was advanced: all these objects, similar in form, iconography and style, were Dacian, for this was the period when the Dacian kingdom was at its most flourishing. Neither theory is correct, as has now been established. The vast territory over which these works of art were so uniformly distributed was never in its entirety invaded by the Sarmatians, or ruled by the Dacians, but it was populated by Thracians and had been since remote antiquity.

Some of the iconographic types, of course, were evolved in the Pontic cities of Southern Thrace; others, such as the horseman, continued the old Thracian traditions, while individual pieces are reminiscent of the Thracian part of the Classical period. So it is, probably, more correct to assume that this was not a new art, but rather a new stage in the development of Thracian art. The restoration of the country's political independence after the ousting of the Celts at the end of the third century BC, gave it a new lease of life as the circumstances of the local aristocracy gradually improved and they were again able to enjoy and encourage art. Although this never attained the richness, brilliance and variety of the Classical period, it did fulfil the same functions and, had circumstances allowed, it might have achieved real brilliance. However, no

sooner had the Celts been driven out, than a new threat loomed in the south west, where the Romans were launching their offensive on the Balkan Peninsula. Brave as the Thracians were, they were also weak and disunited and unable to save their country. The Romans fought their way to the Danube and in AD 46 Thrace became a Roman province. Thus began a new stage in the development of Thracian culture. Although complex and interesting, it lacked the originality that had characterized it from the end of the Bronze Age. The appearance of the Romans ushered in an era of intensive syncretism, yet the Thracians stuck to their traditional religious beliefs and outlook. No matter where fate took them as soldiers of Rome, they carried with them the image of their hero. They dedicated reliefs to him in Africa, Syria, Italy and England. The mysterious horseman galloped through the ages and the lands as a proud symbol of the eternal Thracian spirit.

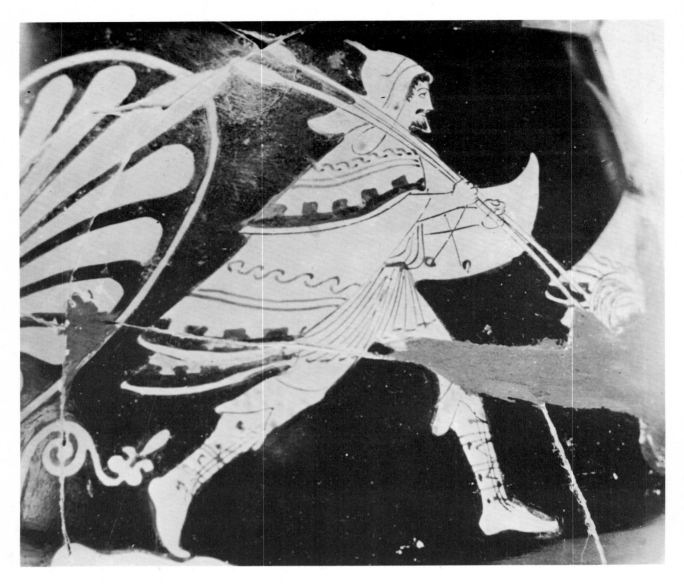

The Greek idea of the Thracian. Details from red-figure vases showing Thracian warriors, on foot and mounted, with typical shield, hat, cloak and two spears.

Silver jug from the Loukovits treasure.

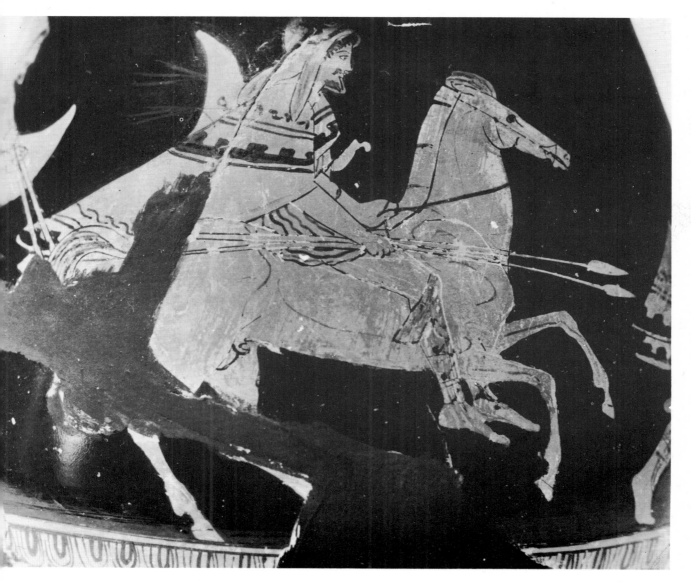

Coin of Seuthes III with the king's head.

PART II

ALEXANDER FOL

Gold medallion depicting a sphinx with two bodies.

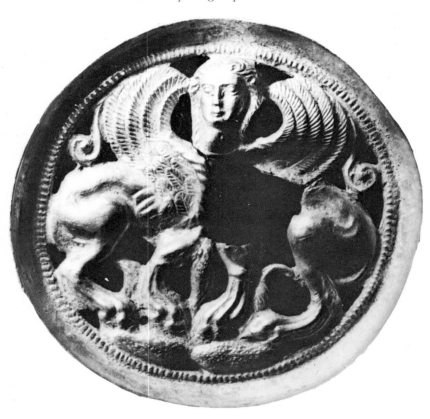

4

ORIGINS & HISTORICAL DEVELOPMENT

THERE ARE TWO theories to explain the ethnogenesis of South-eastern Europe: one that of multiple migration, the other that of uninterrupted development of indigenous populations. The former is based on the presence of vestiges of Indo-European languages in records (at a fairly late period) and on the hiatuses between the different phases of occupation found at some of the sites that have been excavated. The theory is that several waves of immigrants from the north flooded South-eastern Europe, that is to say, Greece and Thrace, to form ethnic groups of Indo-European origin. The two most important of these waves being in the second millennium BC one early on, the other at its close.

Neither theory is proven: to prove that the migrations had taken place, it would be necessary to undertake excavations at all archaeological sites in the territory in question, and this has not been done.

The mere fact that the oldest recorded language vestiges in South-eastern Europe are of Indo-European origin does not mean that other tongues were not spoken earlier. Indeed, the lateness of the recorded sources makes it quite probable that they were. No matter what dating is given to these vestiges, they go no further back than the Bronze Age, that is to the third-second millennia BC.

The second theory, that of indigenous development unobstructed by immigration, is also difficult to accept because in Antiquity, and the pre-classical period in particular, the development of productive forces was not possible without the movement of tribal groups. In this movement, often taking the form of war, the tribal groups accumulated means of production and instruments of labour (tools, weapons, land and valuables) on a much larger scale than they would have done in a permanent habitat in the same span of time. This was axiomatic in an age when war was a way of life and plunder the surest and most expeditious means of social differentiation. It is not possible to imagine in any other way the formation of a society such as, say the Mycenaean, at a time when the productivity of labour was so low.

In fact, the two theories reflect two different aspects of the ethnogenetic process, for in the territories in question evolution was not only continuous, but was actually accelerated by the arrival of immigrants and by displacements of population that speeded up the process of tribal consolidation and strengthened the economy and the social system. This consolidation was of great significance for the so-called 'dark centuries' in Greece, which were even darker in Thrace. It was the northern seafaring peoples, as they are called in the Egyptian sources, who took part in the second great migration of the peoples, known as the Aegean migration, which broke up the big empires of the Bronze Age, ushering in a period of transformation and reorganization of the entire economy and population densities of Thrace and South-eastern Europe, a reorganization necessitated by the introduction of iron. Use of this new metal meant that both the indigenous population and the newcomers had to look for new places to settle in, had to provide new lines of communication from them to the old mining areas, and had to break new land and till it under conditions of more intensive production.

The level of Neolithic civilization within the confines of what was to become Thrace was high. One imagines most settlements having a rectangular plan and being subdivided into rectangular residential areas. It was a farming economy with a very high level of social stratification. The settlements were well planned; some had fortifications of ramparts and palisades; they produced beautifully decorated pottery and finely sculpted figurines of idols. Archaeological finds from the end of the Neolithic Age are extremely rich and would seem to indicate that there was some form of military-political organization, headed by a dynasty, though this has yet to be confirmed. It is a suggestion supported by the finds made in the excavations of the royal burials in Varna dated to the end of the fourth millennium BC.

There is an apparent hiatus in the development of the population inhabiting the territory of Ancient Thrace between the Eneolithic and Bronze Ages; or rather, such a hiatus has been established

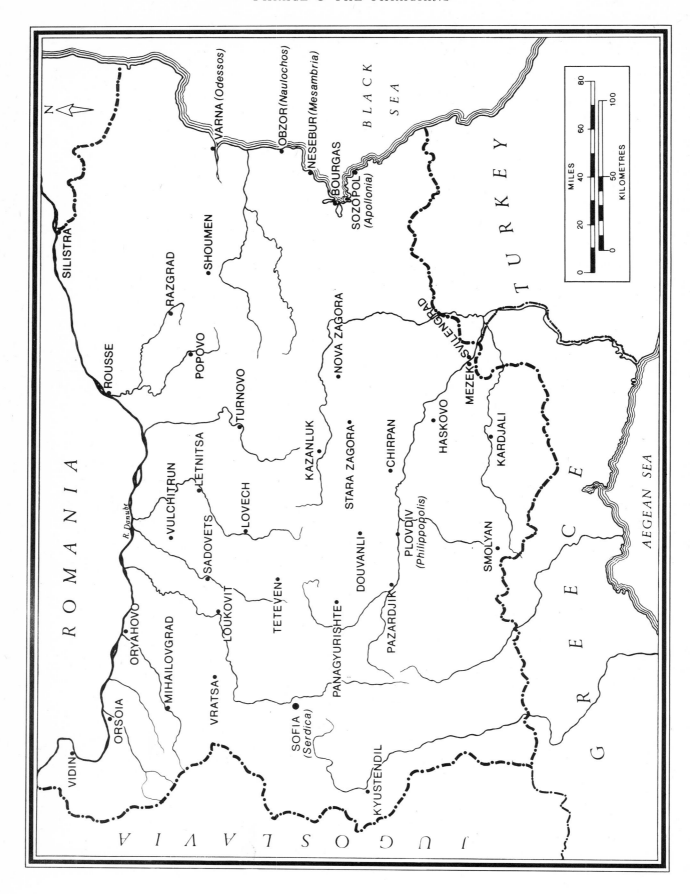

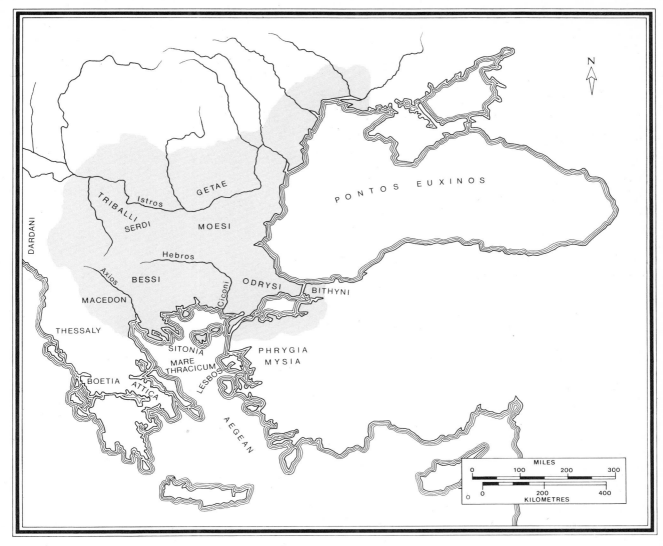

TRIBAL AREAS OF THRACE

OPPOSITE
ANCIENT THRACIAN SITES IN BULGARIA

for some regions; but it cannot be inferred that this is true of all other areas. Archaeologists have yet to find a link between the Eneolithic and Bronze Ages and we have no certain knowledge of how the transition from the use of copper to that of bronze was effected. We must presume that this was an uninterrupted development, since copper was mined in Thrace on a large scale and sold or bartered in vast areas of Northern Europe and in the present territory of the USSR. Thracian copper could easily have become the basis of bronze alloy as there were many ores in the mountains of Southern Thrace containing tin and lead.

Archaeologists maintain that the marked difference in the quality of pottery during the Eneolithic and Early Bronze Ages, that of the Eneolithic being, of course, superior, as well as the adoption of the apsidal type of dwelling, indicate a change in population.

The change in quality of the pottery is of no great significance. It was just one of the results of the new economy brought about by the introduction of bronze, which focused the efforts of producers on the manufacture of weapons and implements of higher quality. The change to apsidal dwellings was not characteristic of the whole area, but it was a change for the better, the apsidal type having advantages, particularly that of the apses usually facing north.

The more important indications of a difference in population are the observable changes in the burial customs, and the appearance of the horse. In Antiquity, the corpse was placed either in a foetal or a horizontal position to be buried, or it was cremated. Archaeologists see an ethnic difference between peoples who interred their dead in a foetal position, who cremated them and placed the ashes in urns, and who buried them. This is hardly accurate.

Indo-European burial customs include all three types, which are identified with the cult of the home hearth, the symbol of family continuity, of the

Clay vessel with a lid in the form of a water bird. The incised ornamentation is encrusted with white. Height 8·2 cm.

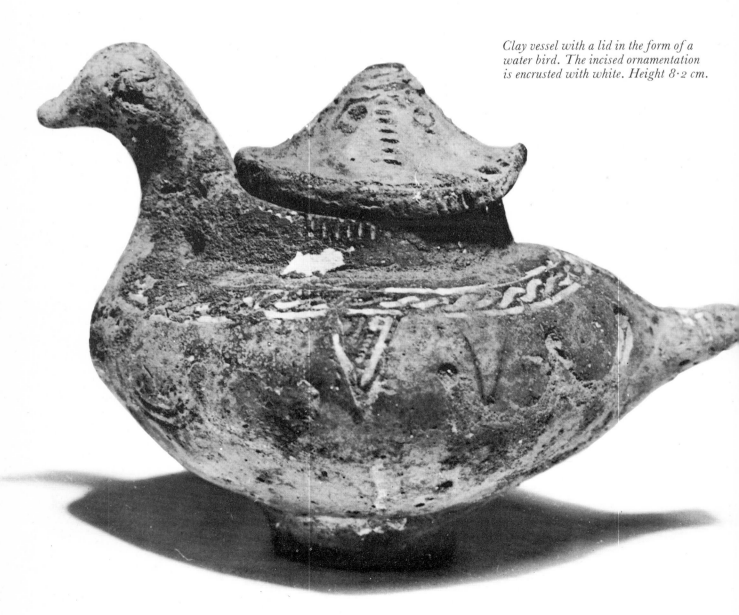

Clasp for a belt in the geometric style. Bronze.

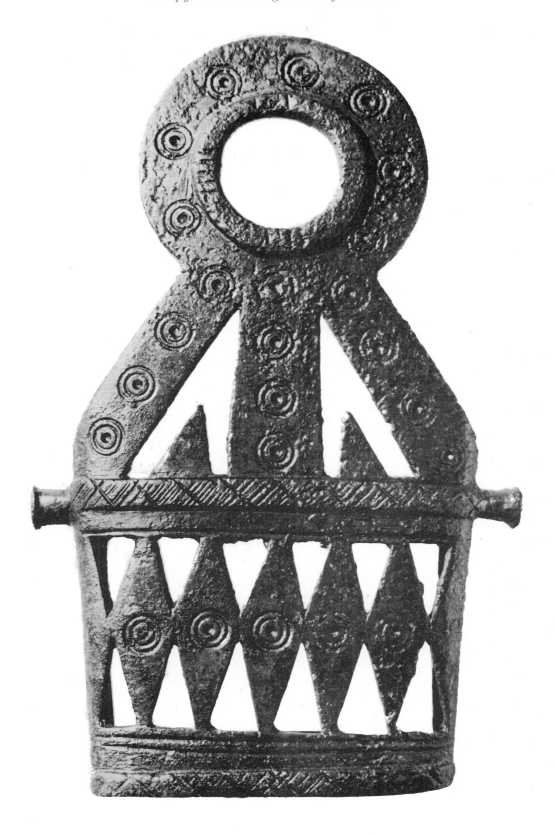

Hearth altar at Seuthopolis.

Mould for making sacrificial axes, dating back to the end of the Bronze Age.

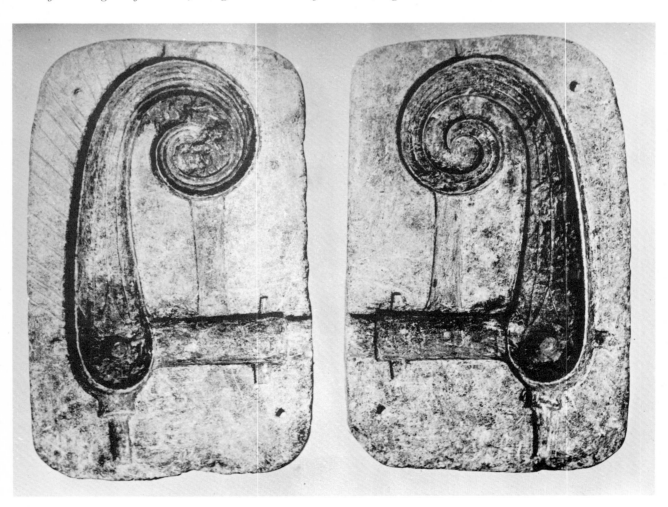

Reproduction axe made from the mould opposite. The ornamentation is very similar to that on the handles of the Vulchitrun treasure.

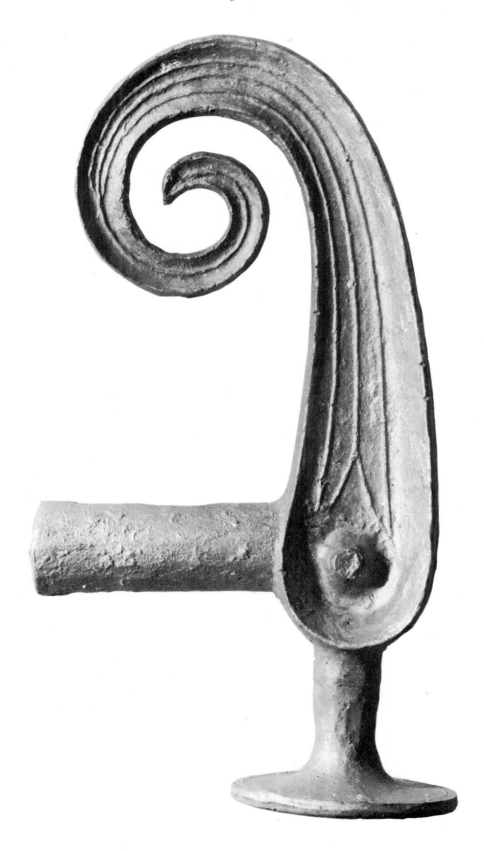

Votive relief of Thracian horseman. The snake in the foreground suggests that he is here depicted as Pluto.

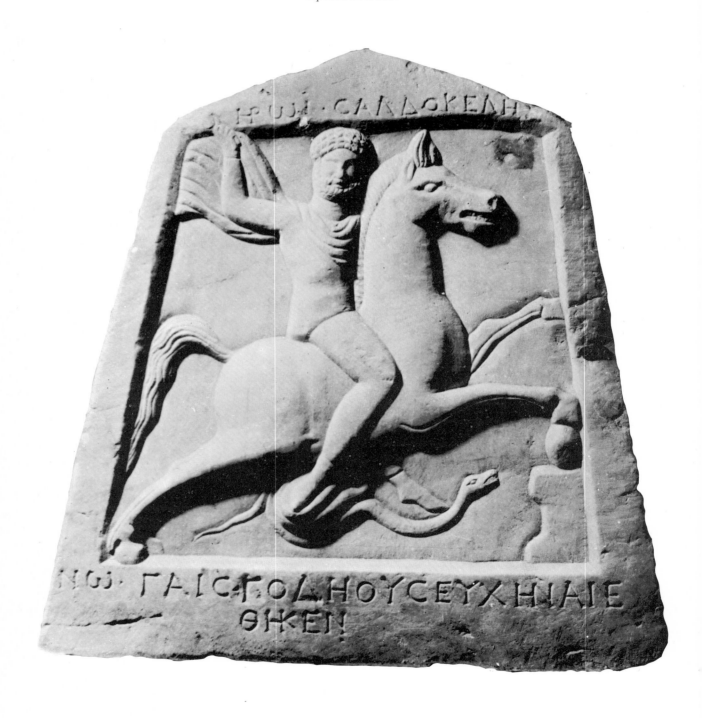

earthly elements and of those obtained by the fusion between earth and fire. Late Greek mythology shows that the cult rituals of cremation and burial had the same weight. In the same way, a newborn infant was either placed near the flames of the symbolic fire or on the earth next to it, thus closing the cycle. As regards burial in which the body was placed in a foetal position, it is obvious that this embodied the idea of the cyclic aspect of life, which sprang from the Great Mother of Gods and ended with her in the earth.

The appearance of the horse in burials is the final proof that the population of the Ancient Thracian lands had been replaced by Indo-European newcomers from the north. The horse is thought to have been first domesticated in the southern steppes of present-day European USSR during the third millennium BC ca 2500, that is to say later than the supposed change of the population in Thrace. But to think that the horse had a single place of origin is tantamount to believing that man's birthplace was none other than the Middle East, a theory that has been shattered by the evidence of man having made his appearance simultaneously in many places both in Europe and Asia.

We must conclude that there was no hiatus between the Eneolithic and Bronze Ages; such gaps as there are in our knowledge being due to inadequate archaeological research. Remembering the activities of the indigenous inhabitants, particularly those of the ore- and gold-mining regions, and of the new arrivals who gave a strong impetus to economic reorganization and the development of the productive forces, it is much more likely that the ethnogenetic process was quite advanced during the Bronze Age.

Certainly, there was no marked interruption in life between the second and first millennia BC: the Iron Age continued to use the tools of the Bronze Age, as it did some types of weapon and pottery. Some Bronze Age ornaments continued to be used during the first millennium BC. Nor did the plan of dwellings change; the fortification system was developed and the communication network extended to meet growing needs. Even though the ethnic process continued (ending only with the probable migrations of the Bithynians to Asia Minor and of the Cimmerians from the north to the south by the middle of the seventh century BC) the term Thracian can be used of the people of the Bronze Age, but it is impossible to fix the date of the consolidation of such a numerous people as the Thracians. It may even be that there were only a few periods of relative calm prior to the advent of the Romans.

From the end of the Bronze Age onward, the general ethnonyms may be used in the relative identification of tribal groups, relative because, as was pointed out earlier, the ethnonym is determined by external factors, unrelated to the group of people to whom it is attached. The two most important of these factors are: the indirect way in which the term reached us after its adaptation to Greek, and the political power of the bearers of the ethnonym. It is this power which determines the area over which the ethnonym is valid. This is reflected in the Greek sources. Also, the political power is linked with the concept of the dynasty, as was shown in an earlier chapter. The period after the third century BC saw the decentralization and decline of the great Thracian states, and that is why in Homer and Herodotus one finds only the general ethnonyms of compact groups of population, while Strabo and the Roman writers name a large number of Thracian tribes.

In Homer the name of the westernmost tribal group, the Paeones, was applied to the territory along the lower reaches of the Vardar, in Herodotus it was applied to the valley of the Strouma, and in Thucydides, it even included the upper reaches of the Strouma. The explanation of the change is the decline of the great Paeonian state union at the end of the Bronze Age. According to Homer, over fifteen Paeonian chieftains and their men took part in the Trojan War, a period when the area between the valleys of the Vardar and Strouma was most densely populated and its inhabitants the intermediaries in the transmission of ideas and objects between north and south. The great Thracian centres of the geometric style and sub-Mycenaean art flourished here between the sixth and third centuries BC. In this fertile area, states of the Mycenaean type were formed at the end of the Bronze Age, headed by kings who must have enjoyed all the prerogatives of power. We know nothing about the break-up of the Paeonian tribal group and no new ethnonyms emerged during decentralization, for the simple reason that the territory was formed into the state of Macedon, after which no other names appear in the sources.

The northern neighbours of the Paeonians were the Dardanians, the latter ethnonym being directly linked to that of the Mysians. The name Mysian was first mentioned by Homer in a text which was later used by Strabo, who says that Homer had in mind the European, not the Asia Minor Mysians. Strabo will have known about the European Mysians, who lived in north-western Thrace, between the Danube and the Balkan Range, from information provided by Roman officers on the staff of Marcus Licinius Crassus, who campaigned in 29–28 BC against them and defeated them, it is believed, near the village of Archar (ancient Ratiaria) in Western Bulgaria. No writer between Homer and Strabo mentions the Mysians of Europe, though their presence in Asia Minor is attested by toponyms and language enclaves. The latter could have belonged to the so-called Daco-Mysian language which is applicable to the

western and north-western territories of Thrace, as well as to the area between the Danube and the Carpathians. In any case, it belongs to the Thracian language group.

Herodotus says that the Mysians and the Teucrians moved to Europe from Asia Minor, and this is corroborated by the more numerous traces of Mysians in Asia Minor. In our opinion, the Mysians travelled the classical road and reached the valleys of the Vardar and Strouma during the second, or Aegean migration of peoples at the close of the second millennium BC. But their migration could not have been very significant, if this great and ancient tribe remained unknown to all writers after Herodotus. Another tribe, the Triballi, who are known to have lived in north-western Bulgaria, invaded the south and east where for some time they evidently dominated other ethnic groups. Traces of their name are met with as late as the Roman period, but by then their might was a thing of the past. Actually, it was the descendants of the Moesian settlers the Romans encountered. The name Moesian was the most popular because it was the oldest and for this and other reasons the Romans named their two Danubian provinces Moesia.

We believe that the case of the Dardanians was very similar. Linguistic evidence of their presence in Asia Minor is much more convincing than that which refers to their presence along the upper reaches of the Vardar. Also there had been a migration, apparently of Phrygians, whose name appears in later literature about Thrace as Briges, from the valleys of the Vardar and Strouma to Asia Minor, which scholars think took place before the Trojan War. It is difficult to imagine that such a populous, great, aggressive power, which had captured the Hittite capital of Hattusas (present-day Boghazköy) should suddenly have decided to up sticks and move. It seems more probable that Briges-Phrygians was the composite name of a large group of tribes with a specific material culture.

Homer mentions the Cicones, who lived in Maronea along the Aegean coast, between the lower reaches of the Mesta and the Maritsa. This group of tribes is mentioned extensively in the two epics, for it displayed great military prowess in the Trojan War. Homer also mentions the Thracians of the Hellespont and all the other neighbouring peoples who were allies of the Trojans.

The general ethnonym of Thrace and the Thracians, is the Greek form of a toponym, a local name that gradually spread over a large area, which eventually came to be known by it. This probably lay along the Straits, the dividing line between Europe and Asia. It can be argued that it was along the lower course of the Strouma, whence came King Rhesus, whom the *Iliad* lists among the allies of the Trojans, telling us that his weapons were as rich and splendid as those of the Aechaeans.

This is an area where early contacts were made between the Greek and Thracian worlds; yet Homer's information suggests that the zone we are looking for was the Hellespont. That part of the *Iliad* that tells about Rhesus is a later insertion, and the king seems to be rather a composite figure representing the powerful Thracian chieftains in the area during and after the Trojan War. To the Greeks the king's wealth was explained by the rich gold and silver deposits of Mount Pangaeus, which were first worked by the Greeks in the days of Pisistratus, the Athenian tyrant of the sixth century BC.

Informative as the *Iliad* is, what it tells us still leaves large spaces blank in the ethnic map of Thrace, especially in the north; yet by the end of the sixth century BC most of these gaps had been filled in by new ethnonyms found first in the logographers and later in the Ionian geographers and in Herodotus. These new ethnonyms were the result of tribal group movement which resulted in new tribes achieving relative military and political predominance, and thus attracting the attention of Greek observers. The Getae were first noticed in North-eastern Thrace and beyond the Danube at the time of the settlement of Greek colonists on the western coast of the Black Sea. The distant echoes of the new power of the Triballi were heard by Herodotus, who was the first to mention them. Later, Thucydides referred to them though indirectly, as worthy rivals of the Odrysae.

Herodotus was also the first to mention the Odrysae. According to him, they lived on the banks of the Artiscus (probably the river Arda). The Odrysae lived in South-eastern Thrace, roughly in the triangle formed by the Toundja, Arda and Maritsa near Edirne. One can scarcely doubt that the great megalithic civilization to which the dolmens and rock tombs in the Eastern Sakar, Rhodope and Strandja Mountains bear witness was that of the tribal group to which the Odrysae gave their name in the fifth century BC.

The Bessi are first mentioned in Herodotus. They belonged to the tribal group of the Satrae (Rila and Rhodope Mountains); it would seem, however, that this dynastic, priestly family was never able to establish its sway over the entire mountain population, at any rate up to the time of Polybius, though it was the guardian of Dionysus's famous sanctuary in the Rhodopes. The most frequently used name for this mountain population from Thucydides to Tacitus, was Dii.

The appearance of new ethnonyms can be explained by the political upsurge of some dynastic families and the greater amount of information which the Greek observers began to receive after the colonization of the Thracian coastline. The appearance of these new ethnonyms coincided with the disappearance of some of the old ones, but this does not necessarily denote a change in the ethnic

Design of another fireplace/altar from Seuthopolis. The decoration of snakes and ivy berries, is very similar to that of the Vratsa greave. The altar was perhaps dedicated to the cult of the Mother of Gods, who was protectress of the hearth.

Ground plan of the palace of Seuthes at Seuthopolis, which is now at the bottom of a reservoir.

composition of the country. The name of the Paeonians continued to exist, but obviously the territory over which they exercised political and military control had shrunk, its border moving northwards, first along the valley of the Vardar and then along that of the Strouma. This was due to the thrust of the Macedonians, who lived along the lower reaches of the Vardar, and of other Thracian dynastic families in South-western Thrace. The name of the Satrae also disappeared, as did others.

According to Xenophon, the Thyni lived along the southern slopes of the Strandja, quite close to Byzantion. Herodotus informs us that the Bithynians, who lived along the Strouma, moved to Asia Minor, where they gave their name to a new region that became a Thracian satrapy and, later, an independent Thracian kingdom of the Hellenistic type. According to others, however, the Thyni and the Bithynians lived in Asia Minor on the southern shore of the Black Sea, near the bay of Izmit. The Thyni were closer to Europe and the Bithynians farther to the east. Now, even though this contradicts Herodotus, is it a more accurate picture of the situation, analogous to that of the Mysians who migrated to Europe from Asia Minor? Why should it not be possible to assume that some tribal groups had crossed the Hellespont to Europe and settled in the nearest fertile region? If the name of the Thyni was applied to that territory in the times of Hero-

dotus and Thucydides, and if the Thyni were conquered by the Odrysae in the reign of Teres, the founder of the Odrysian state, it is impossible that the tribe's name should not have been mentioned by these two writers. It is most probable, therefore, that some tribal groups which had migrated eastwards from the valley of the Strouma to the north-western part of Asia Minor, had been given a Thracian name that was well known in Asia Minor.

Thus it seems that the historical geography of the Thracian tribes underwent changes between the close of the second millennium and that of the sixth century BC; after which the map became relatively stabilized for the next few hundred years and up to the beginning of the Hellenistic crisis and the invasion of the Celts. One has the feeling that the region was very much like a seething volcano, that there were constant demographic movements, and that considerable masses of people were all the time on the go. At the same time, the migration process should not be overrated. Many writers tell us that in the seventh century BC the Cimmerians crossed Thrace along the western coast of the Black Sea and invaded Asia. The same writers maintain that the Cimmerians left a trace on Thrace's material culture, and that they were followed by several tribes such as, for instance, the Treres. This is an example of overrating the migration process and its rôle in Thrace. According to Thucydides,

the Treres lived in the Sofia plain, but there is no mention of them in later literature. That Late Hellenistic writers mention them with the Cimmerians is not evidence, as they are eight centuries removed from the period in question. On the other hand, the Cimmerians were of uncertain origin and their civilization cannot be clearly distinguished from that of the Scythians. In any case, the seventh century BC invasion of Asia Minor by the Black Sea tribal groups was not effected along the north and north-west coast, part of which was called the Getae desert, but across Colchis and along the east coast. That route was shorter and led to the supposed Cimmerian settlements.

In 341 BC Philip of Macedon crushed the resistance of King Kersebleptes and although the Odrysian royal family continued to exist, the territories under its control shrank to the upper reaches of the Toundja. There the Odrysian dynasty stabilized its position and Seuthes III founded his capital of Seuthopolis, near present-day Kazanluk. Other dynastic families or those related to the Odrysae also consolidated their power and formed small states. This process of political decentralization continued after Philip of Macedon and, in spite of the show of force of Alexander the Great in Thrace, the country never fell under the control of the Macedonians; they just maintained garrisons at three or four points. The political decentralization came in the wake of the political crisis, which was a repercussion of the social crisis in Greece and South-eastern Europe, and was aggravated by the presence of the Macedonians, the campaigna of Lysimachus at the end of the fourth and the beginning of the third centuries BC, and the Celtic invasion.

Every tribal chieftain set up a dynasty, many of them short-lived. Often the people left their old settlements, primarily in the mountainous stock-raising regions, and moved to the plains and the rich towns, or to the Greek colonies along the Thracian coast. That is why the Hellenistic writers up to the time of Strabo and Pliny could name some eighty tribes.

The picture was further complicated by the Thracian *strategiae* (military-administrative districts) of the Hellenistic type. Pliny the Elder writes that there were fifty strategies during the late Hellenistic period, probably meaning the first century BC, and the first century AD, when the Romans intentionally increased the number of the strategies in order to affiliate larger numbers of the Thracian aristocracy to their rule. So far, inscriptions have yielded the names of thirty-three Thracian strategies. Claudius Ptolemy also throws a little light on the situation. According to him there were fourteen strategies in Thrace in the second century AD. The explanation advanced for this discrepancy is that after stabilizing their position, the Romans reduced the number of strategies to fourteen. Then, early in

the second century AD, in the reign of Emperor Hadrian, the strategies were abolished altogether, and Roman military-administrative units of town and village territories were introduced instead.

The strategies in Claudius Ptolemy occupy three parallel belts stretching from west to east: the area between the Danube and the Balkan Range; Central Thrace along the Maritsa valley to the Bay of Bourgas; and the Aegean coast and its hinterland. The nuclei of these strategies coincided with the ethnic division of the country during the Hellenistic period and are important as they indicate the ethnic and political centres of the country after the decline of the Odrysian kingdom. The westernmost strategy in Northern Thrace was Serdice with the Sofia plain as its nucleus; this was the old territory of the Triballi. The next strategy was Usdicesice which occupied the central part of present-day Northern Bulgaria. Important royal treasures from the Hellenistic period have been found there.

According to Ptolemy, the nucleus of Selletice was to be found near the site of the future Roman city of Marcianopolis by the Devnya river, in present-day Varna district. An inscription has placed the strategy of Rhysice to the north of Selletice with a probable nucleus in the future Abritus, present-day Razgrad. These two strategies were the tribal, military and political centres of the Getae group.

Ptolemy's map shows the natural nuclei in the territories of the tribal groups which, in their turn, included numerous smaller areas that could also be the centres of military, political and state life. They were situated along the Isker and the Strouma, along the Mesta, along the Toundja and the Maritsa, on the Black Sea coast north of the Balkan Range in the lands of the Getae, and south of the Balkan Range – between the Bay of Bourgas and the Sea of Marmora.

Ptolemy's divisions accent the idea that Thrace was divided into vertical zones. The easternmost of these was the west coast of the Black Sea from the Sea of Marmora to Apollonia across the Strandja Mountains, and from Apollonia across the eastern Balkan Range to the lower reaches of the Danube, and as far afield as the Dnieper-Dniester region, where archaeological finds have provided sufficient proof of a Thracian presence. The second vertical zone begins at the Maritsa-Toundja confluence, crosses the Balkan Range north-west of Kabyle, near present-day Yambol, through the Vratnik and Tvurditsa passes to the valley of the Yantra to reach the Danube. The third vertical zone goes up the Strouma and Mesta, also reaching the Danube along the valley of the Isker. The westernmost zone runs along the valleys of the Strouma and Vardar.

Thus a map is obtained, intersected by parallels and meridians which were the arteries of the Thracian tribal territories and in which the pulse of history beats vigorously.

5

SOCIAL & POLITICAL HISTORY

WHEN AN ATTEMPT was made using epigraphic material and statistics of immovable property in cities like Rome and Constantinople to estimate the composition of the population of the area between the Carpathians and the Aegean during the Roman period, which would have given us an idea of the manpower available, it became obvious that it is scarcely feasible to determine demographic balances for Antiquity. Nevertheless, certain things can be established with some degree of certainty.

In the case of the Thracian dispersion, there are more or less reliable data for the Hellenistic period and, particularly, for Egypt, where a list of settlers' names can be compiled from papyri. Other sources are the Roman inscriptions, especially those of the early dynasties like the Severi. Either source provides a list of roughly five hundred names for Egypt (between the fourth century BC and the fourth century AD) and roughly one thousand for the western part of the Roman Empire (between the first and third centuries AD). These figures do not in themselves tell us much, but are a help in estimating the ratio between the Thracian settlers and the rest of the population. This ratio has been shown to remain constant and can be regarded as reliable. Though the great value of this research is that it enables us to analyse the demographic and social structure of Graeco-Roman Egypt and of the western provinces of the Roman Empire, it also has significance for Thrace, as the Roman inscriptions give the birthplace of every soldier and, sometimes, the name of his tribe, thus his nationality. These lists are important as a guide to the proportions of persons drawn from the various regions. From this we can infer the relative density of populations in these areas in Roman times.

There is no epigraphic material for the pre-Roman period. Little is known about the last few centuries of the Bronze Age, though it is possible to map the settlements, thus showing which regions were the more densely populated. The actual density of the population is difficult to estimate, as we do not know how many people lived in these prehistoric settlements. As far as the first millennium BC goes, there are figures both in Thucydides and

Strabo, and we are told by Herodotus that the Thracians 'were very numerous'. In fact, he said that they were the most numerous people on earth, after the Indians. Thucydides, who is the more reliable writer, said that the Scythian cavalry was much more numerous than the Thracian. If that were so, then Herodotus was wrong, which is not unlikely, as his statement was probably based on the hearsay of the impressions of the Ionian colonists on the west coast of the Black Sea and the recorded amazement of the Greek settlers along Thrace's Aegean littoral, when they compared the large numbers of the Thracian tribes with the limited population of the Greek cities.

According to Thucydides, Sitalkes, the greatest ruler of the Odrysian state, raised an army of one hundred and fifty thousand warriors for his march against Macedon. It was composed of men from all the tribes which lived to the south and south-east of a line drawn between the mouths of the Danube and the Mesta, along which ran the known frontier of the Odrysian state; but not from the Triballian group or any of the tribes living in the valleys of the Strouma and Vardar, or north of the Danube.

It is accepted that in Antiquity an army of one hundred and fifty thousand could be raised from a population of six hundred thousand. Sitalkes' army, however, does not reflect the whole population, as it was recruited from only the south and the south-east of the state. We are entitled to assume that the correct figure for the whole population of the state was between eight hundred thousand and a million.

Five centuries after Thucydides, Strabo said that the Getae could raise an army of two hundred thousand. This would mean that the tribes in North-eastern Thrace and those between the Danube and the Carpathians numbered about eight hundred thousand people. However, for us it is not so important to know the total population between the Carpathians and the Aegean, as to find out how the population was distributed by regions and which regions were the more densely populated. We have been partially successful in this as the records from the pre-Roman period largely

tally with the information from the Roman period. The lists of Thracian army recruits and those enlisted in the auxiliary units are especially useful, and these lists, supplemented by information from writers of the classical and Hellenistic periods provide a clear picture.

One would expect to find the populations concentrated in the four large vertical zones mentioned in the previous chapter. More especially at the intersections of these vertical zones with the horizontal belts of Claudius Ptolemy's strategies. Thus there should have been a relatively great concentration of populations between the valleys of the Isker and the Ogosta, along the course of the Ossum, that is to say, in the Lovech-Sevlievo-Gabrovo triangle, and in North-eastern Thrace, to the north of the Vurbishki Pass, between the bend of the Danube and the Black Sea, and that this was so has been corroborated by archaeological finds.

In Central Thrace, a relatively high density of population was recorded along the reaches of the Strouma between the Djerman and the Stroumeshnitsa rivers, and then in the Maritsa lowlands and the northern foothills of the Rhodopes and, during the Hellenistic period, in the valley of the Toundja and in the Sredna Gora Mountains.

The impression is that the density of population was greatest in the south, which one would expect to find occupied by the tribal groups most prominent in the reorganization of economic life in the Early Iron Age, and this is corroborated by written records.

Another problem is that of the Thracian presence on the Aegean islands and in Greece proper. Our data comes from Greek sources, archaeological finds, or is toponymic and anthroponymic. It is now being suggested that some Thracian names can be traced back to Mycenaean Linear B, e.g. those of the Odrysae and the Thyni, or personal names like Pitakos. It seems more or less certain that many of the place-names of the island of Delos are of Thracian origin, while the presence of Thracians on Naxos, Thasos and Samothrace has been recorded. Last but not least, in the list Diodorus prepared of the nations which were masters of the Aegean sea, the Thracians occupy third place for the period which is that preceding the colonization or maybe just after the Trojan War. The most reliable information on the subject is what Thucydides wrote about the Thracians of Phocis in Central Greece.

We think now that we know the social organization of the Thracian tribes. However, opinions differ as to the form of the Thracian communities in pre-Roman times. Some think that the transition from the family community to the neighbourhood-territorial unit was effected on the eve of the Roman invasion, an idea based solely on one passage in Horace about the annual redistribution of plots by the Getae. This gave rise to the assumption that the old family community structure had been preserved

throughout Thrace and was changed only by the Roman administration in the first century AD. According to others, the transition took place much earlier, namely, in the period of economic reorganization after the introduction of iron. Which it was is of considerable significance, as it touches upon the big question of the nature of slave-ownership and the possibility that some parts of the Eastern Mediterranean did not have the system at all. In Thrace, as in other countries, one can see great civilizations, each reaching its peak just before it ceases to exist and being succeeded by another: first the Neolithic civilization which blossomed at the end of the fourth millennium BC; then the civilization of the Bronze Age, which perished at the close of the second millennium BC, and thirdly that of the Iron Age which assumed a conventionally termed classical form that was given the seal of its approval by the administration of the early Roman Empire. It is not difficult to see that each rise was due to the organization of production which in each case reached the upper limit of its capacities, then it fell before making a qualitative leap forward to the next stage. It hardly matters whether immigrants were the cause of the declines or not; at the most that would be a supplementary factor.

It is scarcely possible that a different social organization existed in each of these three phases. Rather the opposite is more probable, for the data, at least our interpretation of them, do not indicate any essential change in social relations between the Neolithic, Bronze and Iron Ages.

And what changes in social structure could one find in a prehistoric mound where different phases of occupation have succeeded one another over a period of several millennia? The survival of such mounds precludes the existence of social upheavals which would have changed the form of the primitive community. Recent excavation of the necropolises near Varna have shown that they belonged to the people who lived in the pile dwellings on Lake Varna and in the settlements along its shore. There are both Neolithic and Bronze Age settlements and none has yielded anything which could point to any social change from one age to the other. You see the same social structure at the close of a rich civilization, convincingly confirmed by the archaeological finds in the Varna necropolis, as at the beginning of a new era of a rather low-level material culture. This appears to have been equally true of the transition from the second to the first millennium BC, as of the age of those splendid finds, the Vulchitrun treasure and the Sofia gold vessel, and of the Thracian dark ages in the first centuries of the Iron Age.

What of the family community? Science has long considered the family the only proven nucleus of the primitive social structure. Yet, when we look at one of these early settlements, we cannot say whether it belonged to a single family or whether

several families, forming a higher social structural unit, lived in it. We know that such higher units existed in Greece and Italy where they were called *fratria*, but there are no data to show that the same was true of Thrace. Indeed, one has the impression that, since the country was divided into smaller areas belonging to well-defined, big, cultural and demographic zones, the quantitative indicator of the family organization would vary in accordance with local conditions.

The family community was a selective system both because of the blood tie and because of its social structure. It is usually accepted that the family community could not admit of social differentiation, but lately this has been contested. Late Greek and early Roman literature, to which we owe the most detailed description of the family community, supports this revised view. However, the impression given by these ancient authors is a misleading one, as it comes from their tendency to moralize rather than from personal observation or contemporary sources. For this reason, the rather simplified idea that the family community was a community of equality which was upheld by all means, including the annual redistribution of plots of land, is unacceptable.

On the contrary, social differentiation was a process that could be expected to develop as far as was possible in a closed system which did not receive any stimulus from social-forming components from outside, and it would seem that such was the line of evolution during the three great periods and it would not be wrong to suppose that social differentiation then reached its peak. This is borne out by archaeological finds from the Neolithic Age, and archaeological data and written information for the Bronze Age.

If this is correct, then social life in Thrace could be illustrated on a map by drawing red circles around various spots to indicate the peaks of social differentiation in the various periods and, also, the highest points in the evolution of the family community at a specific state or a specific advance of the productive forces.

This is, of course, a simplification and refers only to the two socially antagonistic partners, of which one was the family aristocracy, consisting of the elders and their immediate family. It is to them that posterity owes the great achievements from the end of the Neolithic and of the Bronze Ages, of which archaeological finds are the evidence. The richer the finds, the greater the distance which separated the nobles from the ordinary members of the community.

Did this social reorganization, formed within the closed family community, have a political counterpart, and, if so, of what type was it? There is no equivalent term for the military-political organization that existed in Thrace at the end of the Neolithic Age. To call it family-political would be

close, but that would apply right up to the end of the Bronze Age, despite the changes in the structure of the family which slowly came about.

What, for instance, should one call the prehistoric settlement near the village of Polyanitsa, in which archaeologists have discovered the first (in Bulgaria) earthworks of rectangular shape, the planning of whose quarters more or less resembled a Roman military camp? It is evident that both here and elsewhere in North-eastern Thrace building was done by a military-political organization, no matter how simple.

There is also the difficulty of the term *basileus* or king, taken from Homer. Its Roman equivalent, *rex*, was applied to anyone who wore the attributes of high office, no matter what its prerogatives. There is no Thracian equivalent. The Thracian would be closer to Mycenaean Greece, where the king had both military and priestly power, and was also the biggest landowner. He was surrounded by the notables of the family, who could rival him in every respect, except in the exercise of his priestly functions. The situation in Thrace was similar during the second millennium BC, but it is difficult to tell what it was at the end of the Neolithic Age.

It is our opinion that the community, whatever its size, was always an entity and, given favourable material conditions, was able to achieve a high enough stage of economic development to have a military-political organization, headed by a family aristocracy.

The changes brought about by the use of iron gradually eroded the closed system of the family community. This process was, naturally, connected with the movements of the tribal groups, which took part in restructuring the country's economic life, and, in doing so, changed the pattern of habitation. Naturally, the change was made somewhat earlier, but therein lies precisely the continuity which we wish to stress. So, the processes which began towards the end of the second millennium BC, had now ended and the country's economic life acquired a new aspect.

During this period, a considerable number of unfortified settlements sprang up in the most densely populated regions of Thrace. Some of them had a long life, surviving until Roman times. Interconnected as they appear to have been by a network of roads, they were also linked to the communications systems of the neighbouring areas, and this enabled them to have an active economic life. From the middle of the first millennium BC onward, as they felt the influence of the early Hellenistic centres, these settlements began to assume an urban aspect, yet they continued to function as communities. Seuthopolis, the only city to have been excavated so far, was built by Seuthes, the Odrysian king, on Hippodamus's system. Situated on the Toundja in one of the advanced regions of Thrace, it was a typical community. Its ruler, who

could have been a king at that particular stage, lived in a citadel separate from the quarters of the aristocracy. The latter's houses were within the city walls and the dwellings of the community members outside them.

Now, was this the same type of community which in preceding millennia was defined as a family community? We are convinced that it is wrong to consider it a family community of Horace's type. The development of production could not allow such a system to remain closed, for this was precisely the stage at which new people would come and settle permanently. That is why the term neighbourhood-territorial community has been coined. This does not mean that family ties had ceased to exist, but that they, being impermanent, were no longer a determining element in the form of society. Their influence continued to be felt mainly in the spiritual sphere. The transition from the family to the neighbourhood-territorial community was a long process. In Thrace it continued through the early Roman Empire, when the territorial community became the prevalent form in the old tribal territories.

The essential thing is that it was now possible to pass from the simple to more complex forms of exploitation, including that of having slaves as producers of material wealth. And the Thracians had them, but in numbers insignificant by comparison with Greece or Rome. Indeed, relative enslavement was the eventual lot of all producers of material wealth, who were forced by the aristocracy to either pay tithes or provide unpaid labour, or become servants in the residences of the notables.

Some writers maintain that it was then that a third social group or class appeared; those who, unlike the peasants, owned no means of production and who were not members of the communities. This is quite possible; indeed, there were such people, not only at the residences of the rulers and their immediate entourage, but in the homes of the big landowners. The descriptions of Thracian life in sources from the classical and Hellenistic periods, give a vivid picture, showing the aristocracy playing the leading rôle. These were men who carried rich and heavy offensive and defensive weapons, some of which archaeologists have dug up. Usually they were to be seen on mettlesome horses, always active, either engaged in warfare or going about their various tasks.

According to Greek writers, the Thracian kings spent the greater part of their lives on the battlefield, as they had to exercise constant military control to protect their social privileges. They increased their wealth both through services which they exacted from their subjects and through the wars which they waged against their neighbours. Plunder was a way of life for the Thracian tribal aristocracy. From a historical point of view, it was justified, in that it was a powerful factor in speeding up social differentiation.

Life in Thrace had little in common with that in the advanced cities of Classical Greece. It was dynamic and to a certain extent an anachronism, since, though in Thrace the fully armed warrior, the commander and aristocrat still held the stage, in Greece that was a thing of the past. Yet this anachronism was to be observed in some regions in Greece in the Classical period, too.

The social development of South-eastern Europe and of the neighbourhood-territorial community was two-phased. In the most advanced Greek towns, this type of community had now reached the stage where it was an open system, the result of dual ownership of the means of production: by the town, i.e. the community, and by some members of the community. Any plot of land in the territory of the community or the town belonged to both. Thrace never reached this stage; there property rights were vested solely in the chieftain or king, the members of the community being tenants and able to lose their right of occupancy at the will of their master. The anachronism resulting from these social conditions which, in their turn, were due to the differences in material culture between the coastal and the inland provinces, was enhanced by other circumstances related to the permanence of family relations, especially in the political and public sphere.

The earliest known political organization in Thrace dates back to the late Neolithic or Eneolithic Age, that is to say, the end of the fourth millennium BC. It is a type of political organization for which there is no name, but it is to be identified with the family elder or chieftain, whose presence accounts for the performance of a number of economic and constructive tasks or religious acts by the population; e.g. the fortification system of the prehistoric settlement, the production of high quality articles, like pottery, the finest examples of which were obviously designed for use by the aristocratic families, and the organization of cult centres, in which the family elder or chief undoubtedly played the main rôle.

The Varna necropolis is the most recent proof that the latter had appeared on and dominated the historical stage prior to the decline of the Neolithic civilization. Here (in Grave IV) a symbolic burial has yielded a gilt double axe, gold jewellery, a pectoral and a gold plate featuring a bull. There is no doubt that this was the burial of a chieftain, whose tribe lived in the settlements along Lake Varna or in the pile dwellings. The contrast between the poverty of archaeological finds in the settlements and this exceptionally rich cenotaph, as well as the difference between the burials in the necropolis, in whose centre the notables were put to rest in splendour, while the poor were laid in modest graves along the fringe, further stress the important position of the leader.

The chieftain's regalia found in the symbolic

grave are proof of his prerogatives, being similar in type to the Minoan. The double axe shows that the family elder also fulfilled a religious function and must have been both a military commander and a priest, the rôle of chieftains throughout the Eastern Mediterranean during the Bronze Age. The plate with the bull brings a new element to the kingly image. It shows an affinity with the bulls in the frescoes with the hunting scenes in Mycenae and Tiryns; but the important thing is that the earliest representations of bulls are those found in the Anatolian settlements, at Catal Hüyük and Alaca Hüyük. Predating those of Varna, whether or not they were part of the royal regalia, they are the most ancient representation of the male principle in Indo-European religion.

The old concept of the Indo-European religion is that of the so-called theory of the triad, according to which the Indo-European saw in the heavens above him a father, mother and child, who, individually or jointly, ruled over the elements and the fate of men. But the Indo-European triad is obviously the end product of a way of thinking which paid homage to symmetry and was influenced by classical Greek mythology, in which the triad appeared in its pure form after a great deal of improvement on earlier cults.

The probable truth is that the chief and original European deity was the Mother of Gods, or Nature, indivisible and self-fecundating. Later, a partner appeared, who was her son, but who also impregnated her to ensure the cycle of rebirth. The Mother of Gods and her lover-son may be seen in many representations from the Neolithic Age in Anatolia. She also occurs in Thracian relics of a later period. In some of the earliest Anatolian finds, the bull, symbol of the male principle, is seen with the Mother of Gods and her lover-son. The bull was an early attribute of the mother and son, but did not participate in the cycle of rebirth, which the two were bound to accomplish.

The bull being this attribute, it is obvious that the gold plate from the Varna necropolis was meant to indicate who the deceased was: the lover-son of the Mother of Gods. It may be concluded, therefore, that the society of this particular region looked upon its chieftain not only as a military commander and a priest, but also as a deity, so that the king was a warrior, a god and a priest of his own cult.

No new military-political organization came into being during the third and second millennia BC, as is borne out by the Sofia gold vessel. This was found in an ordinary clay vessel of inferior quality, which in its turn had been placed in a bronze cauldron. It is accepted that placing one vessel inside another is a symbolic burial, one of the vessels being the urn and the other the funeral offering.

In our opinion, this practice is a continuation of the old tradition of revering the Great Mother of Gods and her lover-son. The clay female heads, placed one inside the other, that have occasionally been found in Thrace, are representations of the Great Mother of Gods with her son and not, as is generally believed, the likeness of a pregnant woman or of one that has just been delivered of a child. The placing of one urn inside another and the making of biconical or 'shelved' urns was also a practice of this cult, because the acts of primitive man were dictated by religious motivations and the articles he made had a sacred destination. This makes the Sofia find abundantly clear. The bronze cauldron was the symbol of the Mother of Gods, the clay vessel represented her son, and the gold one was a funeral offering. All this goes to show that we are dealing with the burial of a chieftain. The different dating of the vessel is of no significance. The bronze cauldron belongs to the eighth or seventh century BC, the clay vessel has not been dated, and the gold one appears to be older than the Vulchitrun treasure. And here we come to the most important point – it must have been placed in the earth several centuries after it was made, having been preserved as a precious heirloom of an aristocratic family.

As far as this goes, the military-political leader of the Bronze Age had exactly the same prerogatives as his predecessor of the Neolithic Age: he was chieftain, god and priest of his cult.

Additional information about the Bronze Age is to be had from the legends of Orpheus and Zalmoxis, not as they are in the Greek version but in the Thracian version, obtained by reading between the lines. Analysis of the Greek texts shows that both Orpheus, whose abode was said to have been in three different places in Southern Thrace (by the Hellespont, in the land of the Cicones, or between the Vardar and the Strouma) and the Getic deity Zalmoxis personified the state and religious doctrines of the second millennium BC. Both were aristocrats, tribal chieftains who professed their own cult and admitted to its practice only a chosen few; in other words a purely aristocratic religion that could not have been far removed from the inherited religious tradition. Now, in Antiquity there was no politics without religion. Orpheus, the reformer, introduced the solar cult. Zalmoxis was more a chthonian power. According to the legends, he had been at loggerheads with Dionysus, carrier of the chthonian principle, but later made it up with him. The unity of the two cults is confirmed by another legend, according to which the ashes of Orpheus were exposed to the sun's rays in an urn placed at the top of a column. The ashes were the link between the solar and the chthonian principles, as they were in touch both with the sun and, through the column, with the earth.

The leader was now entrusted with new and more complex functions. He had to maintain the balance between the chthonian and the solar principles by impregnating the Great Mother of Gods and uni-

fying his followers in the profession of a single cult.

Data provided by Homer and mythographical and archaeological information, show that during the Bronze Age military-political organizations existed in North-eastern Thrace, in South-western Thrace along the Vardar and along the entire course of the Strouma beginning with the Sofia plain, in the central area between the Mesta and the Maritsa, by the Hellespont, and the Troad in Asia Minor. This is probably the period to which the information in Thucydides and Diodorus referred, as is the case with our archaeological and linguistic data. These military-political organizations apparently had at their head a chieftain of Orpheus's and Zalmoxis's type, but such kings were not solitary figures; each had an aristocratic entourage. Homer describes them and their entourage in considerable detail, for they were allies of the Trojans and took part, at least those from Thrace's Aegean littoral, in the Trojan War. According to Homer, these Thracian chieftains had rich and splendid battlegear, in no way inferior to that of the others, and archaeological finds from the second half of the second millennium BC, especially the Vulchitrun treasure, show this to have been the case.

The type of state can be called Mycenaean, for want of a better term, and that is why we speak conditionally of Mycenaean Thrace. This is justified by the widespread use of the Mycenaean *koine*, suggesting a relative similarity in a world which was not confined to Mycenae and the Peloponnesus, but took in the Eastern Mediterranean and South-eastern Europe, and, surprisingly, Southern Italy, a world which reached the peak of its development in the wake of the great natural calamities which befell the islands.

A careful reading of the *Iliad* shows that the rivals from the different parts of the Eastern Mediterranean world, who faced each other at Troy, were equally matched. Also they had a great deal in common. During the Bronze Age the difference between the king in Mycenae and the king in Thrace lay not so much in their professed state and religious doctrine, as in the form of ownership and the type of political life. During the second half of the second millennium BC, ownership of the means of production was vested in the ruler, the political system – with some local variants – finding expression through the actions of the ruler and his companions. Homer reveals that the ordinary members of the family community served as infantry, a backup force for battles whose outcome was usually decided in single combat.

Subsequent developments show no essential changes. The status of the king remained the same, no matter what tribe he headed – Odrysae, Triballi or Getae, etc., but we now know much more about his functions as god and priest. Herodotus's information on Zalmoxis, subsequently confirmed by Strabo, dates to the seventh century

BC, i.e. the beginning of Greek colonization of the western Black Sea coast. If Orpheus was no longer more than a myth in the Classical and Hellenistic periods, the Orphic features of the tribal dynasts had been preserved. Coins minted in South-western Thrace show Hermes as the guide of souls to the nether world; and as Hermes was the royal god, as Herodotus tells us, these issues, like all other Thracian coinage, were royal and featured the regalia. In the late sixth and early fifth centuries BC, the period of richest mints in South-western Thrace, the kings continued to practise the chthonian cult and to identify themselves with the solar and chthonian principles.

Plutarch quotes a story how Kotys I, king of the Odrysae in the first half of the fourth century BC, expressed a wish to share his bed with Athena. The ancient writers considered Kotys a brutal, cruel and unscrupulous man, but here he was expressing the conviction that, being a king, he was also a god and so able to be the lover of a goddess. That the old religious and political doctrines survived in Thrace in this way is corroborated by archaeological finds. Ceramic shards found in or near the megalithic monuments of Thrace – dolmens, rock-hewn tombs and niches – date them to between the twelfth and sixth centuries BC. As a rule, these megalithic tombs faced one of the sunny sides, and this is especially true of the dolmens. Some rock tombs in the Rhodopes were even cut at a considerable height so that they could be exposed to the sun's rays all day long. The several hundred dolmens in Thrace and some of the rock-hewn tombs in the Rhodopes were the last abode of kings and symbolized the fusion of the solar and chthonian cults; they were also a place for ritual offerings and the practice of the cult. The numerous stone circles representing the sun's reflection on earth are proof of the spread of this cult among the ruler's subjects.

One still has the military leader who was also a god and a priest. When circumstances demanded, he became a diplomat and a politician. Such was the Thracian political system up to the Roman conquest. It seems archaic in comparison with those of Greece and Rome. However, things changed radically as the country became actively involved in international affairs.

Strong state organizations were created in the late sixth and early fifth centuries BC, by the Triballi, by the Moesians (the population in the central part of present-day Northern Bulgaria) and by the getic tribes in North-eastern Thrace and along either bank of the Danube. There were numerous local dynasties in the broken terrain of South-western Thrace, where various groups set up military-political organizations of their own. Among these were the Edoni, some of whose proper names have come down to us, one being that of their king Getas. This dynasty took an active part in Thraco-

Greek relations in the fifth century BC resisting Athenian colonization and expansion, but aiding the Greeks during the Peloponnesian wars.

The organizations of the Triballi, Moesians, Getae, and others had their ups and downs, but all were eclipsed by the Odrysian state in South-eastern Thrace. It was the most powerful state union of the Thracians. Its rulers sponsored a number of Thracian undertakings and it played a considerable military and political role in South-eastern Europe during the fifth and fourth centuries BC.

It occupied a densely populated region along the Toundja and the Maritsa, stretching as far east as the Thracian Chersonese and the Sea of Marmara, and it also included the Eastern Rhodopes along the lower reaches of the Arda, which empties into the Toundja-Maritsa near Edirne. Herodotus, the first to mention the Odrysae, placed them along the Artiscus (the Arda). This suggests that the Odrysae, like all the rest, were originally called by the name of the dynastic family. The greater territorial range of their ethnonym in the fifth and fourth centuries BC did not mean that they had penetrated the lands of their neighbours; it merely meant that the Odrysian dynasty had imposed its political hegemony over the whole area which was under its military control.

This territory of the Odrysian state is the heart of megalithic Thrace, i.e. the region where the greatest number of dolmens, rock-hewn niches and tombs occur. (The few exceptions only confirm the rule.) The Odrysian royal house was one of those to which the colossal stone tombs belonged. Obviously, this was a socially highly developed region, as the megalithic was first and foremost an aristocratic civilization, with its evidence of deep social differentiation. The development of the megalithic civilization came to an end late in the sixth century BC, when dolmens were no longer built and tombs began to make their appearance. The specialists find a genetic link between them and the dolmens. If this is so, as we believe, then some very important social and political changes must have taken place here at the end of the sixth century BC, for the population remained the same. The second half of the sixth century BC was a historical boundary line for Thrace; it marked the end of the Old Iron Age and the appearance of new organizations.

There may be various explanations why the dolmens were replaced by a new type of royal burial, but from the viewpoint of political history the only explanation is that, at the end of the sixth century BC, the Odrysian royal house began to eliminate its rivals in South-eastern Thrace. An upsurge like that was naturally accompanied by noticeable changes in the population's culture and life-style.

According to the written sources, the Odrysian

A two-chambered dolmen at Sakhar.

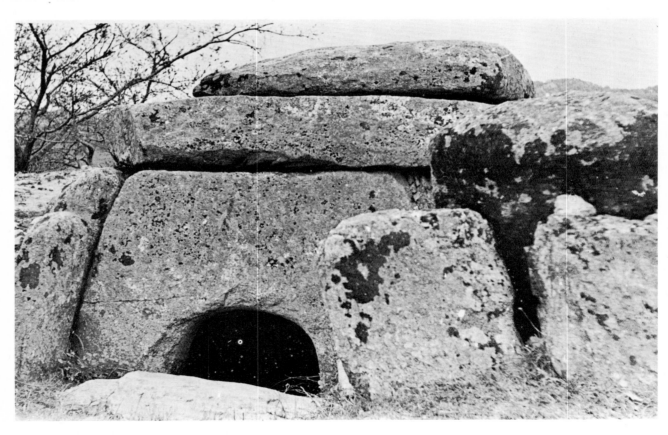

False vault of the central chamber of the Mesek tomb.

state was 'founded' in 480–460 BC; but one cannot speak of foundation in respect of Antiquity, when state formation was never a single act, but a process. This must have been all the more true of the Odrysian state, as its territory was quite large. The dynast and his close companions were always on the move, engaged in constant warfare in their attempt to extend their territories and keep their subjects in submission. Thucydides, who gives the name of the first Odrysian ruler, Teres, never speaks of a state's foundation. He tells us that Teres was the first among the Odrysae to 'create' a powerful kingdom, thus hinting at the possible existence of another dynast before this first powerful Odrysian ruler. Also, 480–460 BC could not be the right date.

Teres and the Odrysae only embarked on military operations after the Greeks had driven the Persians from their garrisons at the mouths of the large rivers in Thrace, and from the Aenus (Enez) garrison at the mouth of the Maritsa, i.e. 480–460 BC; but we know from Herodotus that the first military-political undertaking of Teres was to sign a treaty with the Scythians. This could only have been done after Darius's march against the Scythians at the end of the sixth century BC, when the Scythians followed in the wake of the retreating army and descended to the lower reaches of the Danube. By virtue of this treaty, Teres consolidated his northern frontier. Only then could he turn south-east, against the Thyni, as the sources inform us. The Thyni inhabited the Strandja Mountain and the hinterland of the Sea of Marmara. This could very well have taken place after 480 BC, when the Persians were ousted from the area. Teres' campaign against the mountain people was not very successful, but he did conquer the region between Salmydessus and the Bosphorus. It is not known what gains he had in the south-west, the area towards which his sons and successors directed their attention. Teres had a very long life, most of which he spent in warring, dying at the age of ninety-two; it is, therefore, difficult to tell the dates of his successors. One of his sons, Sparadokos, is known from coins, but as there are no written data about him and specialists are unable to identify the type of his silver issues, it cannot be established whether he was a king or just the governor of a region. In our opinion he was a sovereign ruler and the direct successor of Teres, for there is nothing to suggest that the institution of paradynasts or governors of

regions existed in the kingdom during the latter's reign. What is more, the silver coins of Sparadokos show that he had the same prerogatives which his brother and successor Sitalkes was to have. They were struck in one of the bigger coastal towns of Aegean Greece, where the coins of subsequent Thracian kings were also minted. They were meant to pay the taxes due to the Odrysae, and also to Athens, for the coastal cities were members of the Athenian League.

Sitalkes was the greatest Odrysian king. His first act was to conclude a treaty with the Scythians, after which he apparently reorganized his state, creating the paradynastic institution. This gave him a trusted person in each large region to act as military governor and administrator. Sitalkes increased the pressure on the Aegean cities – members of the Athenian League, and firmly established the right of the Odrysian rulers to collect taxes from them. On the eve of the Peloponnesian War, he began to play an active foreign-political rôle concluding the first treaty between the Odrysae and Athens in 431 BC. Athens entered into this treaty because it wanted the Thracian army to put pressure on Perdiccas, king of Macedon, to ally himself with Athens in its conflict with Sparta and in crushing the resistance of the cities in the Chalcidice. Sitalkes, however, pursued his own expansionist aims and only fulfilled the terms of the treaty in 429 BC, when intervention was no longer necessary. What he gained earlier in the general confusion of the war was to penetrate into Macedon and the Chalcidice. His campaign, however, did not bring him any lasting territorial gain. He died during or immediately after a battle with the Triballi in 424 BC.

Seuthes I, the often underrated successor of Sitalkes was, in the opinion of Thucydides, the king under whom the Odrysian state reached its greatest financial power. The taxes he collected in cash and kind amounted to eight hundred talents, according to Thucydides, and to one thousand talents, according to Diodorus. Collecting this tax from the cities was possible because of Athens' weakness and the break-up of the First Athenian League. Being more far-sighted than his predecessor, Seuthes I abandoned the idea of expansion to the south-west in favour of the Thracian Chersonese in the south-east. His decision was correct. because the southwest was where the interests of Macedon, Athens, Thrace and the local dynastic courts clashed. Also, it was at a considerable distance from the centre of the Odrysian state. The Chersonese offered broader perspectives, because there the Odrysae had to deal only with Athenian military settlements remote from the metropolis.

The aim of the expansion was to secure an outlet to the sea, which, it was hoped, would enable the Odrysae to occupy a leading position in Southeastern Europe. This foreign policy was pursued by the subsequent rulers and their paradynasts and reached its peak under the famous Kotys I (383–359 BC). Kotys can be regarded as a precursor of Philip of Macedon and an exponent of the Hellenistic ideas of which South-eastern Europe was the cradle. Kotys met Philip just after the latter ascended the throne in the spring of 359 BC, in a locality in Western Thrace known as Onocarsis. At this brief meeting they concluded a treaty on the inviolability of their frontiers which, in Kotys' case, was the valley of the Mesta. The intention was that they should jointly continue the fight against Athens, but shortly afterwards Kotys was assassinated by two Athenian conspirators, inhabitants of Ainos.

The meeting was a symbolic handclasp at a time when the two states had the same mission to fulfil. History, however, decreed that Macedon, under Philip and Alexander the Great was to carry it out.

Kotys had the misfortune to be born a little ahead of his time. His aim was to unify Thrace, just as Philip unified Macedon, then to strike at Athens and subjugate Greece with the united forces of all the tribes. His intentions were an expression of the desire of the Balkan countries to act as unifying link in the *polis* system, and through their war effort, to usher in the new historical period of the great Hellenistic monarchies.

Kotys obviously succeeded, if not in making allies of them, at least in neutralizing the powerful Getic, Moesian and Triballian dynasties in the north. This was done through personal contact, negotiation and gifts. He successfully broke the resistance of some paradynasts in his own kingdom and enlisted the support of his own subjects, despite heavier taxes and extra duties for the war against Chersonesus. This was not waged on the battlefield alone. Kotys, like Philip, succeeded in recruiting diplomatic agents in Athens. At times, he even influenced the work of the Assembly of the People so that it took the decisions that favoured his policy. He bought the high-ranking Athenian officers who had been sent against him.

Successful in many of his undertakings, he seized the whole of the Athenian Chersonesus with the exception of two settlements. It was then that he was assassinated.

His son Kersobleptes, whose unenviable lot it was to be vanquished by Philip of Macedon in 341 BC, successfully continued his father's policy in the early years of his rule and maintained for a time his control over the Thracian Chersonese. But the process of political decentralization begun by Philip's pressure eastwards and along the Aegean coast, was intensified by internal dissension with which Kersobleptes was unable to deal, and so the state of Kotys was partitioned in three – the western, central and eastern districts which gradually fell to the Macedonians.

It is incorrect to say that after this Macedonia

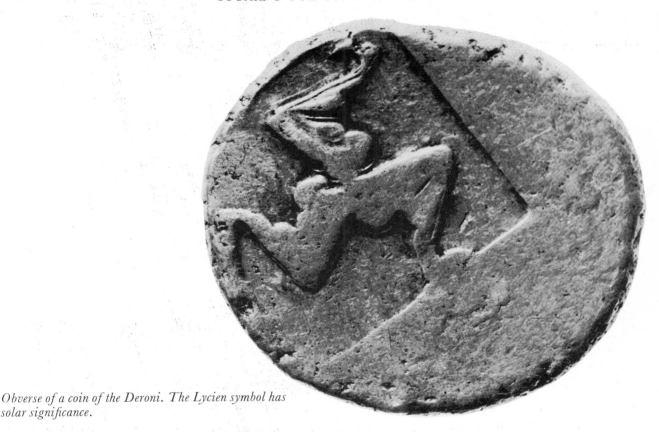

Obverse of a coin of the Deroni. The Lycien symbol has solar significance.

ruled Thrace. Macedonia maintained several garrisons there, the most important of which were that of Philippopolis (Plovdiv), which has been seized by Philip and renamed after him, and those in the Black Sea cities. Lysimachus, who received Thrace as his share of Alexander's Empire, twice had to engage in active warfare to quell risings in the Black Sea cities. He also fought against the Getic ruler Dromichaetes and quite unsuccessfully. But the interior of Thrace was free, as Alexander the Great had found as early as 335 BC when he first went there, not so much to conquer Thrace, as to instil fear and respect in the local tribes, which later contributed troops for his campaign in Persia.

The Thracian dynasties continued to feel free and independent. The territory of the Odrysian dynasty had, however, been considerably reduced in favour of the new local political centres. The kingdom had shrunk to the area along the upper and middle reaches of the Toundja, where was Seuthopolis, capital of Seuthes III, the most famous Thracian king of the Hellenistic period. His powerful personality and the respect he commanded are proof enough that there was hardly any Macedonian presence inside the country. He built his beautiful city, successfully fought Lysimachus and maintained the same foreign contacts as had his predecessors. These extended to the cities of Asia Minor, indeed his wife Berenice was a princess of a

Diadochus family in Asia Minor. The fact that he was able to purchase the Panagyurishté gold treasure, made in Lampsacus, is proof of the brisk and profitable trade his kingdom carried on.

It is not known when Seuthes III left the political scene, but by early in the third century BC, the country had begun to decline. More and more names of dynastic courts of local importance begin to appear in the sources. They were weak, and their military and political activities were confined to plundering the still rich coastal cities.

The crisis in Thrace, which also gripped the rest of the Hellenistic world, was as much economic as political and social. With the decline of the strong state formations, the population could move about more freely and this entailed a break-up of existing social relations, in this case community relations. Many settlements were deserted and their inhabitants, especially those of the mountain strongholds, moved to more fertile areas, where they could enrich themselves by plunder. The power of the aristocrats was weakened and their possessions shrank. The sources tell of constant skirmishes between the Thracians and the inhabitants of the colonies, as well as of tribal invasions of neighbouring territories. The Celtic invasion of the Balkan Peninsula in the third century BC and the creation of a short-lived Celtic kingdom in Thrace, east of the Maritsa and not far from Byzantion, also contributed to tribal movements.

Such was the setting when the two-century-long struggle of the Thracians against the Romans began. The campaign against the Thracian chieftains was conducted with singular success according to all the rules of Roman diplomacy. Gradually they all became vassals to Rome. But the war with the Thracian tribes was not so easy. The Romans had to subdue the country region by region, beginning with the border ones. It was only in the early years of the first century AD that they finally succeeded in breaking into the country's interior. After quelling several successive rebellions, some of which were very destructive, they turned first Northern, then Southern Thrace into Roman provinces.

The iron discipline of the legions and the excellent administrative system the Romans introduced in all their domains, enabled them to achieve what no Thracian chief had been able to do in six centuries of endeavour, the unification of Thrace. In no time at all the provinces of Thrace, Moesia and Macedon were dotted with new cities. The local aristocracy gave up wearing ornate gold jewellery. Many tried to retain their position at the top of the social ladder by adopting Greek or Roman names and ways (though their wives continued to use their Thracian names). Nevertheless, on the whole the Romans failed to Romanize the Thracians. This was true particularly in the sphere of religion. The Roman conquest opened the way for other cults. The Roman soldiers brought with them images of Cybele, Mithras or Sylvan; votive reliefs with the likenesses of Zeus, Hera, Athena, Asclepius and Hygeia, Dionysus and many others became common and yet this syncretism was no more than skindeep, for everywhere is evidence of the continuing vigour of local beliefs and concepts. More than two thousand of the reliefs found in Bulgaria had been dedicated to the mounted Thracian hero/deity. His image accompanied the Thracian soldiers all over the ancient world, to the lands of the Egyptians, Celts, Greeks and Romans.

Reliefs of the Thracian horseman have been excavated in places as far away from Ancient Thrace as England, Germany, Italy, the Crimea, Asia Minor and Egypt. Is this not proof of a very strong sense of national identity?

It did not take the Romans long to realize that it served them better to use the Thracians as soldiers than as slaves. One they recruited was Spartacus, later enslaved and to become famous as the leader of the slave rebellion that inflicted numerous defeats on the might of Rome. As legionaries, the Thracians were dispersed all over the vast Roman empire. Traces of them keep cropping up as excavations proceed.

Although the Thracians lost their political independence in AD 49, they preserved their national identity until a much later date. There is evidence that sanctuaries were set on fire and votive reliefs destroyed in attempts to aid the spread of Christianity in Thrace. To break the spirit of the Thracians was no mean task. Many pagan motifs strikingly reminiscent of Thracian mythology are to be met with in Bulgarian and Romanian folklore to this day. The Thracians are now looked upon as the carriers of a considerable culture, which has made scholars re-evaluate many of their ideas on ancient history. The Thracian treasures so far unearthed, reveal a powerful spirit and original artistic values, the memory of which has survived the people who created them.

ACKNOWLEDGEMENTS

The Publishers wish to acknowledge their debt of gratitude to the Director and Staff of the Bulgarian Copyright Agency, Jus Autor, without whose help this book would never have come into being; to Rosa Staneva, Michail Enev and Petko Petkox who took most of the superb photographs which illustrate the book; to Nevyana Zhelyaskova who made the translation, and to Mrs Ralph Hoddinott for helping them avoid some of the pitfalls of Thracian orthography; and to the skill and patience of the printers.

BASIC BIBLIOGRAPHY

The literature on Thrace and the Thracians in English is far from extensive, but the reader is referred above all to R.F.Hoddinott's BULGARIA IN ANTIQUITY, London, 1975, and then to

S.Casson: Macedonia, Thrace and Illyria, Oxford, 1926

D.P.Dimitrov: Bulgaria, Land of Ancient Civilizations, Sofia, 1961

A.H.M.Jones: The Cities of the Eastern Roman Provinces, 2nd Ed. Oxford, 1971

I.Venedikov: Bulgaria's Treasure from the Past, Sofia, 1965
of German sources the following should be consulted:

G.I.Kazarov: Die Denkmaler des Thrakischen Reitergottes in Bulgarien, Budapest, 1938

J.Wiesner: Die Thraker, Stuttgart, 1963

Antike und Mittelalter in Bulgarien: Ed. Beshevliev & Irmscher, Berlin, 1960

Kunstchatze in bulgarien Museen und Klöstern, Essen, 1964

Pauly-Wissowa: Real-Encyclopaedie der classischen Altertumswissenschaft
while the 11th edition of the Encyclopaedia Britannica suggests one consults

Tomaschek: Die Alten Thraker (1893–1895)

Hiller von Gaertringen: De Graecorum fabulis ad Thraces pertinentibus, 1886
the main source in French is

Actes de 1er Congrès international des études balkaniques et sud-est européenes, II, Sofia, 1969

The literature in Bulgarian, Romanian and Russian is extensive and good, but as few in the West can avail themselves of it, it is not listed here.

INDEX

ABANTES, called the Gods of Battle, 24
ACHAEAN(S)
– compete for Thracian sword, 60
– material culture equalled by Thracian, 10
ADONIS
– as son and lover of Aphrodite, 21
– considered a mortal in Asia Minor, 32
AGATHYRSI
– laws embodied in chants, 59
– use of gold jewellery, 104
AGENOR, father of Europa and Cadmus, 27
AGIGHIOL
– greave, 19, 41
– helmet from, 18
AKINAKES, short sword, revered by Scythians, 24
ALEXANDER THE GREAT
– declines help of Lysimachus, 55
– depicted as a mounted hunter, 18
– regarded as new Dionysus, 58
– show of force in Thrace, 143
AMATOKOS, Thracian King, 54, 58
AMPHIPOLOI, attendants of Maron, 48
ANTHROPODEMON, 34, 40, 50, 52, 58
APHRODITE, 21
APOLLO
– attributes as a musician, 29

– as horseman, 31
– associated with Hera, 22
– fusion with Dionysus, 32
– *geikethlenos*, 17
– temple of, at Delphi, 31
APOLLODORUS
– claims Orpheus invented Dionysiac mysteries, 26
– claimed Phoenicians settled in Thrace, 27
APOLLONIAN
– cult, struggle with Dionysiac, 31
– principle, strong in Orpheus, 31
APSYNTHII, Thracian tribe, capture Oeobazus, 24, 25
ARCAS, 32
ARCHELAUS, King of Macedon, 55
ARCHITECTURE
– funerary, 63, 64
– monumental, 63, 64
– palace, principles of, 65
ARES
– a separate deity, 25
– description of Scythians sacrificing to, 24
– feared by Greeks, 24
– one of three Gods revered by Thracians, 24
– personification of barbarian fighting qualities, 24

ARGANTHONE, love of Rhesus and, 33, 48
ARGONAUTS, 22, 31
ARIADNE
– killed by Artemis, 20
– wife of Dionysus, 27
ARMOUR
– breastplate, 92
– bronze mail, 85
– chain mail, 85
– greaves, 85, 86, 96
– helmet, 85, 86, 92, 97
– shield, 85
– sheath, 93
ART, THRACIAN
– amphora-rhyta, 75
– animal fights in, 89, 110, 121
– appliqués, 64, 66, 93, 109, 130
– armour, 85
– axes, ritual, 60, 62, 136–7, 148
– borrowings from Persian, 80, 89
– bracelets, 85, 98
– bronze, use of 60; replaces gold and silver, 64
– ceramics, 88, 118
– connections with Eastern art, 80
– depictions of Hero in, 120
– geometric period of, 62, 73, 88, 93, 135

– gilding, use of, 64
– gold and silver table ware, 64
– gold crown, 102
– horse in, 89
– horse trappings, 72, 85, 88, 118–20
– jewellery 85: earrings 85, 95, 105, 119; necklaces, 85, 99; pectorals, 85, 90–1, 108; phalerae, 85, 94, 120; rings, 85, 94, 119
– jugs, 64, 106–7, 113
– laws of perspective not observed, 97
– monumental, 104
– motifs, limited range of, 60
– new stage in development of, 125
– on a par with Greek, 60
– phialae, 66, 80, 89, 112
– recourse to anthropomorphism, 85, 88, 97, 118
– repoussé technique, 64
– rhyta, 78–81, 84, 114–17
– silver plating, 64
– social basis of, 89, 118
– statuary, 104
– syncretic style, 104
– teratological style, 88–9, 93, 108
– toreutics, 60, 64, 85, 93, 100, 104, 118, 120
– use of Greek manner, 93, 100; of symmetry, 97
ARTEMIS
– a Thracian Goddess, 21
– kills Ariadne, 26
– mistress of the Animals, 21
– one of three deities revered by Thracians, 24
ASSA, mother of Sithon, 37
ASCLEPIUS, protector of health, 17, 19, 30
ATHENA, personifying Great Mother of Gods, 52
ATHENS
– grants honorary citizenship to Kotys, 52
– not a yardstick, 11
ATREIDES, Thracian King, lavish entertaining by, 56
ATTALUS II
– contemporary of Diegylis, 49
– uncle of Cleopatra, 53
ATTIS
– son of Croesus, 21
– considered a mortal in Asia Minor, 32
– fails the test, 40
AUDATA, Illyrian wife of Philip of Macedon, 53
AXE, ritual (double), 60, 62, 136–7, 148

BACCHANTES, use of snakes for adornment, 29
BARBARIAN(S)
– meaning of term, 9
– personification of fighting qualities of, 24
– revere Dionysus, 25
– virtues, 9
BASSARIDES, 31
BENDIDEIA, date of Athenian, 23
BENDIS
– complex syncretism of functions, 24
– cult of, adopted in Athens, 22; described by Socrates, 23
– derivation of name, 21
– honoured by Bithynians, 22, 24
– identified with Artemis, 22
– link with nymphs, 23, 44; with Cybele, 24
– personification of Mother of Gods, 22
– referred to as Great Goddess by Aristophanes, 24
– temple of, 23
– two-speared, 22
BERENICE, wife of Seuthes III, 153
BESSI
– family of the Satrae, 12, 140
– first mentioned by Herodotus, 140
– in charge of Dionysus sanctuary, 12

– provide priests for Dionysus sanctuary, 31
BITHYNIAN(S), Thracian tribe
– honour Bendis, 22
– move to Asia Minor, 22, 139, 142
– originally called Strymonians, 22
– sit facing the sun when in council, 30
BOAR
– associated with life and death, 18
– Calydonian, 18, 19
– enemy of fertility, 19
– Erymanthian, 18, 19
– hunted by Hero, 18, 40
– Mysian, 18, 19, 55
– symbol of Cronus, 40
– symbol of destructive element, 41
BOW
– attribute of kingly rank, 37
– on a Letnitsa appliqué, 37
– symbolic meaning of, 40
BRANGAS, son of Strymon, founds Olynthus, 40
BRIGES, *see* PHRYGIAN
BRONZE, change to use of, 134
BULGARIA(N), State, foundation of first, 9
BULL
– attribute of mother and son, 148
– element in kingly image, 148
– herds of, owned by Yima, 48
– most ancient representation of male principle, 148
BUREBISTA, ruler of Getae, 48
BURIAL
– appearance of horse in, 139
– customs, Indo-European, 134; changes in, 134, 150
– mounds, 150
– of chieftains, 147, 148; of kings, 150
– symbolic, 21, 148
BUTES, son of Boreas
– plots against his brother, Lycurgus, 25
– sent off his head, 26
– takes to piracy, 26
– victim of struggle between two cults, 31

CABIRI
– cult of, 20; Argonauts initiated into, 20
– myth of, 20
– shrine of, 49, 63
CADMUS, son of Agenor
– a Phoenician, 27
– stays in Thrace, 27
CAENI, Thracian tribe, 50
CALLIOPE, mother of Orpheus, 26
CAPNOBATAE, organizers of male mysteries, 58
CARY, M., reads paper on Thracian coins, 10
CEBRENII, Thracian tribe
– believe Cosingas threat, 36
– chiefs of, high priests of Hera, 49
– main deity of, 22
CELT(S)
– invasion by, 11, 142, 143, 153
– kingdom of, 153
– ousting of, 125
CENTAUR, idea of suggested by Thracian horsemen, 18
CHARIOT
– of Rhesus, 60
– of Zeus, 56, 57
– similarity of those in Paestum frieze to that in Kazanluk fresco, 50
– winged, 20
CHAROPS
– betrays Lycurgus, 25
– installed as King, 26, 48, 57
CHTHONIAN
– cult, 26, 57, 149
– principle, 148, 149
– symbol, 26, 32

CICONES
– mentioned by Homer, 12, 140
– tribe of Orpheus, 33
CIMMERIANS
– coins of, 10
– cross Thrace and invade Asia, 142
– origin of, 143
CLEITUS
– becomes King by marrying, 44
– fights Dryas for hand of Pallene, 37
– marriage with Pallene, 53
CLEOPATRA, sister of Hippostratus and niece of Attalus, 53
COINS
– in the regalia, 149
– of Amatokos, 58; Cimmerians, 10; Derroni 32, 153; Nicomedes I, 22; Patrajos, 45; Seuthes III, 45, 55, 128 Sparadokos, 152; Teres II, 58; Thracian Kings, 54; tribes of south-western Thrace, 12
– Persian, 55
COLCHIS, invasion route across, 143
COMMUNITY
– family, 145–6
– neighbourhood-territorial, 147
COMOSICUS, King-high priest of Getae, 48
CONON, on Orpheus, 28, 48, 57
COPPER, large-scale mining of, 134
CORONIS, abducted and ravished by Butes, 26
CORYLLUS, King of Getae, 48
COSINGAS
– King-priest of Cebrenii, 49
– threatens Cebrenii, 36
CRASSUS, MARCUS LICINNIUS, defeats Mysians, 139
CRATERUS, favourite of King Archelaus, 55
CRIMEA, 10
CTISTAE, Thracians who lived without women, 58
CUP, symbolic meaning of, 40
CYNANA, daughter of Audata and Philip of Macedon, 53
CYBELE
– and Attis, 21
– Mother Rhea, 27
– orgies, 24
– Phrygian cult of, links with Bendis, 24
CYPSELA MINT, 55

DACIA, Roman province of, 9
DACIAN(S)
– art, 125
– defeated by Trajan, 9
– kingdom, last Thracian political organization, 11, 125
DACO-MYSIAN, language, 10, 139
DARDANIANS
– linguistic evidence of, in Asia Minor, 140
– northern neighbours of Paeonians, 139
DARIUS
– entrusts Zeus's chariot to Paeones, 56
– marches against Scythians, 151
DARZALAS, Great God, 17
DECEBALUS, King of Dacia, 11
DELOPTES, on Athenian relief, 21
DELOS, place names of Thracian origin in, 145
DELPHI, 26, 33
DEMETER
– and Persephone, cult of, 21
– comes to Greece from Crete, 27
– embodiment of Great Mother of Gods, 27; of one of the two basic principles, 27
– identified with Europa, 27
– idol of, 27
– institutes mysteries in honour of her daughter, 27
DERDAS, brother of Phila, 53

DEVELOPMENT
– indigenous, theory of, 131
– of productive forces, 134
DICINEUS, ruler of Getae, 48, 49
DIEGYLIS
– King of the Caeni, 49
– performs human sacrifice, 49
DII, population of Rhodope mountains, 140
DIODORUS SICULUS
– account of Archileus being wounded, 55
– account of capture of Lysimachus, 54
– account of contradictions in Thracian society, 25
– account of Diegylis' human sacrifice, 49
– account of Lycurgus encounters with Dionysus, 25
DIONYSIAC
– cult, 24–5, 31, 48, 58; clashes with traditional beliefs, 25; struggle with Apollonian, 31
– mysteries, invented by Orpheus, 26
– principle, 31
DIONYSUS
– a Thracian God, 25
– as horseman, 31
– Asia Minor origins of, 25
– blinds Lycurgus, 25
– buried in temple at Delphi, 26
– deity of Kings, 57
– distinction between Thracian and Greek, 31
– falls in love with Ariadne, 26
– fetches Semele, 26
– first contact with Thracians, 25
– first mentioned in Homer, 25
– form of King-high priest, 57
– identified in Hades, 26
– in a chariot with Hercules, 28
– in Greek religion, 57
– Liber, 31
– link with Great Mother of Gods, 27
– lover of Great Mother of Gods, 21, 58
– meets Lycurgus, 25
– one of three Gods revered by Thracians, 24
– oracle of, in land of Satrae, 31, 57, 58
– places Charops on throne, 57
– prophecies made under influence of, 57
– route to Eleusis, 27; to Thrace, 25
– sanctuary of, in Rhodopes, 12
– sends Butes off his head, 26
– solar aspect of, 31
– son of Persephone, 21, 26; of Semele, 27
– spread of cult of, in Balkans, 25
– torn to pieces by Titans, 26
– use of force and cunning, 25
DIVINE RIGHT of Kings, Thracian idea of, 49
DISPERSION, Thracian, 11, 144
DOLONCOS, clan-founder, 37
DRAGON, THREE-HEADED
– depiction of, 39
– fought by the Hero, 37
– lord of the world, 19
– personified by rain clouds, 19
DRIUS, place in Thessaly,
– scene of orgies celebrated by Dionysus' nurses, 26
DROMICHAETES, ruler of Getae
– captures and entertains Lysimachus, 53, 56
– successfully resists Lysimachus, 154
DRYAS, suitor of Pallene, 37

EAGLE, in investiture symbolism, 40, 41
EDONI
– include Sithonians, 44
– military-political organization of, 149
– people of Getas, 12
EGBEO, goldsmith, 46, 54, 79, 81, 100

ELEUSINIAN(S)
– agree to obey Athenians, 27
– cult of Demeter and Persephone, 21
– deities, 28
– mysteries, 27
ERECTHEUS, King of Athenians, killed in battle, 27
EUMOLPUS
– etymology of name, 58
– founder of Eleusinian mysteries, 27
EUROPA, daughter of Agenor, abducted by Zeus, 29
EURYDICE
– condition of return, 30
– dies of snake-bite, 28, 29
– legend of, 27
EVANTHES, father of Maron, 31
EXHIBITION, THRACIAN TREASURES FROM BULGARIA, 7

FAMILY
– community, 145
– fratria, 146
FEASTS
– distinctive feature of kingship, 56
– importance in religious and political life, 104
– of Kotys, 56; Seuthes, 49, 56
– only notables invited to, 56
FISH, as a symbol of kingship, 40
FUNERALS, rites of royal, 57

GEBELEIZIS, alternative name of Zalmoxis, 33
GEOGRAPHERS, Ionian, 9
GERMAN SCHOOL
– cartographic, 12
– dominates historiography, 10
– historiographic, 7
GETAE
– desert, 143
– family of God-King Zalmoxis, 12; of north-eastern Thrace, 12
– first noticed in north-eastern Thrace, 140
– have Zalmoxis as their chief hero, 33
– high priests welcome Macedonian army, 59
– method of sending messengers to Zalmoxis, 36
– ritual fight with monster, 19
– size of armies of, 144
– strong state system of, 149
– territory occupied by, 12
GETAS
– King of the Edoni, 12
– Thracian royal name, 12
GIFT(S)
– King's guests required to provide, 56
– necessary to accomplish anything among the Odryssae, 56
– ritual deifying of the King, 56
GREAT GODDESS, see MOTHER OF GODS
GREAVE, see also ARMOUR
– Agighiol, 19, 41
– a sign of royal rank, 40, 96
GREECE
– aided by Thracians in Peloponnesian War, 150
– differences in dialect in, 10
– interrelations of Thrace and, 11
– social crisis in, 143
GREEK
– art, 11
– epic memory, 9
– idea of Thracians, 9, 25, 59, 126–7
– languages, 11
– miracle, 11
– religion, 33, 34
– ritual of burial, 139

HADES, 26, 28
HARE, as a symbol of kingship, 40
HASANLU, gold cup from, 37
HECATE, 26
HELIOS
– considered greatest of the Gods by Orpheus, 30
– revered by Thracians, 30
HELLENOCENTRISM, 10, 11, 17
HERA
– and the Hero, 19
– association with Apollo, 22
– cult in Thrace, 22
– other image of Great Goddess, 23
– protectress of fertility, 17
– supreme deity of Scaeae and Cebrenii, 22, 36
HERCULES
– in a chariot with Dionysus, 28
– fighting a lion, 46
– slays Erymanthian boar, 18
– strangling a lion, 44
HERMES
– identified with Tereus, 51
– name used for Thracian royal deity, 49
– royal aspect of the Hero, 49
HERO
– a demigod, 20
– as lover of Mother of Gods, 21, 34, 40; son of, 32–4
– as progenitor, 20, 37
– as protector, 20, 37
– attendant depicted behind, 18, 28
– called Apollo Geikathlenos, 17
– depicted as Asclepius, 30; as hunter, 18; holding a lyre, 30; with three heads, 17, 28; in art, 120–5
– given attributes of Apollo, 17; of Pluto, 17
– in chain-mail, 18, 25
– martial aspect of, 34
– must give proof of prowess, 37
– not mentioned by Herodotus, 24
– representation of universal God, 17
– Scythian, 37
– shares functions with Great Goddess, 23
– Thracian mounted deity, 13, 17, 110, 138
– universal God, 17
– various names given to, 34
– votive reliefs dedicated to, 154
HERODOTUS, 9–26, 33, 58, 139, 144
HESYCHIUS, compares Great Goddess to Persephone, 24
HIEROGAMY, scene on Letnitsa appliqué, 21, 37, 38, 40, 52
HOMER, 9, 10; see also ILIAD, ODYSSEY
HORSE(S)
– appearance of, 134
– attribute of power of aristocracy, 18
– characteristic figure of Thracian art, 80, 89
– constant companion of Hero, 18
– importance in Thracian religion, 80
– in burials, 139
– place of origin of, 139
– sacred to Sun God, 18, 30, 56
– sacrificed by Moesians before battle, 24
– symbol of nether world, 18
– trappings, 72, 85, 88, 118–20
– used for riding by Thracians, 18
– white: bred by Rhesus, 30; element in ideology of kingship, 57; presented to Seuthes, 56
HUNT, THE
– a royal privilege, 18, 48
– a test of valour, 48, 55
– importance in political and religious life, 104
– in the iconography of the Hero, 18
– ritual character of, 55
– theme on Assyrian etc. monuments, 55
HYGIEIA, 17, 19, 26

ILIAD, 9, 12, 140, 149
IMMORTALITY
– available to women only if slain on husband's grave, 59
– snake an attribute of, 19
– Thracian concept of, 35
– won by Hero destroying the enemies of life, 19
INDO-EUROPEAN LANGUAGES
– newcomers, 139
– Thracian included among, 12
INVESTITURE, 40, 54
IPHICRATES, weds daughter of Kotys, 56
ITALO-CENTRISM, 10
IVY
– indicates presence of Dionysus, 58
– symbol of political and religious power, 52, 58

KAZANLUK, tomb, 53, 54, 70, 104
KAZAROV, G., Thracian scholar, 10
KAZAROV, K., 12
KERSEBLEPTES, son of Kotys I
– conquered by Philip of Macedon, 143, 152
– unable to deal with internal dissention, 152
KING(S)
– assumes function of Hero in real life, 53
– dual function of palace and sanctuary, 49
– has sole right and obligation to dispense food and wine, 48
– life of, 147
– no Thracian equivalent of rex or basileus, 146
– oneness of, and Hero, 57
– property vested in, 147
– residence the centre of public life, 146
– status of, 149
– warrior, God and priest, 148–9
KING-PRIEST(S)
– central figure in political and religious life, 104
– characteristic form of power in Thrace, 48
– deified, 13
– embody political and religious power, 49
– status of, 146
KOTYLAS, King of Thrace, father of Meda, the wife of Philip of Macedon, 53
KOTYS, a Thracian royal name, 12, 54
KOTYS I, King of the Odrysae
– agents of, in Athens, 152
– aims of, 152
– anti-Athenian policy of, 152
– assassination of, 152
– blasphemous behaviour of, 52, 149
– concludes treaty with Philip of Macedon, 152
– gifts made by, 54
– has image inscribed on coins, 54; name on phiale, 46
– himself serves food and wine, 56
– invites only high officials, 56
– King and high-priest, 56
KOTYTTO, King of the Edoni
– link with Cybele, 24
– orgies of, described by Aeschylus, 22

LANGUAGE
– Thracian, 10
– vestiges in south-eastern Europe, 131
LEBAEA, King of, employs Perdiccas, 58
LESBIANS, 31
LETNITSA
– appliqué, 20, 23, 25, 37
– treasure, 19, 21, 25, 39
LIBETHRA
– destroyed by flood, 58
– Orpheus's monument at, 30

LIGURIANS, 33
LINEAR B, origin of certain Thracian names, 145
LINUS, famous Thracian musician, 59
LOVETS BELT, 18, 20, 22, 41, 104
LURISTAN, bronzes, 17
LYCURGUS, son of Boreas
– a Thracian, 25
– encounter with Dionysus, 25
– identified with sun's brilliance, 26
– orders attack on Maenads, 25
– victim of struggle between two cults, 31
LYSIMACHUS
– campaigns of, 143
– captured by Dromichaetes, 56
– depicted holding tail of Alexander's horse, 18
– kills a lion, 55
– receives Thrace as his share of Alexander's empire, 154

MACEDONIA(N)
– absorbs lands of Paeones, 139
– dynasty, legend of how founded, 58
– garrisons in Thrace, 152, 153
– no real presence in territory of Seuthes III, 153
MAENADS
– and Dionysus, 19
– slaughtered by Lycurgus, 25
– tear Orpheus to pieces, 26
MARON, King-high priest
– himself pours the wine, 48, 56
– instructed to found city, 31
– links with Dionysus, 31
– name of his attendants, 48
– offers advice to Midas, 58
– priest of Apollo, 31, 44
– son of Evanthus, 31
– typical King-high priest, 48
MARONEIA, 31, 48
MARSIGLI, Count L., 9
MEDA
– daughter of Kotylas, 53
– married to Philip of Macedon, 53
MELEAGER
– death of, 40
– relinquishes head of Calydonian boar, 18
MENDEIS, 44
MEROPSES, King of Anthemusia, 37
MESAMBRIA, grants privileges to Sadalas, 12
MEZEK, tomb, 58
MIDAS, 50
MIGRATION(S)
– Aegean, 131, 140
– multiple, theory of, 131
– process, role played in Thrace, 131, 142
– to Asia Minor, of Bithynians, 139; of Phrygians, 140; of the 2nd millennium BC, 11
MITHRAS, overcomes dragon, 19
MOESIA
– lower, 9
– two Roman provinces, 140
– upper, 9
MOESIANS
– abstain from eating living things, 59
– sacrifice a horse before battle, 25
– strong state system of, 149
– territory occupied by, 12
MOHENJO-DARO, representation of God with three faces at, 17
MOLOSSIANS, kingdom of, 53
MONOTHEISM, not practised by Thracians, 13
MOTHER (GREAT) OF GODS
– affinities between Greek and Thracian concept of, 23
– an eastern concept, 21
– compared to Persephone, 24

– depicted in Kazanluk tomb, 42, 52; as winged on appliqué, 122
– development of cult of, 21
– difference of function, 24
– epithets of, 51
– incest with, 53, 54
– marriage with her own son, 40
– original European deity, 148
– representations of, 148
MOTHER GODDESS, *see* MOTHER OF GODS
MULTIPLICATION, of face, body or limbs suggesting omnipotence, 17
MUSAEUS
– challenges the Muses, 40
– famous musician, 59
– leads Eleusinian mysteries, 27
– son of Orpheus, 27
MYSIAN(S)
– boar, 18, 19
– European, 139
– first mentioned by Homer, 139
– of Asia Minor, 139, 140

NAXOS, (Strongyle), Thracian presence on, 145
NECROPOLIS
– at Varna, 145, 147
– in Mesambria, 119
NEOLITHIC, civilization, level of, 145
NEREID, riding on hippocampus, 19, 32
NESSEBUR, *see* MESAMBRIA
NESTUS, *see* MESTA
NICOMEDES I, King of Bithynia, 22
NYMPHS, The three
– connected with cult of Great Goddess, 23, 44
– figure with Hera on votive tablets, 23
– link with Bendis, 23
– sanctuary of, 22, 23

OCTAVIUS, father of Augustus, 57
ODOMANTI, Thracian tribe, 26
ODRYS, clan-founder, 37
ODRYSAE
– first mentioned by Herodotus, 140
– most powerful state union, 150
– tribal union of, 10, 140, 150
ODRYSIAN
– cavalry, how recruited, 18
– royal house, 150
– State: decline of, 154; foundation of, 151; reaches greatest financial power, 152; reduced, 153; territory of, 150
ODYSSEUS, given presents by Thracians, 31, 48, 60
ODYSSEY, 31, 48
OEAGRUS
– father of Orpheus, 26
– second king of 'Dionysian' dynasty, 31
– son of Charops, 26
OEDIPUS, story of, 40
OEOBAZUS, Persian commander, sacrificed by Apsynthii, 24, 25
OLYMPIAS, wife of Philip of Macedon, 53
OLYNTHUS, son of Strymon
– helps Priam in Trojan War, 40
– killed while hunting, 40
ONOCARSIS
– feast hall at, built by Kotys, 63
– place of meeting between Kotys and Philip of Macedon, 152
ORACLE, of Dionysus among Satrae, 31, 57, 58
OREITEIA, rape of by Boreas depicted on hydra, 122
ORPHEUS
– abodes of, 148
– an anthropodemon, 48; healer, 30;

musician and singer, 59; soothsayer, 29
– association with Dionysus, 26, 48, 58; with Mother of Gods, 28
– chthonian essence of, 27
– daily climb of Mt. Pangeus, 30
– derivation of name, 26
– descent to the nether world, 26
– Eurydice's death a warning to, 28
– grave of, becomes a sanctuary, 26
– head of, 26, 28, 31
– idol of, 28
– initiates Argonauts into mysteries of Cabiri, 20, 30
– invites only notables to his feasts, 56
– legends of, 148
– lyre of, 29, 31
– music of, 29, 30
– musician and singer, 59
– one of the Cicones, 33, 58
– participates in establishing cult of Demeter, 27, 28
– reforms Dionysiac religion, 29, 31, 148
– royal rank of, 48
– sanctuary barred to women, 28, 58
– son of Oeagrus, 26
– symbol of musical talent, 29
– teaches Thracians to farm, 32
– Thracian replacement of Dionysus, 26
– torn to pieces by Maenads, 26, 28
– urn of, 57, 148
– victim of struggle between two cults, 31
ORPHOS, deity of the nether world, 26
ORSOYA, idols found at, 21
OTTOMAN TURKS, conquest of Bulgaria, 9

PAEONES
– keepers of Zeus's sacred chariot, 56
– mentioned by Homer, 12, 139
– settled west of Strymon, 9
– take part in Trojan War, 139
– westernmost tribal group, 139
– women send gifts to Artemis bundled in straw, 23
PALEOCASTRO, CLIFFS at, symbol of sun carved on, 29
PALLENE
– daughter of Sithon and Mendeis, 37
– helps her chosen suitor, 37
– legend of Sithon and, 37, 44
– saved by Aphrodite, 44
PALMETTO, chthonian sign, 32
PANAGYURISHTÉ, treasure, 24, 60, 66, 69, 75, 79, 83
PANDION, King of Athens
– daughter of, marries Tereus, 44
PANGAEUS
– daily ascent of by Orpheus, 30
– mines on, 27, 140
– stage in journey of Dionysiac cult to Thrace, 31
PAN-SCYTHIANISM, 89, 125
PARTHENIUS, 34
PAUSANIAS, 30, 32
PEISISTRATUS, 9
PENTHEUS, King of Thebes, punished by Dionysus, 25
PERDICCAS
– ancestor of Alexander, 58
– finds employment as a baker, 58
PERIPHAETES, King of Mygdonia, 37
PERSEPHONE
– abducted by Hades, 26
– and Demeter, cult of, 21
– compared to Great Goddess, 24
– function of cult of, 23
– mother of Dionysus, 21
PERSEUS, myth of, 19
PERSIAN(S)
– ousted from south-east, 151

– religion, close to Thracian, 20
PHIALE, attribute of deity and of king-hero, 40, 42, 54
PHILA, sister of Derdas and wife of Philip of Macedon, 53
PHILIP OF MACEDON
– anti-Athenian policy, 152
– defeats Kersebleptes, 143
– marries Audata, 53; Phila, 53; two Thessalian women, 53; Olympias, 53; Meda, 53; Cleopatra, 53
– meets Kotys I at Onocarsis, 152
– use of marriage to aid political expansion, 53
PHILOSTRATUS, 18, 30, 48
PHINEUS, legendary King of Thrace
– son of Agenor, 27
– knowledge of navigation, 27
PHOCIS, Thracians at, 145
PHOENICIAN(S)
– expansion, 27
– settle in Thrace, 27
PHRYGIAN(S)
– art, 88
– migration of, to Asia Minor, 139, 140
PISISTRATUS, Athenian tyrant, 140
PITAKOS, name of Linear B origin, 145
PLATO
– describes Bendideian festivities, 25
– on Zalmoxis, 48
PLEISTORUS
– household God of Apsynthii, 24, 25
– Oeobazus sacrifices to, 24
– possible Thracian God of War, 25
– universal God of Propontic litoral, 25
POLITICAL ORGANIZATION, in Thrace, 146–7, 149
POLYAENUS, 22, 49
POLYANITSA, earthworks at, 146
POLYBIUS, 140
POLYGNOTES, frescoes of, 28
POSEIDON, 41
POSEIDONIUS, 59
POWER
– indivisibility of religious and political, 37, 59
– insignia of royal, 40; 118, 148
– political, of bearers of ethnonyms, 139
PRIAM
– helped by sons of Strymon, 40
– presented with beautiful Thracian cup, 60
PROCNE, 51

RESKYTHIAN Mountain, Hera worshipped on, 22
RHEA, Mother, *see* CYBELE
RHESUS
– a famous hunter, 33, 48
– after death becomes oracle of Dionysus, 48
– ally of Trojans, 140
– decorated chariot of, 60
– described by Homer, 118; by Philostratus, 48
– goes to cave, 26
– goes to help Priam, 40
– horse-breeder, 33
– killed by Diomedes, 40
– King-high priest, 48
– legends about, 57
– life story of, 33
– love for Arganthone, 33, 48
– possessions of, 18
– white horses of, 30, 56
RHODOPE, Mountains
– sanctuary of Dionysus in, 12
– thickly populated, 57
RHYTON
– attribute of King-hero, 40, 41, 54

– Rosolets, 54
– symbol of investiture, 40
RIDING, skill acquired by Thracians, 18
ROMAN(S)
– diplomacy of, 9, 154
– make Thrace a province, 9
– struggle with Thrace, 9, 154
ROSETTE, as solar symbol, 34, 81
ROSTOVTSEV, M., Proponent of Pan-Scythianism, 89
ROSOLETS, rhyton, 54
ROUSSÉ, treasure, 67, 79, 83, 110

SACRIFICE
– human, 49
– of a pig, 23
– to the God of War a common practice, 25
SADALAS, dynast, granted privileges by Mesambria, 12
SAMOTHRACE, Thracian presence on, 145
SATRAE, Thracian family
– have sanctuary of Dionysus, 31
– mentioned by Herodotus, 12, 140
– name disappears, 142
SCAEAE
– believe their King could climb to Heaven, 36
– chief deity of is Hera, 22
– chieftains of, high priests of Hera, 49
SCHLIEMANN, discoverer of Troy, 11
SCORPIL, Brothers, travellers, 9
SCYTHES, given attributes of royalty, 37
SCYTHIAN(S)
– art, 88
– cavalry, more numerous than Thracian, 144
– religion, 20
– sign treaty with Teres, 151; with Sitalkes, 152
– snake-limbed goddess of, 20
– version of the story of the origins of the human race, 20
SELENE, 26
SEMELE
– an earth Goddess, 27
– mother of Dionysus, 27
– son of, 29
SEUTHES I
– extent of taxes collected by, 152
– succeeds Sitalkes, 152
– switch of expansion to south-east, 152
SEUTHES III
– buys Panagyurishté treasure, 153
– capital of, 63, 143
– considers Athenians his kin, 49, 51
– entertains the Greeks, 49
– feast of, 49, 56
– invitation from, 56
– palace of, 142
– starts the war dance, 59
– successfully fights Lysimachus, 153
– usages at court of, 56
SEUTHOPOLIS
– archaeological evidence of, 49
– cult of Cabiri practised at, 20
– excavations at, 49, 146
SEVERI, 144
SITALKES
– army of, 144
– concludes treaty with Athens, 152; with Scythians, 152
– goes into Macedon, 152
– hero, 59
– reorganizes state, 152
– son of Teres, 51, 59, 152; of mythical Tereus, 51
– song of, 57, 59
– Thracian royal name, 12

SITHON
– institutes contests for daughter's hand, 37
– legend of, 37, 44
– son of Poseidon and Assa, 37
SITHONIA
– country of Sithon, 37
– renamed Pallene, 44
SLAVE-OWNERSHIP
– Greek cities the centre of, 11, 13
– in Thrace, 13
SNAKE
– attribute of deification, 19, 40
– round tree of life, 17
– symbol of vernal awakening, 19
SOFIA, gold vessel, 21, 147, 148
SOLAR
– cult, 26, 30, 57, 148
– principle, 148
SOUL
– healing of, 35
– immortality of, 35
– more important to the Thracians than the body, 35
SPARADOKOS, son of Teres, 151
SPARTACUS, leader of slave rebellion, 154
STRYMON
– clan-founder, 37
– legend of, 40
– river, *see also* STROUMA, 40, 44

TARGITAUS
– first inhabitant of Scythia, 20
– given attributes of royalty, 37
TELEPHASSA, child of Agenor, stays in Thrace, 27
TEREIA
– goddess, 22, 51
– nymph, daughter of Strymon, 51
TERES I
– dies aged 92, 151
– father of Sitalkes, 55
– founder of Thracian dynasty, 49, 142, 151
– identified with mythical Tereus, 51
– signs treaty with Scythians, 151
TEREUS
– King of Daulis, 51
– marries daughter of Pandion, King of Athens, 44, 51, 52
– myth of, 52
– mythical Thracian hero, 51, 57
TEUCRIANS, 140
THAGIMASADAS, God of Scythian kings, 49
THAMYRIS, famous Thracian musician, 59
THASOS, island, Thracian presence on, 145
THEOPOMPUS, King-high priest, builder of banqueting halls, 49
THRACE
– affected by Phoenician expansion, 27
– affinities with Mycenaean Greece, 34, 146
– ethnic division of, 143
– first mention of, 9
– frontiers of, 9
– interrelations of, with Greece, 11
– land of musicians and singers, 59
– largest country in south-east Europe, 13
– Mycenaean, 149
– origin of name, 30
– part of the ideological world of Asia Minor, 118
– population of, 144

– rediscovery of, 9
– religious links with Asia Minor, 24; Greece, 24
– renowned for its healers, 30
– royal power in, 48, 146
– subjugated by Celts, 119; by Romans, 125, 154
– vertical division of, 143
– voice of Ancient, 11
THRACIAN(S)
– as legionaries, 154
– belief in immortality, 35, 59
– coinage, 118
– conservatism of, 125
– considered inveterate drunkards, 25
– cult, strangeness of to Greek writers, 24
– cultural community with north and east, 17
– decline of states, 139
– deities, 13
– dispersion, 11, 144
– ethnic element, resilience of, 11
– evolution, 13
– family community, 145–6
– historical geography, 12, 142
– horseloving, 18
– horsemen, *see* HERO
– ideological gap between, and Greeks, 17
– kings, wealth of, 60
– language, 10
– leave the historical stage, 9
– level of material culture, 147
– life as described in classical sources, 147
– luxury of aristocracy, 64
– material culture, 10
– medicine, 30
– military-political organization, 146
– milk-drinkers, 59
– most numerous: neighbours of the Greeks, 10; people on earth, 144
– musical talent of, 59
– mysteries, 59
– political system, 146–7, 149
– polygamous, 59
– presence in Aegean islands, 145
– preserve national identity, 155
– religion, 10, 11, 17, 21, 31–2, 59, 64, 134, 148
– sanctuaries, erection of, 31
– social organization of, 145–6
– *strategiae*, 143, 145
– trade orientated to Persian world, 118
– tribal enclaves, 11, 145
– unfortified settlements, 146
– viewpoint, 11
– women: famed for their beauty, 85; send gifts to Artemis, 23
– World, 10
THRACIDAE, main priestly family at Delphi, 31
THRACOLOGY
– Institute of, 7
– International Congress of, 7
– What it is, 10
THRAKE
– gives name to Thrace, 23
– skilled in incantation and herbal lore, 23
THUCYDES, 51, 56, 144
THYNI
– attacked by Teres, 151
– not mentioned by Herodotus, 142
– tribe, 26

TISSAPHERNES, Satrap, 55
TOMBS
– at Kazanluk, 57, 64; Mezek, 57, 64, 77, 104; Tatoul, 64
– megalithic, 63, 76, 149
– Mesambria necropolis, 119
– of Thracian heroes, 57, 63, 104; wealthy Thracians, 119
– rectangular, 64
– rock, 64, 76, 140, 149
– round, 63–4
TRANSMIGRATION OF SOULS, idea of in Thrace, 59
TREE
– of life, 18, 20, 34, 40; northern, 21
– symbol of rebirth of Nature, 18
TRERES, founder of Thracian clan, 37, 142–3
TRIBALLI, tribe of Northern Thrace
– first mentioned by Herodotus, 140
– strong state system of, 149
– territory occupied by, 12, 140
– worthy rivals of Odrysae, 140
TROJAN WAR, 12, 140
TURK(S), Ottoman, 9

VOLOGAESUS, high priest of Dionysus, 58
VOTIVE TABLETS, 17, 18, 20, 31, 51, 138, 154
VRATSA, treasure
– gold crown, 102
– gold jug, 20, 32
– greave, 41, 52, 58
VULCHITRUN
– treasure, 10, 60, 63, 65, 148
– cantharus from, 60, 61

WEAPONS
– an important social attribute, 59
– manufacture of, 134
– of the aristocracy, 147

XEBANOKOS, name on cup, 54
XENOPHON, 25, 51, 56

YANTRA, river, 9
YIMA
– one of the 'first people', 20, 37, 59
– wealth of, 48

ZAGREUS, epithet of Dionysus, 31
ZALMOXIS
– anthropodemon, 48
– chief hero of Getae, 33, 48
– chthonian character of, 59
– dance of, 57
– God-King, 57
– high priest, 48
– imparts doctrine to Thracians, 35
– invites only notables, 56, 59
– legends of, 148
– model of royal power, 49
– preaches immortality, 59
– quinquennial messenger sent to, 36, 59
– underground apartment of, 26, 36
ZEUS, 17, 19, 25, 26, 28–9
– Cretan, reared in a cave, 26; torn to pieces by boar, 18
ZILMISOS, Mt., Dionysiac temple on, 31